D0209312

Fakes, Forgeries, and Frauds

Nancy Moses

ROWMAN & LITTLEFIELD
Lanham • Boulder • New York • London

Published by Rowman & Littlefield
An imprint of The Rowman & Littlefield Publishing Group, Inc.
4501 Forbes Boulevard, Suite 200, Lanham, Maryland 20706
www.rowman.com

6 Tinworth Street, London SE11 5AL, United Kingdom

British Library Cataloguing in Publication Information Available

Library of Congress Cataloging-in-Publication Data
Names: Moses, Nancy, 1948- author.
Title: Fakes, forgeries, and frauds / Nancy Moses.
Description: Lanham : Rowman & Littlefield, 2020. | Includes bibliographical references
and index. | Summary: "What's real? What's fake? Why do we care? In these times of
false news and fake science, these questions are even more important than ever because
they hold a mirror to the unsettling reality in which we live. Fakes Forgeries and Frauds
goes beyond the headlines, tweets, and blogs to explore the true nature of authenticity and
why it means so much today. The book delivers nine fascinating true stories that introduce
the fakers, forgers, art authenticators and others that populate this dark world. Examples
include: Shakespeare—How an enterprising teenager in the 1790s faked Shakespeare and
duped Literary London Rembrandt—How is art history, connoisseurship, and science
re-shaping our view of what the great Rembrandt painted and how the canvas changed
over time? Relics—Was Saint Cecilia, the patron saint of music a real teenage girl who
lived in 3rd century Rome and was martyred in the same location as the church that bears
her name? Jackson Pollock-How do experts pick out the real Pollocks from the thousands
of fakes? Nuremberg—How repeated reconstructions of medieval Nuremburg—including
one by Adolph Hitler—shows how historic preservation becomes a tool for propaganda
Fakes, Forgeries and Frauds also raises provocative questions about the essential nature
of reality. For example: What happens when spiritual truth conflicts with historic fact?
Can an object retain its essence when most of it has been replaced? Why did some art
patrons place a higher premium on an excellent copy than on the original? Why do we
find fakes so eternally fascinating, and forgers such appealing con artists? Fakes Forgeries,
and Frauds is a full-color book with 30 color photos. It shows that reality, exemplified
by discrete physical objects, is actually mutable, unsettling, and plainly weird. Readers
discover things that are less than meet the eye—and might even come to reconsider what's
real, what's fake, and why they should care"—Provided by publisher.
Identifiers: LCCN 2019038370 | ISBN 9781442274433 (cloth) | ISBN
 9781442274440 (epub)
Subjects: LCSH: Forgery. | Literary forgeries and mystifications. | Art—Forgeries. |
Historic buildings—Reconstruction. | Authenticity (Philosophy)
Classification: LCC HV6675 .M67 2020 | DDC 364.16/3509—dc23
LC record available at https://lccn.loc.gov/2019038370

To Mother and Nella, my heroes.

Contents

List of Figures

CHAPTER 1.
ABOUT AUTHENTICITY

CHAPTER 2.
IRELAND'S SHAKESPEARE

CHAPTER 7.
AUTHENTICALLY BARNES

CHAPTER 8.
DINOSAUR TALES

CHAPTER 9.
INCORRUPTIBLE

Acknowledgments

One of my greatest pleasures as an author is working with generous and wise colleagues. Many of them are already cited in the text, and I wish to thank them all, especially those who patiently explained their expertise to an eager author. I am also grateful to Jehane Ragai who provided insights into the science used in art authentication, and Bruce Bellingham, Esq., who assisted on legal matters. I appreciate the American University of Rome, Amy Baldonieri, director of development, who provided introductions and support, and Romana Franziska Waller, librarian, who located and secured critical source materials. A special thanks to Giovanni Linari, a member of the university's board of trustees, who kindly arranged a meeting at the Vatican Congregation for the Causes of Saints.

Fakes, Forgeries, and Frauds benefitted from Suzanne Garment's editorial prowess and Randi Kamine's meticulous fact checking. Members of our author's collective, Carol Shloss, David Barnes, Darl Rastorfer, and Margie Patlak, challenged me to write better and reach higher. One could not ask for a more insightful and supportive editor than Charles Harmon, executive editor at Rowman & Littlefield Publishing Group.

Finally, I wish to thank Myron Bloom, my first reader and beloved husband.

Foreword

"The world wants to be deceived, so let it be deceived."

This is the opening quote of my own book on the history of forgery, but it could apply to so many aspects of life. Fraud and falsification are all around us. We tend to associate it with the art world, or perhaps counterfeit money, but it decided recent elections, it has infiltrated the news. It is a significant and influential part of contemporary life, whether we like it or not.

The term "whether we like it or not" implies that it is inherently unlikeable. And yet, in my own researches into the world of fakes and forgeries, I found myself often delighted, often admiring, often smiling at the antics of fraudsters. There have been devastating frauds, to be sure. But in most cases, frauds of the cultural world do not come with reverberant damage beyond those immediately involved. In art terms, this is usually the collector, the expert who (incorrectly) authenticated the work in question, and few others.

Art forgers, as I wrote in *The Art of Forgery*, tend to be "more prankster than gangster," and there is an aspect of illusionism to the way they pull the wool over the eyes of so-called experts. There is also an element of schadenfreude visible in the way that particularly the tabloid media reports on forgers and fraudsters. They are depicted as Robin Hood types, hoodwinking the wealthy elites, with the implication that the victims deserve to be fooled. In criminological terms, forgery of cultural objects tends not to involve organized crime groups, which makes it distinct from other types of cultural crimes, for art theft and antiquities looting is largely the realm of criminal gangs, and therefore damages far more than the immediate cultural institutions victimized. As a result, it's easy to find oneself almost cheering for the fraudsters. Their stories are often outrageous, fascinating, entertaining, dramatic, and they can be wonderfully engaging tricksters, not

the threatening sort of criminals. So, when it comes to "whether we like it or not," I feel that, when it comes to hearing about cultural frauds, we tend to "like it"—provided, of course, we are not the ones hoodwinked.

And yet, we volunteer ourselves for hoodwinking on a daily basis. The "fake news" scandals of recent years are a case in point. We tend to believe what we choose to believe, what supports our a priori hypotheses about life and how the world works or should work. We ignore or dismiss counterarguments to what we already believe and are willing to accept as fact demonstrably blatant falsehoods, if they support what we want to hear.

So, yes, the world wants to be deceived. Clever fraudsters weave appealing traps into which their victims will eagerly entangle themselves. We are an all-too-willing audience for spun stories and crafty creations.

This makes the book you now hold of immediate importance. Not only does Nancy Moses paint portraits of these dynamic frauds with great skill and interest, but the overall lessons of caveat emptor, "buyer beware," are as pertinent as they have ever been. Moses's knowledge is evident from the title: she is aware that there is a difference between fakes, forgeries, and frauds. While we tend to use the terms interchangeably in casual conversation, from a criminological perspective, a forgery is a new object, made wholesale from scratch in fraudulent imitation of something else. A fake, by contrast, is an object that already exists but is altered in some way to make it appear something else. Fraud is the crime committed by fakers and forgers, and it need not involve an object, but could be a confidence trick or other sort of scheme.

Most books on fakes and forgeries (and the shelf is not so large that it could contain them all) are largely full of works by journalists—simply telling a good story. My work was new because it took a criminological and psychological approach. Moses's book is from the perspective of the museum world, normally the victims of fraud, and for that reason is distinctive and enlightening. As such, *Fakes, Forgeries, and Frauds* contributes to the diverse literature by showing the breadth of objects that can be the subject of fraud in the museum world. Most people think only of paintings, perhaps of sculptures, but just as cultural heritage is a broad term, with myriad elements and subcategories, so too is fraud within that realm.

With a lively diversity of case studies examined, from paintings to literature, from ancient manuscripts to bones, Moses's book offers a wonderful introduction to a subject that fascinates, whether we like it or not because, to be frank, we *do* like it.

Dr. Noah Charney
Author, *The Art of Forgery: The Minds, Motives and Methods of Master Forgers* (London: Phaidon, 2015), and president of the Association for Research into Crimes against Art (ARCA)

Preface

Fakes, forgeries, and frauds are the curse of museums and the plague of art collectors. Fakes destroy reputations, bankrupt galleries, and frustrate panels of experts who authenticate artworks. The value of a painting can soar to hundreds of millions of dollars based on a certificate of authenticity, or crash to worthless when the certificate is discovered to be forged.

What determines authenticity? It is not a scientific absolute; even the most advanced biochemical and technical analyses cannot definitively prove it. It's not an aesthetic absolute, since two authorities can reach diametrically opposed conclusions about it. It's not even a physical absolute. When a piece of antique furniture gains the patina of age, or an ancient marble sculpture loses its original polychrome paint, we admire it even more—even though its maker might find it unrecognizable. Some fakes hide in plain view on the walls of even the most august museums and toniest art galleries. Some start out as genuine—then are unmasked as frauds, only to be resurrected as genuine later on.

I rarely thought about authenticity before beginning this book. My motivation for writing it was less philosophical than pragmatic: to add to my series of books about cultural treasures. The first volume, *Lost in the Museum: Buried Treasures and the Stores They Tell*, is about intriguing objects that are buried in museum storage crypts and are seldom, if ever, publicly displayed. The second, *Stolen, Smuggled, Sold: On the Hunt for Cultural Treasures*, went darker, describing objects that were taken, purloined, or burgled but eventually returned home. This, the third book, was to take another cut at the subject, focusing on more fundamental questions. I thought it would be an easy book to write, cutting a clear path between the genuine and the faux. Instead, I found a twisted, murky road filled with potholes, obstacles, and

barriers. The reality I had imagined, exemplified by discrete physical objects, was actually mutable, unsettling, and plainly weird.

So, I bring you a book about authentic fakes, admirable forgeries, and imagined representations of tainted reality. Here you will find things that are *less* than meet the eye. I hope it will lead you to reconsider what is real, what is fake, and why *you* should care.

Chapter One

About Authenticity

"Things are seldom what they seem."

—Gilbert and Sullivan, *H.M.S. Pinafore*

In the summer of 1883, Moses Wilhelm Shapira, a respected Jerusalem dealer in antiquities and manuscripts, brought an unusual item to one of his clients, the British Museum: fifteen fragments of a goatskin parchment scroll inscribed in a language so old that it predated Hebrew. Shapira explained that Bedouin had discovered the manuscript, wrapped in linen or cotton, in the 1860s in a cave near the east bank of the Dead Sea. Shapira had then spent years methodically translating the fragments before concluding that they were likely an early version of Deuteronomy, "the last speech of Moses in the plain of Moab."[1]

This was a stunning find. If the scroll was genuine and its version of Deuteronomy predated the one in the Bible, Shapira's parchment would literally rewrite history: every biblical and Hebraic expert would have to reconsider his or her scholarship. The script appeared genuine, since it was the same as the pre-Hebraic script on the Moabite Stone, a then-recently discovered stele that had served as prototype for early Semitic writing. Now, Shapira was offering his treasure to the British Museum for one million pounds.

By the time Shapira made his offer, a group of distinguished British experts assembled by Sir William Besant, secretary of the Palestine Society, had spent three hours examining the document. The sale to the British Museum rested on the judgment of one of them: biblical and Masoretic scholar Christian David Ginsburg. Even before he finished the examination, he and the museum were actively promoting the find. Ginsberg had published three articles in the *Athenaeum*, an important intellectual journal. The museum had quickly placed

1

some of the fragments on display, to the wonderment of scores of curious visitors, including biblical scholars who had made the trip from Europe, and even Prime Minister Gladstone, himself an antiquarian. English newspapers carried features on the scrolls every day; they were the talk of London. Shapira's prospects for a sale seemed bright . . . until the questions began.

Who was this Moses Shapira, a Polish Jew who had converted to Christianity? How had he discovered this potentially groundbreaking text when so many legitimate scholars and archaeologists had failed to do so? One Biblical authority noted that the script, though archaic, was in suspiciously pristine condition. Another remembered the Dead Sea caves as being damp and earthy, terrible conditions for manuscripts of perishable parchment. Bedouin shepherds had known about the caves from time immemorial; why had the scrolls come to light now? Shapira himself was somewhat suspect, once accused by Charles Clermont-Ganneau, an archaeologist and the French consul to Palestine, of selling fraudulent Moabite statues. Clermont-Ganneau came to the British Museum, conducted a "hasty inspection of two or three pieces," and announced his assessment. "The fragments are the work of a modern forger," he declared, then went on to describe how Shapira faked them: he had cut pieces off the bottom of "one of those large synagogue rolls of leather which Mr. Shapira must be well acquainted with, for he deals in them," darkened the parchment with chemicals, and inscribed a version of Deuteronomy in proto-Hebraic script.

That indictment tipped the scales. Many of Shapira's supporters quickly joined the naysayers, including Ginsberg, who claimed that he had spotted the counterfeit from the beginning. The ancient scroll was not so ancient after all. Bedouin shepherds had not discovered it in a cave near the Dead Sea.

Shapira was devastated. He had brought the precious document to the British Museum in good faith. Some scholars had found it to be genuine; some, including Ginsberg, had even offered to buy it, though not at Shapira's astronomical price. In desperation, Shapira wrote to Ginsberg, "You have made a fool of me by publishing and exhibiting [the fragments]) that you believe them to be false. . . . I do not think I will be able to survive this shame." Shapira departed London in disgrace, leaving the precious manuscript at the British Museum. Six months later, he committed suicide in a hotel room in Rotterdam.

Who should we believe: Moses Shapira or the phalanx of biblical scholars who refuted his claim? Shapira had proven himself to be trustworthy and knowledgeable: although he had once been accused of selling questionable statues, he had also supplied museums and collectors with hundreds of genuine antiquities over many years. Why would he risk his entire career on the sale of a single manuscript, however valuable?

On the other hand, distinguished scholars and archaeologists were already scouting Palestine treasures, and none had discovered anything like this. Moreover, they had staked their entire careers on the accepted version of the Bible, now at risk if Moses' Deuteronomy parchment was real. The Shapira Affair, as it came to be called, leaves us wondering: were these bits of old looking goat skin actually from the ancients, or had a clever prevaricator manufactured them to line his pocket and dupe the stodgy scholars? Was it genuine? Was it a ersatz? How can we ever know?

This book explores the provocative issues raised by the Shapira Affair. Through eight very different cultural objects, it takes a hard look at authenticity and its dark sisters, fakes, forgeries, and frauds. This journey of discovery will introduce us to objects in museums, rare book libraries, upscale art galleries, and city streets. We will debate whether the suspicious-looking ones are what they seem to be. We will meet the fakers, forgers, and fraudsters, the art authenticators, law enforcers, dealers, and collectors.

But, before we set off, let's spend a moment to find our bearings and chart our path. What exactly are fakes, forgeries, and frauds? Well, it's all about intent, the intent to deceive. A fake is a new creation based on an object that already exists. It is, in the words of Thierry Lenain, "meant to steal the identity, place, and status of the original it simulates."[2] Fakes are deliberately created facsimiles that someone puts forward as genuine. The discovery of such fakes doesn't always damage reputations. In the early twentieth century, Fritz Kreisler, a famed violinist, was celebrated for performing "lost classic" compositions by Corelli, Vivaldi, and others discovered by Kreisler in a French monastery. When he confessed to composing them himself, the critics were but not the public: his popularity remained undiminished after the scandal.[3]

A forgery is another type of deception. It is an exacting new copy of an original, a copy that purports to be the original itself. There are many types of legitimate copies, including homages, duplicates, clones, replicas, and analogs. But if the copy is created to dupe someone—for example, a counterfeit hundred-dollar bill produced on a color copier—it is a forgery.

Fakes and forgeries can be inconvenient. Undetected, they create a false impression of an artist's intention, skill, or scope, as happens when phony paintings by a major artist are considered part of the oeuvre. Fakes and forgeries can be pernicious: Holocaust deniers point to fake concentration camp uniforms and bars of soap purportedly made from Jewish bodies to refute the greatest mass murder of modern times. Fakes and forgeries can be instructive, a tilted, tinted mirror reflecting what we value, causing us to look closer and see more—as when *Salvator Mundi*, an extensively restored painting attributed to Leonardo Da Vinci, was sold for a record $450 million, principally because of Leonardo's celebrity status.

Fraud is the final piece in the triad. Fraud is a crime in which the perpetrator is charged with seeking to benefit from conveying a fake or forgery. Say you own a painting that you love. You could commission an artist to create a new painting in the style of the one you cherish—homage. Or you could ask the original artist or another artist to prepare an exact reproduction—a copy. If you then sell this new painting as an original, you've committed fraud and may be on your way to jail.

With these definitions in hand, I began searching for examples. The first stop was collecting institutions—museums, historical societies, archives, and rare book libraries—since their mission is to preserve and display cultural objects. Most people don't realize how many questionable objects are displayed in galleries or hidden in storage crypts. Many were acquired in the institutions' early years, when curators, eager to fill their walls, would accept a donor's dross in order to secure the few diamonds. Others were purchased from unscrupulous dealers, or from honest ones who didn't realize they were abetting fraud. Regardless of how the questionable objects arrived, it's tough to get rid of them. The guidelines of professional museum and archival associations prohibit selling or donating questionable, suspected, or actual fakes, since they could enter the market and be sold to another unsuspecting institution.

Some institutions find productive uses for their fakes. The Rosenbach Library and Museum, known for its outstanding Shakespeare holdings, also owns some rare fake Shakespeares, a special favorite of its founders, A. S. W. Rosenbach and his brother Philip. They are now also a favorite of the visiting public, highlighted in exhibits and programs. Winterthur, a distinguished museum of American decorative arts, uses its fake clocks, chests of drawers, chairs, and other alleged antiques to help decorative arts students train their eye.

LITANY OF FAKES

COPY HOMAGE PASTICHE KNOCK-OFF CLONE DUPLICATE EMULATION RUSE DOUBLE CON UNREAL REPLICATION ERSATZ MISCONCEPTION SLEIGHT-OF-HAND REPLICA REBUILT FACSIMILIE DIGITAL-MEDIATION FRAUD ANALOGUE FAUX ILLUSION REPLICA SQUEEZE ARTIFICIAL REPRODUCTION IMITATION FORGERY TRICKERY COUNTERFEIT PHONY

Not all cultural objects are inside collecting institutions: some of the more interesting are outside their doors. Many are in churches, like the five thousand reliquaries in a chapel in Pittsburgh, Pennsylvania. Some are culturally significant buildings or entire districts, like the medieval core of Nuremberg, Germany. These and other objects bring new perspectives on authenticity (see "Litany of Fakes").

About halfway through the research, it became apparent that some of most fraudulent cultural objects wore a thin patina of truth, and some of the most authentic ones emitted a faint odor of fakery. Authenticity, the notion of what's genuine, turned out to be more complicated than it originally seemed. That's when my black-and-white certainty faded to shades of gray and to more nuanced questions. How much of the authentic is needed for a cultural object to count as real? Where does truth lie when people with differing values and views contest an object's authenticity? Can a cultural object change from genuine to fake? Can a fake later become genuine and then turn fake again? Over time, authenticity became more mutable, contingent, almost a shape shifter. The questions took on a philosophical cast: Is authenticity a characteristic embedded in an object, something intrinsic to the object? Is authenticity in the eye of the beholder, something outside the object that the observer brings to it?

Seeking to unravel these conundrums, I turned to the extensive literature: a bibliography published in 1950 included more than 850 entries of books on fake and forged artworks, and another circa 1997 listed an additional 1,835 books covering art and literature.[4] My own growing stack of books includes philosophical treatises, cultural studies, historical surveys, books about one or more frauds, and tell-alls by forgers and law enforcement officials. There are books about a single artist, a type of forgery, and about museums like the Getty and the Metropolitan Museum of Art that seem to own significant numbers of fraudulent artwork. Finally, there are a number of technical books about authentication science, art law, and museum practice (see Figure 1.1).

I learned which scientific tests and technologies reveal the most about different types of objects, as well as many interesting facts. Fakes and forgeries have long been with us: the Romans created replicas of Greek masterpieces, and some of their own designs. View change over time and in different cultures: Michelangelo was celebrated for his brilliantly executed fake of an ancient statue. Forgery wasn't even a crime until the 1860s. Today we ferret out fakes while at the same time celebrate appropriation art and music sampling in the digital age. I was fascinated: cheering on perpetrators for duping the experts, and gasping at the "reveal" when the dirty deeds were unmasked. Fraud is a crime with built-in appeal. A victim's pride may be wounded or pocketbook emptied, but he will seldom suffer bodily injury.

Chapter One
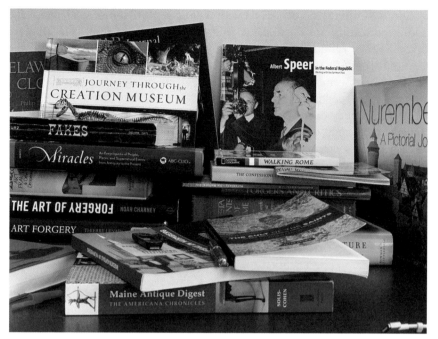
Figure 1.1. Books about Fakes, Frauds, and Forgeries.
Courtesy: Nancy Moses
While digging through the literature, then surfing the Internet, I continued to search for a working definition of authenticity that applied to my diverse roster of cultural objects. I eventually found it at the World Heritage Organization's website: the *Nara Document on Authenticity*.[5] This document, created by an international group of experts in Nara, Japan, attempts to arrive at a universal definition of authenticity applicable to every nation and culture on the planet. No small task. "Depending on the nature of cultural heritage, its cultural context and its evolution through time," the *Nara Document* concludes, "authenticity judgments may be linked to the worth of a great variety of sources of information." The document then goes on to list aspects of these sources of information: "form and design, materials and substances, traditions and techniques, location and setting, and *spirit and feeling*."
Spirit and feeling? That seemed to resonate. The Nara definition implies that authenticity is both intrinsic to an object—its "spirit"—and also extrinsic—the observer's "feeling" about the object. Authenticity lies in the space where spirit and feeling intersect, a dynamic dialectic that shapes our reality. This definition implies that the reality of a cultural object does not exist in a vacuum; an observer must validate it.

The significance of this dialectic became apparent during an interview with the undersecretary for the causes of saints at the Vatican about relics, saints, and those who believe they are real. When I asked him to explain the connections, he thought for a minute, then said, "What's most important to remember is this: it is the *cult* that makes the *saint* as much as it is the *saint* that makes the *cult*." According to the undersecretary, a saint is not a saint unless there are people who believe that he or she is indeed a saint. If you're looking for the final word on religious authenticity, there's no better authority than the Vatican.

The dialectic between the saint and the cult, the spirit and the feeling, might be unsettling for those who are wired for certainty. We want truth to be self-evident, solid, and unchanging. We yearn for security. When these core beliefs are threatened, our world becomes unstable and frightening.

With the right technology, almost anyone can fake most anything: a photograph, video, person, and even a monument. Factum Arte, owned by Alan Lowe, has created a three-dimensional fake monument of King Tut's tomb that authentic people can actually enter. His team digitally recorded the tomb with a fleet of scanners for seven weeks, stitched the data sets together, and then recreated it in its original form in a 3-D computer-controlled milling machine. Lowe coined the term "digital mediations" to describe his mega-duplicate-replicas, which are now being enhanced with "acoustical signature" sounds from King Tut's actual tomb.

Some find all of this very troubling. They ask: Will children raised in this climate of mendacity be able, as adults, to distinguish truth from lies, reality from manipulated reality? Will they cherish King Tut's actual tomb or prefer a digital mediation with acoustical signatures? Will future generations see our time as a brief moment when fake trumped truth? Will they see it as the start of something permanently disfiguring or transformative?

Now, let's return to poor Moses Shapira, the Jerusalem antiquities and manuscript dealer. He stood in a room as some of the greatest minds in the field debated the veracity of his scroll from the Dead Sea. He watched, the tide turn from acclaim to disgrace, unable to stop it. He spent his final days suffering at the hands of biblical pedants, ultimately so wounded that he took his own life.

Though Shapira himself was dead, the controversy surrounding his scroll lived on as a festering wound in the heart of Biblical scholarship. Seventy-three years after he carried his manuscripts to the British Museum, the biblical scholar Menahem Mansoor sparked a scholarly firestorm by suggesting that Shapira's inscribed goatskins may have been authentic. His evidence? The Dead Sea Scrolls.

The discovery of the Dead Sea Scrolls has haunting parallels to the discovery that Shapira had promoted seventy-three years earlier. In 1947, a young Bedouin entered a cave near the Dead Sea, reached into a jar, and discovered some goatskin rolls inscribed in an ancient script. When a high-ranking official in Jerusalem saw them, he was convinced they were genuine, though others doubted. The scrolls ended up in the hands of a young scholar, John C. Trever, at the American School of Oriental Research in Jerusalem, who then sent photographs of the manuscripts to a leading biblical scholar, William F. Albright of the Johns Hopkins University. Within a few days, Trever received a startling letter: "My heartiest congratulations on the greatest manuscript discovery of modern times. What an absolute incredible find! And there can happily not be the slightest doubt in the world about the genuineness of the manuscript."[6]

That endorsement tipped the scales and sent the scholars to reexamine the evidence. The dampness in the caves was discredited, as was the likelihood that Shapira, or anyone else, could have inscribes such exacting, proto-Hebraic script onto ancient goatskin. As to the remarkable discovery of the scroll in the nineteenth century, the reason, through new eyes, became clear. Bedouin had indeed visited the Dead Sea caves from time immemorial to harvest guano to fertilize their fields. They had ignored the bits and pieces of dried old skin. Only much later, after European academics arrived in Palestine, did the worthless skins become more valuable than the bird droppings. In fact, the marketability of these once-unappealing scraps of writing was so alluring that the Bedouin scaled the cliffs near the Dead Sea and combed the caves for the tiniest particles of inscribed parchment.

Today, no one would dispute the authenticity of the Dead Sea Scrolls. So what about Shapira? Was his scroll authentic? Two years after he died, the British Museum auctioned off his precious find at Sotheby's, where it was bought by another auction company, then perhaps sold to Sir Charles Nicholson. It may have been destroyed in a fire in Nicholson's home near London in 1899.

Moses Willhelm Shapira's parchment scroll will always remain a mystery. Like other questionable objects, it will continue to raise provocative conundrums and spark unanticipated wonder. But does this fully explain the enduring grip of fakes, forgeries, and frauds on the human psyche?

I have come to realize that fakes, forgeries, and frauds possess enormous psychic power. They can pierce into the blighted memories we enshrine in our museums of regret. They can release the lies, prevarications, and half-truths we spin to protect our reputation, wealth, and standing. Fakes, forgeries, and frauds remind us that the struggle for truth and the lure of falsehood are embedded together in our souls.

Chapter Two

Ireland's Shakespeare

For a man whose work left such an indelible mark on world literature, Shakespeare left precious few traces of himself. Beyond a few signatures and a will with the cryptic phrase, "I gyve unto my wief my second best bed," which leads one to wonder who got the *very* best bed, there's almost nothing to be found in Shakespeare's own hand: no correspondence, no manuscripts of any of his thirty-some plays or 154 sonnets, no notes to actors, books of accounts, or even shopping lists. Almost nothing.

The world's libraries hold more than 334,200 books, articles, audiotapes, and videos of Shakespeare's work or about the man himself, with more produced every year.[1] Some of the latter argue that Shakespeare wasn't actually Shakespeare, but instead someone else who may have had reason to hide his or her identity. Among the candidates are Anthony Bacon, the well-traveled courtier and brother of famed explorer Sir Francis Bacon; Roger Manners, the Fifth Earl of Rutledge; William Stanley, the Sixth Earl of Derby; Edward de Vere, the Seventeenth Earl of Oxford; playwright Christopher Marlowe; and even Queen Elizabeth I. Scholars and buffs also continue to dig for clues to Shakespeare's identity in his sonnets and plays, and they mine the letters, diaries, and other writings of his contemporaries. They can't look at the letters, diaries, or manuscripts by the great Bard himself, because there aren't any.

Or are there? Could there actually be documents penned by Shakespeare that haven't turned up yet?

With all the decades of sleuthing since Shakespeare hit London around 1596, it seems that the odds should favor something—some little scrap of a letter, a deed, or even a book inscribed by him—turning up in the basement of a dusty book shop or the stacks of a village library. But no luck, at least no luck so far. Since the 1700s, every so often, new "discoveries" are made; but each time a somewhat shaky Shakespeare signature is discovered it turned

out to have been penned by one of the many opportunists more than happy to fulfill the yearning for all things Shakespeare.

Of all of these forgers, the most brazen of all was William-Henry Ireland, an English teenager who lived at the turn of the nineteenth century and made his name, and permanently ruined his reputation, by counterfeiting the Bard.

There are two plausible ways to think about William-Henry and tell his story. In the first, he was a bored and lonely teenager who so yearned to please his hard-hearted father, Samuel, that he was willing to perpetrate a fraud. In this version, the naive William-Henry soon found himself trapped in a tangle of lies that left him, at age twenty-one, with his life destroyed. In the second version, William-Henry Ireland was a clever, conniving criminal who enjoyed nothing more than hoodwinking the stuffed shirts of literary London, especially his father. Convinced of his genius, William-Henry created masterful replications of Shakespeare's handwriting and used them to invent a corpus of work that actually improved upon Shakespeare himself. These letters and plays were so cleverly wrought that London's literary world bowed down to his talent, only to abandon their protégé when they later found themselves deceived.

Was William-Henry Ireland a clueless youth whose life was essentially destroyed by a single foolish decision? Or was he a clever prevaricator with a literary bent? What is the truth?

Sadly, we will never really know. The truth about William-Henry Ireland is slippery, mutable, and perhaps ultimately irrelevant. He became so adept at lying to so many people about so many things that truth may have just melted away, replaced by a fantasy life as rich as a Shakespearian drama in which William-Henry figured as playwright, stage manager, and lead actor. In our time, someone with this flair for virtual reality might have become a creator of epic films or sci-fi video games. In his own, he was a dunce.

I learned about William-Henry Ireland from Derick Dreher, executive director of Philadelphia's Rosenbach Library and Museum, now called The Rosenbach, a privately assembled collection of rare books and manuscripts that is open to the public. We were having lunch in a restaurant on Rittenhouse Square when I mentioned that I was thinking about writing a book about fakes and forgeries.

"Ah, fakes and forgeries. There are some excellent ones at the Rosenbach," Dreher said proudly.[2] "In fact, in 2009 we staged an exhibition of three dozen manuscripts, books, and decorative items titled *Friend or Faux: Imitation and Invention, from Innocent to Fraudulent* curated by Jack Lynch, an English Literature professor at Rutgers University. I imagine you might be most interested in the Shakespeare forgeries made by William-Henry Ireland when he was age seventeen or so, at the turn of the nineteenth century."

"I knew Dr. Rosenbach was a Shakespeare collector," I said, "but why would he own fakes?"

"He was also a jokester," he replied, "someone who loved to buy notorious items and display them. But beyond that, I think everybody is interested in forgeries. They make you feel like you're being let in on a secret. The crime may have hurt people financially, and people may even have gone to jail, but you didn't shoot anyone."

All of this was very intriguing. Whatever would lead an English teenager in the late 1700s to perpetrate such a hoax? How exactly did someone go about creating phony Shakespeare items good enough to dupe the experts? And, ultimately, who cares? What does it matter if there's a fraudulent Shakespeare autograph or two floating around?

By the 1790s, when William-Henry Ireland forged Shakespeare, the Bard of Avon had already become the subject of considerable research. His baptism record had been found, dated April 26, 1564, handwritten in Latin: "Gulielmus filius Johannes Shakespeare—William, son of John Shakespeare."[3] John Shakespeare, a skilled craftsman and a civic leader, may or may not have been a devoted Catholic, which is important to know since practicing Catholicism had been outlawed at the time. Many years after John's death, a roofer discovered a document purporting to be his profession of Catholic faith hidden in the rafters of the family home. Since the document disappeared soon thereafter, some doubt its authenticity.

William Shakespeare likely attended a local school, though there's no record of it. In 1582, at the age of eighteen, married Anne Hathaway, age twenty-six; they had three children before he turned twenty-one. Then Shakespeare's trail ends, a period some refer to as his "lost years." In 1592 he reappeared, living in London and working with a troupe at the Rose Theatre. Soon after his arrival, however, an attack of the plague shut all the theaters; Shakespeare spent some time writing sonnets. When the playhouses reopened a year later, he joined an acting company named Lord Chamberlain's Men and was soon writing plays, acting in plays, and serving as the company's managing partner. Lord Chamberlain's Men, like many theatrical troupes, was named after a royal, a precautionary move to keep the actors from being pegged as vagrants. Actors were not held in particularly high regard.

In 1599, when Shakespeare and his partners opened their own theater, the Globe, everyone went to the theater: laborers, shop owners, prostitutes, gentlemen, householders' wives accompanied by servants and husbands, tourists, and children. In a city whose population was then fifty thousand, a remarkable one in three adult Londoners saw one or more plays every month.[4] There were dozens of theaters producing scores of plays to audiences sometimes

exceeding three thousand patrons. Eager theatergoers paid a penny to stand in the pit, two pence to enter the galleries, or six pence to hire a box. They ate, drank, chatted, flirted, and people-watched as the drama or comedy unfolded.

Feeding this theatrical appetite was a band of playwrights: Christopher Marlowe, Ben Jonson, George Peele, Robert Greene, John Marston, Thomas Nashe, and Thomas Decker, along with Shakespeare. English theater had long featured miracle plays, part religious ritual, part pageant, that depicted stories from the Bible. When Queen Elisabeth outlawed Catholicism, miracle plays were deemed subversive and soon replaced by secular ones, giving rise to a new form of theater that attracted even larger audiences.

By the time Elizabeth died in 1603, Shakespeare's Lord Chamberlain's Men had become the most popular troupe in London. Elizabeth's successor, James I (aka James VI of Scotland), adopted them as his own company, the King's Men, which afforded them the honor of marching in royal processions in scarlet cloth. While Shakespeare was not wealthy by the standards of the day, his ownership stakes in the King's Men and the Globe allowed him to retire to New Place, one of the grandest homes in Stratford-on-Avon, where he died in comfort at around fifty-two years of age.

In a very real sense, of course, Shakespeare never really died. His works, in the words of historian Ian Mortimer, "are the biggest step ever taken along the path toward understanding the human condition. It is a path we still follow. Through his plays we can see that our ancestors are not inferior to us; they do not lack sophistication, subtlety, innovation, wit, or courage."

The Rosenbach is a red brick townhouse that stands among the stately mansions on the 2000 block of Delancey Street, one of the prettiest streets in Philadelphia. The former home of Dr. Abraham Simon Wolf Rosenbach and his brother Philip, an antiques dealer, the house is filled with their possessions. Dr. Rosenbach was America's most important rare books dealer in the first half of the twentieth century, widely credited with launching a market for Americana at a time when the wealthy were only collecting work from abroad. Dr. Rosenbach had a head for business and a heart for books, and the heart often won out. According to Dreher, when Rosenbach fell in love with a first edition or manuscript and that he wanted to keep it, he would price the item well above its market value and tell his more prudent brother that it failed to find a buyer. Dr. Rosenbach's passion for the very best is now available to us all. The library's holdings include Bram Stoker's notes and manuscript for *Dracula*; the only surviving first printing of Benjamin Franklin's *Poor Richard's Almanac*; the inventory of Thomas Jefferson's slaves; more than six hundred letters and rare photographs by Lewis Carroll; first editions of Phillis Wheatley, the first African American to publish in America; manu-

scripts of books by Charles Dickens and Joseph Conrad; the manuscript of James Joyce's *Ulysses*; rare copies of Cervantes and Shakespeare; and much more. One fan called the Rosenbach "a wildlife refuge for the imagination in its natural habitat."

On a chilly January morning, I was standing on the steps of The Rosenbach when Jack Lynch arrived by taxi. I recognized him immediately from Dreher's description of him as "somewhat Shakespearian in appearance." He has a barrel chest, twinkling eyes, and frizz of shoulder-length graying hair reminiscent of Falstaff. He's the type of fellow you might encounter in a pub around the corner from the British Museum and spend a delightful evening sipping sherry and listening to his stories. Lynch had just returned from London where he was researching a book on William-Henry Ireland, and was eager to share his finds.

Although Lynch is a Shakespearian scholar, he is quick to point out that he is not an authority on the life of the Bard, the meaning of his work, his influence on world literature, or any other of the other topics that keep vast armies of scholars busy with all things Shakespeare. Instead, Lynch is an authority on Shakespeare from his death to his three-hundredth birthday. Lynch writes about the process through which Shakespeare, the poet and playwright, became Shakespeare, the cultural monument. In other words, Lynch is an authority on the Shakespeare brand. He is also a lover of fakes, frauds, and forgeries. "I've always admired the *chutzpah* of these people," he explained soon after we met. Lynch described himself as one of the luckiest men in the world, and perhaps he is. Not many can devote their careers to playing a sort of scholarly game of cops and robbers.

Elizabeth Fuller, The Rosenbach's librarian, welcomed Lynch and me into the building. She invited us to hang up our coats and wash our hands, which seemed an odd request until she told me that anyone with clean hands can actually hold a Rosenbach treasure, an honor that in other such institutions is restricted to scholars and major donors. The Rosenbach recently became an affiliate of the Free Library of Philadelphia, a testimony to its dedication to sharing its treasures with everyone.

We climbed a flight of stairs, opened a secured door, and entered a square room lined with glass-fronted bookcases that were filled with leather-bound books. Along the tops of the bookcases were glass boxes holding miniature cardboard buildings that depicted key locations in Shakespeare's life: the Globe Theatre, Shakespeare's birthplace and last home in Stratford-on-Avon, the mulberry tree that Shakespeare allegedly planted in his garden. A poster from the early nineteenth century announced a tour through England of these little replicas, a kind of sideshow for the literary-minded. A handsome 1931 portrait of Dr. Rosenbach himself hung over the mantelpiece, a middle-aged man in the

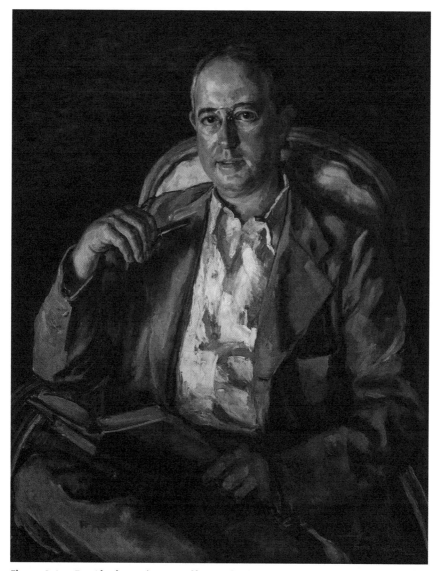

Figure 2.1. *Dr. Abraham Simon Wolf Rosenbach at Fifty-Five Years of Age* by Nikol **Schattenstein, 1931.**
Courtesy: The Rosenbach, Philadelphia

slightly rumpled brown suit of an Ivy League professor. Rosenbach, who held a PhD in English literature from the University of Pennsylvania, had traded a career in academe for one in commerce. He wanted everyone to know that, although he was a book dealer, he was also a scholar, so insisted that every image of him contain books. This portrait features three, one opened (see Figure 2.1).

The Rosenbach owns an excellent but idiosyncratic collection of Shakespeare quartos, folios, and other rare books, reflecting the excellent but similarly idiosyncratic appetite of its collector. Notably missing is a First Folio, the first, and generally considered the most accurate, compiled by former actors in his company and published in 1623. Shakespeare collectors swoon over First Folios, but not Dr. Rosenbach, who considered them commonplace. While at one time or another he owned six First Folios (actually five, but he owned one of them twice) he sold them all, preferring to keep for himself things that were even more rare. As a result, his library features a Second Folio, Third Folio, and Fourth Folio and, for most of the plays, rare quartos editions, small, one-play booklets that were published during Shakespeare's lifetime and printed on cheap paper.

The library also owns eight exceptional volumes of William-Henry Ireland's fakes, representing only a portion of those that the Rosenbach Company once owned. As it turns out, Dr. Rosenbach trafficked not only in real Shakespeare, but also in bogus ones.

Upstairs, in the archival workroom, seven of William-Henry Ireland's fat scrapbooks and one small notebook, all a bit worse for wear, were waiting for Lynch and me, guarded by Elizabeth Fuller. She gently cradled Volume 1 of the scrapbooks between two foam wedges. We studied it closely. The cover was dark green leather with a bit of gold leaf and a broken binding. Lynch opened the book, and the first page fell out. On it was handwritten, "*From a complete elucidation of the contents of this volume consult The confessions of W.H. Ireland published in 1805.*" On the facing page, the title of the book appears in print:

Miscellaneous Papers, Legal Instruments,
The Tragedy of King Lear
And
A Small Fragment of Hamlet
From the Original
Mss. of
William Shakespeare.

On the next page was a portrait of Shakespeare and the Shakespeare family crest. Facing that was yet another title, *The Shakespeare Fabrications of Wm Hy Ireland 1796*. Lynch turned the pages to an etching of Shakespeare from 1796, a facsimile of Shakespeare's allegedly handwritten manuscript for *King Lear*, the profession of faith proving Shakespeare was a Protestant, and a love letter from Shakespeare to Anne Hathaway (see Figure 2.2). None of it was genuine.

As we settled in, Lynch told me about the first time he saw this book. He had been invited by The Rosenbach to curate an exhibit about Shakespeare

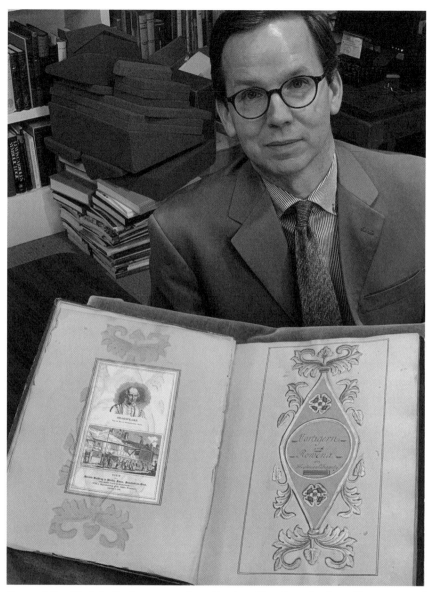

Figure 2.2. Derick Dreher, executive director, The Rosenbach, with a copy of William-Henry Ireland's fabrications of Shakespeare documents, 1805.
Courtesy: Nancy Moses

in the eighteenth century, when a staff member who knew Lynch's peculiar penchant for forgeries mentioned that the library owned some by William-Henry Ireland.

"I knew there were Ireland forgeries in the British Museum, Harvard, and the Huntington Library, so imagined I would only find some minor items here. When I saw this," he said, pointing to the volume, "I was surprised to find it filled with the most famous stuff."[5] In the Rosenbach's provenance records, Lynch had found a Photostat of Shakespeare's love letter to Anne Hathaway. He just happened to be looking at the facsimile of the letter in Volume 1, so he then compared the two love letters, and discovered minute differences between the facsimile and its photostat.

"That's odd, I thought," said Lynch. "When I went home, I looked at the Ann Hathaway love letter in a book in my collection. That one didn't match either the one in the book or the files." Since then, Lynch has personally handled twenty-six purported originals of the love letter from Shakespeare to Anne Hathaway and knows of three more, one of which was lost in a fire.

Ireland had faked them all.

That came to twenty-nine fakes. "Which is the real fake, or . . . the first fake?" I asked, reaching for the correct terminology.

"Do you mean, is this the real fake or a fake fake by the real faker?" he replied, grinning. "This is ultimately unknowable, though one scholar makes a pretty good case that the real fake is the one in the Hyde collection at Harvard University's Houghton rare book library."

According to Rosenbach Company records, in December of 1952 an avid collector named Donald Hyde purchased a number of Ireland manuscripts that were "torn, burned, smoked, and otherwise stained to give the appearance of age. The paper is often genuinely old."[6] Hyde's widow, Mary Crapo Hyde, herself a serious literary collector, eventually bequeathed the treasures to Harvard.

The Rosenbach also owns a real fake: a small notebook that Shakespeare allegedly took notes in (see Figure 2.3).

Lynch and I returned to Volume 1 of *From a Complete Elucidation of the Contents of This Volume Consulting Confessions of W.H. Ireland published in 1805*. It was one of five volumes of scrapbooks that William-Henry assembled from facsimiles of his fake Shakespeare documents, Shakespeare-related images, and his own commentary. William-Henry had sold the whole package as a memento of his moment of infamy.

We tend to think that Shakespeare was always considered a genius, but Lynch, in his book, *Becoming Shakespeare*,[7] refutes that assumption. Lynch points out that Shakespeare, in his lifetime, was only one of many who wrote for the

theater and, at the time, was not even considered the best. It was only after Shakespeare's death that he was transformed from a pretty-good-but-out-of-date entertainer to a literary demigod. Much of this occurred in the 1700s, what Lynch calls "the beginning of the modern idea of genius, when 'neoclassical' ideals about propriety and decorum gave way to 'Romantic' ideas about individual expression and unbounded passion."[8] Shakespeare's sense of history, rich characterizations, and psychological insights resonated with the English, and his style appealed to their patriotism. He disregarded the classical unities of action, time, and place, which characterized French theater. This made the French hate Shakespeare, and the English love him even more.

By the late 1700s when William-Henry Ireland was born, the English were mad for Shakespeare. His plays were performed more than those of any other playwright and his works were studied in school along with the classics of Greek and Latin. This Shakespearian mania set the stage for William-Henry Ireland's remarkably successful run of fakes and forgeries, now owned by the Rosenbach.

William-Henry Ireland's record is murky from the day he was baptized to the day he died. He seemed to want it that way. His autobiography, *Confessions of William-Henry Ireland*, published in 1805, is a mix of self-congratulation and defensiveness, quotes from his own writing, and apocryphal stories or outright lies, depending on your perspective. When the autobiography of a notorious liar appears suspect, you've got to search out the facts. That's exactly what Jack Lynch did. On his recent trip to England, Lynch had discovered William-Henry's baptismal record in a London parish. It is dated 1775, so we know when and where he was born. The name on the certificate is William-Henry Freeman and lists Anna Freeman as the mother. But no one is listed as the father, so we don't know if it was Samuel Ireland or someone else. There is some evidence that Anna Freeman was a cast-off mistress of the Earl of Sandwich, an infamous womanizer. Other evidence suggests that Samuel Ireland was paid £1,200 to raise William-Henry, but we don't know why.

Samuel Ireland was an engraver who published a line of expensive illustrated tourist books: *A Picturesque Tour Through Holland* (published in 1790), *Picturesque Views on the River Thames*, and so on. He was crazy for Shakespeare. As his son later wrote, "I had daily opportunities of hearing Mr. Samuel Ireland extol the genius of Shakespeare, as he would very frequently in the evening read one of [Shakespeare's] plays aloud dwelling with enthusiasm on such passages as most peculiarly struck his fancy . . . there was not a divine attribute which Shakespeare did not possess, in Mr. Ireland's estimation: in short, the Bard of Avon was a god among men."[9]

William-Henry admitted in the *Confessions* that, as a child, he was "very backward," noting that his schoolmaster advised his father to stop wasting

money on tuition. William-Henry completed his education with four years of study in France, and when he returned to England, his father "deemed it expedient" to apprentice him to a lawyer named Mr. Bingley at New Inn. This arrangement was not a good one either for Mr. Bingley or William-Henry. Instead of copying documents and handling other legal tasks, he spent his days crafting tiny coats of armor out of bits of paper and spinning out fantasies in his head.

Samuel Ireland was partial to old books and manuscripts, and his son took up this zeal for the hunt. Nothing gave the young man greater joy than his father's "astonishment on my production of some rare pamphlet which chance or research had thrown my way."[10] One day, William-Henry found an old religious tract that appeared to have been part of Queen Elizabeth's library, and decided to see if he could fool his father with it. He used what he imagined was sixteenth-century handwriting, wrote a dedication, and went to a printer to insert the phony dedication into the actual tract. At the printer's, a helpful journeyman took one look at William-Henry's amateurish fake and supplied him with a type of fermented brown ink that appeared faded on the page, but would darken when heated. Ireland used the counterfeit ink to pen a new fake dedication. He then presented it, embedded in the tract, to his delighted father.

Some forge for money, others for fame. As William-Henry relates in his autobiography, his motivation was to attain his father's respect. The path became clear when father and son traveled to Stratford-on-Avon. Although Samuel came to Stratford-on-Avon to paint picturesque scenes for a new book, he and his son spent most of the time hunting for traces of Shakespeare. They soon found a willing guide whom William-Henry later referred to as "Jordan the wheelwright poet." Jordan introduced them to a shopkeeper who sold Samuel relics made out of the wood of the alleged mulberry tree from Shakespeare's own garden; the local church where Ireland stopped to sketch the monument to Shakespeare; the site of New Place, Shakespeare's mansion in later life, by then demolished; and Shakespeare's childhood home, still occupied by one of his descendants, a butcher named Hart. Father and son were in heaven.

Then, something even better happened. Samuel heard a rumor that there were some interesting manuscripts at Clompton House, owned by a gentleman farmer named Mr. Williams. When the Irelands stopped by the mansion and told the owner they were looking for Shakespeare items, he replied, "By G-d I wish you had arrived a little sooner! Why, it isn't a fortnight since I destroyed several baskets-full of letters and papers . . . and as to Shakespeare, why there were many bundles with his name wrote upon them. Why it was in this very fire-place I made a roaring bonfire of them."

Though this may have sounded fishy to William-Henry, Samuel took the story as fact. By the time they returned home, the enraptured father told his son "that he would be willing to give half his library to become possessed even of his signature alone."

That struck a chord. As William-Henry later wrote, "the idea first struck me of imitating the signature of our bard, in order to gratify Mr. Ireland." William-Henry found a signature of Shakespeare's printed in one of his father's books, traced it, and repaired home. Using what he called "Shakespeare ink" and a piece of parchment cut from an old document, William-Henry penned a fake deed, adding fake signatures by Shakespeare and his business associate, John Heminge. William-Henry then sealed the document with a counterfeit seal made from an old wax top and a new wax bottom and covered it with soot to mask the differences. That evening he proudly presented it to his father. Samuel carefully examined the parchment and replied, "It is impossible for me to express the pleasure you have given me by the presentation of this deed." Soon, the elated Samuel was showing this extraordinary find to his literary friends.

At this point in the *Confessions*, William-Henry assures the reader that he had no intention of producing any more fakes. "I must, however, solemnly affirm," he continues, "that had not such incitements been used, I never should have attempted a second document—my real objective having been to give Mr. S. Ireland satisfaction; that wish accomplished, my purpose was fully answered." But his father's overwhelming delight, and the secret pleasure of duping Samuel's literary colleagues, must have made for an intoxicating brew. When they questioned the source of this remarkable original, William-Henry explained he had met a "gent from____ of very considerable property" at a dinner party. The man later presented William-Henry with a vast collection of old deeds and papers he had inherited. Digging through them, William-Henry found, to his "utter astonishment, the deed between our bard and Michal Fraser, bearing the signature of Shakespeare." The secret donor agreed to give William-Henry the document under two conditions. First, the young man needed to pen an accurate copy of it. Second, William-Henry must never reveal his benefactor's identity.

Of course, there was no mysterious benefactor. William-Henry had concocted the entire story.

Over the next eighteen months, young Ireland delivered a plethora of phonies, each one more tantalizing. Quickly moving from forging Shakespeare's signature to faking entire documents, William-Henry presented Samuel with Shakespeare's Protestant profession of faith in the Church of England, designed to wipe away any suspicion that the son might have shared his father's alleged Catholicism. That document appeared, as if by magic, not long after

the discovery and disappearance of John Shakespeare's profession of faith in the rafters of the family house. Ireland also presented his father with a letter from Shakespeare to the actor Richard Cowley, which included a "witty conundrum;" a letter to Shakespeare signed by Queen Elizabeth, whose signature William-Henry traced from an original Elizabeth autograph owned by his father; and the ersatz letter from Shakespeare to his sweetheart Anne Hathaway. To add a patina of verisimilitude to the major finds, William-Henry crafted Shakespeare contracts, agreements, deeds, and receipts.

As word got out and the daily newspapers "teemed with paragraphs on the subject," Samuel Ireland welcomed more "gentlemen" to his home, inviting them to add their names to a certificate affirming the validity of the documents. England's poet laureate, Henry James Pye, was among those who did. Famed biographer and diarist James Boswell carefully inspected the manuscripts, drank a tumbler of warm brandy and water, knelt down before the volume, and exclaimed, "I now kiss the invaluable relic[s?] of our bard: and thanks to God that I have lived to see them!"

Buoyed by such unexpected success, William-Henry wrote out most of the manuscript for *King Lear* in his Shakespearian hand. For this exercise, he borrowed his father's rare quarto edition, dated 1608, but eliminated the ribaldry that eighteenth-century audiences found off-putting in Shakespeare's actual play. This absence of ribaldry delighted Shakespeare buffs, as William-Henry later explained: "[I]t was generally conceived that my manuscript proved beyond doubt that Shakespeare was a much more finished writer than had ever before been imagined." When someone speculated that a Shakespeare heir might be able to claim ownership of these treasures, William-Henry delivered an extraordinary letter. In it, Shakespeare awarded a certain sixteenth-century William-Henry Ireland ownership rights to all of Shakespeare's work as a reward from saving the playwright from drowning. The letter conveniently connected the Ireland family's lineage to the Bard and closed the door on any future claim.

But, after forging a couple of pages from *Hamlet*, William-Henry "became weary of this plodding business." What with his vocation as a law clerk and his avocation as a forger, there was little time for fun. And, though he worked in secret, there were a couple of instances when a friend or a laundress caught him in the act. Either one of them could have told—perhaps should have told—and put the poor young man out of his misery, but they didn't. Throughout the *Confessions*, William-Henry points an accusing finger at those who failed to stop him on his road to perdition. He bemoans the constant pressure of inventing yet another sixteenth-century document; the constant threat of discovery.

In December 1795, Samuel Ireland published a compendium of the Shakespeare documents his son had found, titled, *Miscellaneous Papers and Legal Instruments Under the Hand and Seal of William Shakespear* (*sic*). He sold the book to the public, along with a VIP ticket to see the "originals" at his home. William-Henry then announced that he had found an entirely new Shakespeare play, titled, *Vortigern and Rowena*. The play was based on an old British legend about Vortigern, King of the Britons and the beautiful princess Rowena. The subject came from a painting that hung over the chimneypiece in Samuel's study, and the plot and characters from William-Henry's imbibing of years of Shakespeare performances and texts. William-Henry himself penned the entire manuscript in less than two months. He said his copy came from the original, which was owned by his mysterious benefactor. Some of Samuel's friends commented on the coincidence of Ireland junior discovering a play on the same subject as Ireland senior's painting, but no one seemed to mind. In the *Confessions*, William-Henry drily comments, "It is extraordinary to observe how willingly persons will blind themselves on any point interesting to their feelings."

Soon, his elated father was negotiating production rights for the play with the Drury Lane Theater. Its managers, who knew their Shakespeare well, opined that *Vortigern and Rowena* must have been one of Shakespeare's earliest works, since the ideas it presented were "crude and undigested." But this would be the first Shakespeare premiere in nearly two hundred years and would make everyone rich, so they were willing to overlook its faults.

William-Henry watched in fear and delight as the deal was struck, the papers signed, the actors hired, rehearsals begun, and tickets sold. On the evening of the premiere, William-Henry was so nervous he hid behind the stage.

He had good reason to worry: the play was a resounding flop.

Actually, *Vortigern and Rowena* was doomed before the curtain went up, murdered by Shakespeare scholars who had long smelled something rotten in the Ireland's magically appearing manuscripts with their old-timey spelling and many anachronisms. Edmond Malone, the most acclaimed critic of the era, was so enraged by William-Henry's ham-handed fakes that he wrote a four-hundred-page exposé, *An Inquiry into the Authenticity of Certain Miscellaneous Papers and Legal Instruments by Shakespeare*. Malone distributed a handbill to patrons on the way to the premiere of *Vortigern and Rowena*, promoting the upcoming publication of his exposé and "cautioning persons against the fraud." Samuel Ireland, who had caught wind of Malone's promotional devise, produced a handbill of his own asking patrons to keep an open mind.

That evening, the house was packed with eager patrons. Things got off to a good start, but by the end of the play, the actors could no longer sustain the sham. The tragic ending was played as broad slapstick.

William-Henry's confessions, written nine years after the event, suggest he expected to be caught. What he didn't expect was his father's reaction. Samuel refused to believe the precious Shakespeare items were fakes, not because he believed in his son's integrity but because he thought William-Henry was too stupid to pull off the hoax. Shakespeare-loving Londoners were furious at being duped. Instead of accusing the son, though, many turned against the father. Samuel begged William-Henry to come clean and reveal the name of the mysterious donor. Since there was no mysterious donor, William-Henry had none to reveal. Instead, he published *An Authentic Account of the Shaksperian Manuscripts* [sic] *&c.*, in which he took full responsibility for the entire corpus of phony Shakespeare documents and exonerated his father. The *Morning Chronicle* reported that "W. H. Ireland has come forward and announced himself author of the Papers attributed by him to Shakespeare which, if *true* proves him to be a *liar*."

But not even this confession could convince Samuel of William-Henry's treachery. Until the day he died, Samuel believed the manuscripts were real.

The entire hoax, ending with the *Vortigern and Rowena* debacle, left William-Henry Ireland a bitter young man with no prospects for the future. Few were interested in reading the histories, poetry, and other books he wrote, none of which were very good. Not surprisingly, no one would hire a forger as an attorney. He spent some time in debtor's prison and a couple of years as a librarian in Paris, but never again gained the attention he craved.

Eventually, William-Henry hit on a scheme. He decided to create a special, deluxe, one-of-a-kind edition of his famous forgeries—special deluxe editions were popular luxury items at the time. He took a couple of copies of his father's *Miscellaneous Papers*, cut them up, and added them to a scrapbook. He then added more purported Shakespeare manuscripts, some Shakespeare-related images, and his own commentary. These extra items bloated the original, single volume *Miscellaneous Papers* to five scrapbooks. He housed the scrapbooks in elegant green leather with gold embossed covers and titled the set, *From a Complete Elucidation of the Contents of this Volume Consulting Confessions of W.H. Ireland Published in 1805.*" He sold it for the handsome sum of four guineas—the equivalent of hundreds, maybe thousands of today's dollars. This was the very item that Dr. Rosenbach has bought for his collection.

Was this deluxe edition actually one-of-a kind? Not really. In fact, a number of institutions with significant Shakespeare collections also own copies of *From a Complete Elucidation of the Contents of this Volume Consulting Confessions of W.H. Ireland Published in 1805*, each of which claims to be unique. In other words, William-Henry mass-produced forgeries of his own fakes.

"He was brazen, I'll give him marks for that," said Lynch. "He was very clever but a pathological liar. These are lousy forgeries, but impressive for a nineteen-year-old." It may be added that William-Henry was exceptionally creative. With his Shakespeare ink, stock of old paper, and samples of sixteenth-century script, he fabricated the detritus of an entire imagined life: Shakespeare at home, at work, at play. The Rosenbach owns a forged small velum notebook called a commonplace book, with candle-scorched edges, each page scribbled with notes, numbers, and sketches, as if Shakespeare had pulled it from his own pocket to jot something down. The commonplace book is an original fake—there is only one of it—as opposed to the five scrapbooks, which are forgeries of fakes.

At this point, I was beginning to pity poor William-Henry, raised in a house of lies. Samuel was in the habit of calling Henry "Samuel," the name of his deceased first-born son. His father never called Anna Freeman, his common-law wife and William-Henry's mother, Mrs. Ireland, referring to her as the housekeeper or an aunt. For a while, William-Henry called himself

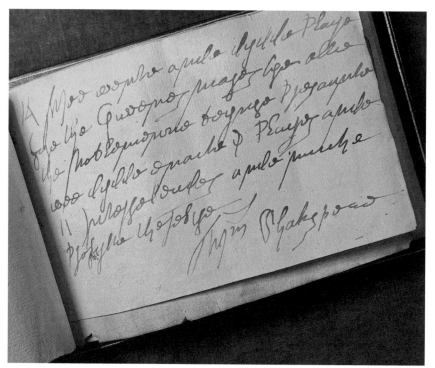

Figure 2.3. Authentic fake Shakespeare notebook created by William-Henry Ireland, circa 1795.
Courtesy: Nancy Moses

William-Henry Freeman, his baptismal name. It must have been very confusing for the boy, very sad.

This weird upbringing set the stage for William-Henry's later life. After the hoax, he married either one or two women. The first, Alice Crude, disappeared from the record. There is solid evidence that his second wife, Martha Baily, existed but there is no record of their marriage. So, maybe William-Henry was a bigamist—or maybe not. After the hoax was exposed, he never visited Samuel again and didn't attend his funeral. Lynch discovered an unpublished autobiography in which William-Henry wrote that his father died in his arms, saying, "You were my only happiness." There is no evidence this touching scene ever occurred.

Still, was William-Henry, as Jack Lynch described him, a pathological liar? To check this diagnosis, I contacted Dr. Beulah Trey, a psychologist whose specialty is ethical behavior. I told her about William-Henry's forgeries and his lies, motivated, he said, by his desire to please his father. I told her about the confessional in which William-Henry detailed the technical steps in the forgery process, his father's and other people's reactions, and the ultimate discovery. I told her that you could read between the lines and see how elated William-Henry was by his father's praise, how proud he was that he duped the experts, how frightened he was when he thought his hoax might be exposed, how despondent he was when it happened—and how his father refused to believe his stupid son was actually clever enough to pull it off. Finally, I told Trey about the finger-pointing:" this person should have known, that person could have told, as if they were culpable for William-Henry's acts.

"What does this all add up to?" I asked. "Was he a pathological liar? I know I shouldn't, but I feel sorry for this guy."

"Well," she said, "William-Henry certainly lied; but saying he's a pathological liar begs the question. All of us lie at one time or another. All of us feel what it's like to be caught in a lie. Some of us, though, have something that pulls us out of the lie and sets us back on track. William-Henry didn't have that."[11]

"Could William-Henry's absence of a moral compass have something to do with how he was raised?" I asked. "After all, he didn't know whether or not Samuel was actually his father."

"Interesting question," said Trey. She paused. "Maybe William-Henry isn't the important character in the story. Maybe it's his father, Samuel."

That got me thinking. I had assumed William-Henry was either an innocent youth or a crook. But if the story were told from Samuel's point of view, would something new be revealed? I decided to give it a try.

Samuel Ireland's story begins when a poor boy bootstrapped himself from the lower-classes to middle-class respectability and a business as an engraver and printer. His customers were the literati who could afford to purchase his

expensive illustrated travelogues. Samuel's passion for Shakespeare gave him more common ground with his customers and greater opportunities to spend time with them.

Somewhere along the way, the Earl of Sandwich approached Samuel with an unusual offer. Sandwich's mistress, Anna Freeman, was pregnant; and Sandwich was willing to pay 1,200 pounds if Samuel would take her into his house and raise the bastard child as his own. That child was William-Henry. Anna Freeman became Samuel's common-law wife.

Samuel accepted the arrangement, but never really accepted the child. He did his duty: he paid for the child's education, secured him a position as a law clerk, and gave William-Henry all of the advantages that Samuel had never enjoyed. It must have infuriated him to see the boy waste them and simply float along in a dream world.

The only passion father and son shared was the hunt for old manuscripts and books. The two of them spent happy days prowling through dusty book-stalls searching for the greatest prize of them all: Shakespeare's own signature. Hoping to encourage William-Henry's growing interest, Samuel invited him along on that trip to Stratford-on-Avon. Samuel even invested in a local guide named "Jordan the wheelwright poet," who arranged for a visit to the manor house where Samuel heard, to his horror, that the owner had recently burned a pile of old Shakespeare papers to clear out a room for a pigeon coop. In frustration, and perhaps to spur on his son, Samuel announced that he would trade anything in his library for a single Shakespeare signature.

One can only imagine Samuel's joy when his dunce of a son presented him with a never-before-seen deed bearing Shakespeare's signature. Samuel's income was derived through connections with those who shared his passion for Shakespeare. Now he had something extraordinary to show them, something rare and valuable and discovered by his own son. It was just too wonderful to keep secret. Soon his parlor was full of gentlemen admiring the ancient paper with its yellowing edges and faded signature.

Samuel must have looked on in amazement as his son proudly delivered one miraculous find after another, each extraordinary in its own right, all contributing to Samuel's growing library and status. How proud he must have been that this boy, who had never accomplished anything, had lucked upon this stash of literary treasures. No matter if some visitors were rude enough to note the odd spelling or point out an anachronism. Other luminaries believed. Some were even willing to sign an affidavit attesting to the authenticity of the Shakespeare discoveries. Others purchased his compilation of Shakespeare facsimiles. It was a dizzying time.

When William-Henry delivered an entirely new Shakespeare play, Samuel could not believe his luck. *Vortigern and Rowena* would make his fortune.

Although his son was the legal owner of the work, Samuel decided to handle negotiations with the Drury Theater even though its owners questioned the play's peculiar dramaturgy. Samuel then got wind of the plot by his greatest nemesis, the Shakespeare critic Edmond Malone, to brand the play as a hoax in a pamphlet to theatergoers. Samuel countered with a pamphlet of own. But it was too late.

Samuel continued to believe that the Shakespeare manuscripts delivered by his son were the real deal. Or did he? Did he doubt their authenticity and keep these doubts to himself? If the originals were fakes, Samuel would lose everything: his customers, his friends, his status. There were many reasons to perpetuate the lie, even on his deathbed.

William-Henry wrote his *Confessions* five years after his father's death, so he had the final word on where the blame lies.

"It was at first to me the innocent exercise of a leisure hour in boyhood," he wrote, "to please an indulgent parent and gratify a blameless vanity . . . after dissemination, contrary to my desire, of those things which I had given in confidence, alone transformed the act from innocence to criminality." In essence, William-Henry is saying he committed an innocent act of love. It was his father who made it a crime.

This could be the most truthful statement in the whole book. Or maybe not.

There is a generally held theory about forgery: whenever there's not enough of something valuable to fill the market's demands, someone will step in to create it. That certainly happened in the 1790s, when Shakespeare aficionados were so eager for more Shakespeare that they were willing to suspend disbelief. William-Henry Ireland wasn't a very talented forger, but he learned his craft well enough to dupe London's literati, including perhaps his own father.

One final question remains. Who cares? What does it matter if Ireland faked Shakespeare? Was anyone really hurt?

Shakespeare wasn't damaged, because he was long dead. Literary London may have been caught up in the foolishness for a while, but it soon recovered. The real victims of the hoax were its perpetrators, William-Henry and Samuel Ireland. Their lies corrupted their judgment, mutilated their closest relationships, and corroded their souls. The whole thing was a scaffold of lies. When one plank was pulled, the entire edifice fell.

Chapter Three

Zombie Pollocks

Jackson Pollock dipped his brush into a can of fluid paint, reached over the canvas, and with a flick of his wrist, the paint leapt into the air before falling into a perfect arc. He two-stepped alongside the canvas, his torso curved slightly forward, raised his arm, and his hand, extended by a brush, scrolled ribbons of paint into the center. He furrowed his brow, a cigarette between his lips, then knelt, dipped the brush into the can, and sketched elegant swirls in the air. The movement was free and controlled, spontaneous and contained, an improvisational ballet carefully choreographed from the depth of his psyche (see Figure 3.1).

These images come from Hans Namuth's film, shot in the fall of 1950 in the Springs Long Island, home of Jackson Pollock and his wife, Lee Krasner. You can see it on YouTube and it's remarkable: Pollock's brush never once touched the canvas.

Namuth captured the artist painting on a long, narrow strip of canvas, and on a sheet of tempered glass set high on two stanchions so the filmmaker could lie below and direct his camera upward, through the glass. Here, Jackson Pollock is at his best, when he was sober and productive and his drip paintings were pouring out of him.

The final shoot took place on a cold October day. Soon after it ended, Pollock came inside his house, poured himself his first whisky in two years then joined his guests already seated around the dining room table. According to eyewitnesses, Pollock sat brooding for a while, said the word "now" twice, as if threatening the guests, then stood, yelled "now" at the top of his lungs, and upended the table, sending glasses, plates and cutlery crashing to the floor.

This October afternoon in 1950 encapsulates the best and worst of Jackson Pollock. As an artist, his genius is indisputable: his best work transformed painting, transfixed the art world, and signaled America's ascendance as the

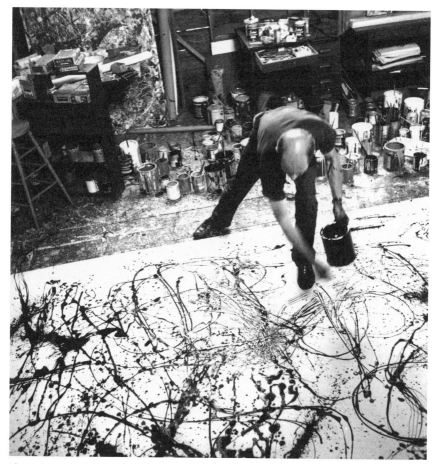

Figure 3.1. Jackson Pollock in his studio, October 1950. Photograph by Hans Namuth.
© **Hans Namuth, Ltd.**
Courtesy: Pollock-Krasner House and Study Center, East Hampton, New York

international creative capital. As a man, he suffered from debilitating alco-
holism, crippling depression, vicious anger, chronic misogyny, and recurring
death wishes. Since his death in 1956, the value of his work has continued to
climb, regardless of aesthetic trends or economic conditions. Running paral-
lel to this acclaim has been a stream of fake Pollocks, some of which have
appeared on the market multiple times.

"Pollock is probably the only major artist of his generation whose work is
so widely forged,"[1] wrote the authors of his catalogue raisonné, the definitive
source of Pollock's work. In 1969, art dealer Joan Vitale purchased a pur-
ported Jackson Pollock at an auction in Pennsylvania and gave it to Lee Kras-

ner, Pollock's widow, to be authenticated. She, in turn, turned it over to the Manhattan District Attorney's office, which kept the painting for a criminal investigation and did not return it for five years. Teri Horton, a seventy-three-year-old truck driver, purchased what she hoped was a Pollock in a thrift shop for five dollars and spent a decade trying to authenticate it, a quixotic quest documented in the 2007 film, *Who the #$% Is Jackson Pollock*. Alleged Pollocks have been exhibited at the University of California, Berkeley, and the Museum of Biblical Art in Dallas. They have been the subject of two recent lawsuits: one sent the dealer, John Re, to jail, and the other contributed to the closing of the Knoedler Gallery, the oldest art gallery in the United States. The Pollock-Krasner Foundation's authentication board was sued three times by angry owners whose paintings turned out to be fakes. Although the foundation won them all, the high cost of litigation drove it out of the authentication business in 1995. Some alleged Pollocks appear, are found to be fake, then disappear and later reappear, like zombies that never die.

It seems obvious that there would be a lot of fake Pollocks, since his poured paintings are so very valuable and it's so very easy to imitate them. After all, anyone with a paintbrush, a can of runny paint, and an oversized canvas can create a Pollock. Or can they?

"If you want to understand Jackson Pollock, you've got to experience one of his paintings, really experience it," said Samuel Sachs II. "People will spend days or months reading a book. They will go to a Broadway play and spend an hour or two, or an opera that might last five hours. But painting? People want instant gratification and move on to the next one. Not many want to give back the same amount of time that went into the creation of art. Pollock is one who deserves it."[2]

Sachs should know. As president of the Pollock-Krasner Foundation he was surrounded by Pollocks, though he was quick to point out he was not an expert. Sachs was responsible for overseeing the sale of works by Pollock and Krasner that are owned by the foundation and then distributing the proceeds, in the form of grants, to artists of recognized artistic merit and financial need. The former director of three art museums, Sachs has a special interest in fakes, frauds, and forgeries, so I thought he might have something important to share about fake Pollocks. He greeted me at the entrance of the august Century Association, a private club in Manhattan frequented by curators, artists, authors, dealers, publishers, and the like. I recognized him immediately: an older, elegant gentleman with a warm smile.

"Pollock is particularly dammed by the fact that the vast majority of the public subscribes to the statement, 'My kid could do that.' No . . . your kid can't do that . . . or if your kid can do that, I want to meet your kid," said

Sachs. He suggested I see a lot of Pollocks since the only way to spot the *fake* paintings is to see the *real* ones and compare the two, and alerted me to the Pollock Retrospective at the Museum of Modern Art (MoMA).

A week after our meeting, I took Sachs's advice and went to MoMA to experience, really experience, Jackson Pollock. The museum had just opened and was already buzzing. Chic Asian matrons were pushing baby carriages, uniformed school children were huddling around docents, and retirees were squinting at labels and fiddling with audio guide headsets. The Pollock retrospective was on the second floor and as I climbed the wide stone stairs, I was joined by six movement artists in gray sweat suits snaking their bodies up backward—feet first—one step at a time.

MoMA owns the most representative collection of Jackson Pollocks, and this retrospective presented fifty paintings, drawings, and prints from the 1930s to early 1950s, an unparalleled opportunity to see the depth and breadth of his work. At the entrance, I passed four black and white silk screens from 1951, and then walked into the gallery displaying his early work. Pollock started as a figural artist, then moved onto more dreamlike, Jungian images. Over time the canvases and works on paper became less representational and more expressionistic and abstract until he left the figurative world behind and pioneered the radical abstractions for which he is best known. I stopped in front of *The She-Wolf*, the first Pollock purchased by MoMA, a jumble of Jungian symbols, perhaps a product of his years of psychotherapy with Jungian analysts, and then some paintings combining figures, drips, and free forms.

Pollock's work comes in many sizes but the most impressive are gigantic: he loved murals. I stopped in front of the painting MoMA refers to as one of Pollock's greatest masterpieces: *One: Number 31, 1950* (1950), an almost wall-sized oil and enamel on unprimed canvas.

I studied it for an hour.

Sixty minutes looking at a single painting demanded Zen-like concentration and I'm not proud to admit that I yearned for distraction, but once I disciplined my eye, the more I looked the more I saw. From a jumble of lines, splotches, drips, and spatters on a dull beige canvas, something slowly emerged. The lines danced and swirled, the paint fell in a kind of syncopated rhythm. I stood as close as the guards would allow to examine the intricate layering of color, some lines as thin as threads, others more robust; the tiny splatters of black, white, brown, and silver; the puddles of paint so thick the pigment cracked. I stepped back to view the massive piece as a whole and noticed that the lines, splatters, and puddles were less dense around the edges, adding a sense of lightness to the canvas. Critics call these paintings spacious, exuberant, energetic, calming. *One: Number 31, 1950* (1950) is all of these.

"Abstract painting is abstract," said Pollock. "It confronts you."

It certainly confronted the MoMA visitors who first encountered it in the 1950s. *One: Number 31, 1950* was revolutionary, its scale and aesthetic audacity overwhelming. This painting told nothing about the artist and at the same time it told everything. It told me: you are in the presence of genius.

Standing in front of the painting, I wondered about the source of this genius. Where did it come from? How did he, how *could* he sustain it through a lifetime of debilitating alcoholism? And, ultimately, how did his singular creative impulse lead to work that is so difficult to fake? I decided to search for the answers in his life story.

Although there are piles of books about Pollock and his work, it's not easy to sort fact from opinion. He wrote very little about his own creative process and didn't like to talk about it, leaving much of that to his wife, Lee Krasner. When sober, he tended to be reticent with strangers, some say shy. Some who talked to him in social situations later interpreted his silence as affirmations of their own views, when he was really just Pollock being Pollock. He was known for making things up, especially when he wanted to impress someone. The authoritative source is the catalogue raisonné, which is a clear, objective, and documented description of each work by an artist, authenticated by those who knew it best. The fourth volume of Pollock's catalogue raisonné includes a biographical timeline enriched by photographs, illustrations, correspondence, and other documents.

He was born in 1912 as the youngest of five sons of Leroy and Stella May Pollock on a ranch in Cody, Wyoming. Soon after his birth, the family moved to San Diego where his father purchased a truck farm, which he was forced to sell within a couple of years. What followed was a repeating rhythm of moving, settling in and moving on that continued for much of Jackson Pollock's unstable childhood. He was a poor student, restless and combative, a frequent truant, expelled from two high schools before walking away from secondary schooling permanently. His father, who referred to himself as a failure, suffered from alcoholism. Jackson's own drinking problem began at age fifteen when he and his brother worked on a surveying gang along the north rim of the Grand Canyon. From then on, alcohol was a central part of his life.

The one class Jackson enjoyed was art, where he was able to express himself and connect with other outsiders. After dropping out of high school, he joined Charles, the oldest Pollock son, in New York City where Charles was enrolled in the Art Students League. In the fall of 1930, Jackson moved in with his brother and his then-girlfriend and registered at the Art Students League's classes in Life, Drawing, Painting, and Composition, taught by Thomas Hart Benton, a representational artist specializing in images from his Midwestern birthplace. Benton became Jackson's mentor, hosting him

at the family's summer home on Martha's Vineyard and helping him find the part-time work he needed for tuition and living expenses. Despite his struggles as a draftsman—one of his fellow artists and friends called his work "tortured"—Jackson nevertheless impressed his mentor with sketches Benton called "magnificent. . . . Your color is rich and beautiful. You've the stuff old kid—all you have to do is keep it up."[3]

By 1934, Jackson Pollock was on relief, occasionally stealing food from pushcarts. In 1935, he joined the Federal Art Project of the Works Progress Administration, a godsend for many artists who were living on the margin because there was no market for their work. Inspired by Benton and the Mexicans artists who painted large walls with striking, sometimes politically charged murals, Pollock began in the mural division. Later, he joined WPA's easel division, where he was expected to submit one painting about every eight weeks, depending on the size and his normal rate of production.[4]

Throughout the 1930s, Pollock cycled through periods of productivity followed by binge drinking, hangovers, and periods of recovery. Sweet and laconic when dry, Pollock was a mean and aggressive drunk. People remember him as tall and handsome, standing silent on the fringe of parties until he had a couple of drinks, then groping women and punching out men. He received his first psychiatric treatment for alcoholism in 1937 after he smashed up Charles's car in an expensive accident. A year later, at his family's urging, Jackson checked himself into a psychiatric institution where he remained for about three months. Jackson's brothers stuck by him throughout his repeated struggles to get clean and maintain a functional life. Their wives became less sympathetic as time went on and Jackson failed to improve.

In 1941 as America entered World War II, Jackson Pollock's therapist wrote to his draft board that he was mentally unstable and unable to serve. That year he was reintroduced to Lee Krasner, a young painter whose work was already gaining attention. The day she stopped by unannounced to see his work, Pollock was suffering from a hangover. "To say that I flipped my lid would be an understatement," she said in one version of the tale. "I was totally bowled over."[5] Krasner became Pollock's lover and eventually his wife, nursing him through his depressions, weathering his alcoholic rages, keeping him focused, and providing the constancy and compassion his tortured soul needed to continue working. She was his strongest, most steadfast advocate and a powerhouse promoter, pursuing every opportunity, cultivating every gallery owner, collector, and critic to advance his career.

In 1943, soon after the WPA Art Program ended, Pollock took a job as a custodial worker at the Museum of Non-Objective Painting, now the Solomon R. Guggenheim Museum, a job reserved for young, hungry artists that allowed him to continue painting. That year, a curator at the MoMA who was

serving as an informal advisor to the heiress, Peggy Guggenheim, saw his paintings. Guggenheim had just opened Art of This Century, a showcase for her collection of contemporary art, and in the spring of 1943 she invited Pollock to submit a collage for a juried show of young New York artists. Pollock then submitted a painting to another juried exhibition and one of the judges, the geometric abstractionist Piet Mondrian, declared the frenetic, graffiti-covered canvas "the most interesting work [he'd] seen in America." That sealed it. Guggenheim offered Pollock his first one-man show, a commission to paint a portable twenty-foot mural for the entrance to her townhouse, and a yearlong contract. Overnight he went from art custodian to professional artist, working at a furious pace, creating dynamic, Jungian-influenced canvases, including *The Moon-Woman Cuts the Circle* and *The She-Wolf*. Soon his work was appearing in *Harper's Bazaar* and *Arts and Architecture*, and was being bought by adventuresome collectors and museums.

Pollock continued to struggle with drinking. To separate him from the temptations of the New York bar scene, in 1945, he and his bride moved to the hamlet of Springs in East Hampton, Long Island. With the help of a down-payment loan from Guggenheim, they bought a derelict wood-frame house set on an acre and a quarter of land. Pollock converted the barn into a studio, placed his canvases to the floor, and began a series that some later called his "drip" or, more accurately, his "poured" paintings.

"On the floor I am more at ease," Pollock wrote. "I feel nearer, more a part of the painting, since this way I can walk around it, work from the four sides and literally be *in* the painting."

He had been introduced to liquid, commercial paint by the Mexican muralist David Alfaro Siqueiros, and had used the technique as one of many in the 1940s. While neither the first nor the only artist to employ it, for Pollock, the technique of applying commercial paint to canvas became the central element of an entire body of work. The spacious studio in the country allowed him to tap "into the unconscious,"[6] which was the font of his work. "When I am *in* the painting, I'm not aware of what I'm doing. . . . I have no fears about making changes, destroying the image, etc., because the painting has a life of its own," he wrote. It must have taken an enormous emotional toll to, in words of one of his critics, "paint pictures on the inside walls of his mind"[7] day after day after day. But it was well worth the effort. The canvases painted in Springs became his greatest achievements.

Slowly, sales of his work picked up and he gained wider attention. The critic Clement Greenberg was an early and avid champion; he saw Pollock as "the strongest painter of his generation and perhaps the greatest one to appear since Miró." Pollock stood out from all of those who later became known as the Abstract Expressionists: "Pollock's superiority to his contemporaries in

this country lies in his ability to create a genuinely violent and extravagant art without losing stylistic control,"[8] Greenberg wrote.

Pollock's career received an enormous boost when, in August 8, 1949, *Life* magazine devoted a three-page spread to his work. It featured a photo of the artist in front of a long poured painting. While the subhead, "Is he the greatest living painter in the United States?" may have been intended as a poke at the weird new brand of art, it nevertheless catapulted Pollock to fame. The rugged man in paint-splattered dungarees became America's quintessential artist, with Ernest Hemingway's virility, James Dean's looks, and Gene Kelley's masculine grace. The fame proved intoxicating for the man and toxic for the painter. For the first time, his annual show almost sold out, yielding the first substantial earnings in his life. But the celebrity eventually unbalanced his fragile emotional state.

At the peak of his fame, Pollock abruptly abandoned allover abstraction. Pollock resisted the temptation to follow the path of many artists who find a style and then use it repeatedly. He needed to evolve; he refused to paint anything that felt less than authentic. After 1951, his work became darker in color, including a series of powerful black paintings on unprimed canvases. When he exhibited them at the Betty Parsons Gallery, none of them sold. His collectors wanted his earlier style. As his work became more popular, the pressure to produce, along with personal frustration, drove his alcoholism deeper. In December 1951 he wrecked his Cadillac convertible, though he was unhurt.

Over the following years, his drinking took over as his productivity diminished. In 1955 he told his homeopath that he had not touched a brush for a year and a half because he wondered whether he was saying anything. He continually sought cures for his drinking: psychiatry, quack treatments, homeopathic remedies. Nothing worked. His binges became longer and his behavior wilder. Photos from this period show his once-handsome face deeply lined and bloated.

In 1956, Pollock began an affair with Ruth Kligman, a twenty-six-year-old beauty, occasional painter, sometimes model, and avid arts groupie with a passion for Abstract Expressionist artists. She had sought him out at the bar he frequented during trips to New York to see a therapist. By this time Pollock was drinking heavily and had essentially stopped painting. Lee Krasner, who had believed in his genius, nursed his hangovers, and lived for years with his embarrassing, abusive behavior, was furious when she learned about the affair. She decided to decamp for Europe for the summer. Kligman stepped into her place.

On August 11, Kligman and her friend, Edith Metzger, arrived by train in East Hampton for a weekend visit and were greeted by the drunken, bel-

ligerent artist. That evening, after a day of drinking, Pollock drove them to a concert, but turned around and headed home before they arrived. Frightened by his condition, Metzger had been reluctant to ride with him, but Kligman reassured her, so the two young women took their seats in the car. Heading home along Springs-Fireplace Road, Pollock hit the gas on his big, powerful Oldsmobile convertible and missed a curve in the road. The car veered off, lurched across the shoulder, snagged a patch of dense vegetation, and sailed end over end. Pollock was thrown from the car into the air, his head struck a tree, and he died instantly. Edith Metzger was crushed to death when the car fell to the earth. Ruth Kligman sustained serious injuries. Pollock was forty-four years old.

Jackson Pollock the man was gone, replaced by Jackson Pollock, the dark angel of Abstract Expressionism. Four months after his death, the MoMA opened a retrospective of his works. Pollock was included in traveling exhibitions in Western European capitals, including one organized by MoMA in 1958 that also included de Kooning, Newman, Still, Guston, Motherwell, Kline, and Rothko.[9]

Lee Krasner lived for twenty-eight years after her husband's death. She continued to paint and exhibit her own work while actively and very cleverly managing her husband's posthumous career. Some believe she was the engine that drove the market, not only for Pollock but also for many of his contemporaries. In her last will and testament, she established the Pollock-Krasner Foundation, donating the monies and artworks that remained in her possession to carry on their legacies. Over his lifetime, Pollock created some one thousand two hundred documented artworks, Krasner only six hundred. Some say she sacrificed her art for his.

In his will, dated March 1951, Jackson Pollock had expressed his desire to have the unity of his work preserved after his death.[10] Since it became impossible to meet this request, the Pollock-Krasner Foundation decided to do the next best thing: publish a catalogue raisonné, a complete and authoritative accounting of all his known work in chronological order. Dating proved especially problematic since more than half the works carried no date, and the progression of his oeuvre was, in the words of Frances V. O'Connor and Eugene V. Thaw, the editors of the catalogue raisonné, "dialectical." "Certain works anticipate, others resolve; still others innovate, some recapitulate." It took twenty years until the four volumes of the main catalogue were published in 1978, and another seventeen for the supplement that documents works that later came to light. In both publications, the authors were aided by a board of three experts who were responsible for separating the real from the fakes. Krasner led the board until her death, when she was replaced by art

historian Ellen G. Landau, a professor of art history at Case Western Reserve University in Cleveland, Ohio, who had authored a well-regarded Pollock monograph and the Krasner catalogue raisonné.

The Philadelphia Museum of Art owns a copy of the Pollock catalogue raisonné. After a quick visit to the two excellent examples of his work on display, I spent a couple of afternoons perusing it in the museum's library. Though detailed and accurate, a catalogue raisonné is not the best way to experience, really experience, Pollock. Most of the art is presented in small photographs, printed in black and white.

At this point, I had seen fifty actual Pollocks at MoMA, two at the Philadelphia Museum of Art, and little pictures of all of the rest of them in the catalogue raisonné. That was a whole lot of Pollocks. The next challenge was to find some phony ones and compare them with the real.

I didn't have to look any further than Volume 4 of Pollock's catalogue raisonné, which includes a section titled "False Attributions." It begins with an essay in which the authors explain they felt the necessity to include fakes after so many works that were submitted to the authentication board as real turned out to be "either maliciously or mistakenly attributed to Pollock's hand." They fall into three categories:

1. Works that are more or less outright "copies," which were attempts to duplicate known genuine works reproduced in the literature;
2. Works made not to replicate known works but to simulate them in a general way, which the authors referred to as "imitations"; and
3. Works that bear no informed resemblance to any of Pollock's known styles but simply "an attempt to drip paint in accordance with the popular mythology which has long surrounded his work." These are called "arbitrary designs."

Examples of fakes came not only from collectors but also from leading auction houses, some accompanied by fake letterhead with forged letters and fake signatures. The same hand painted some of them, and others were unique. But if the authors thought including fakes would discourage future would-be forgers, they were sadly mistaken. Owners of allegedly original Jackson Pollocks continue to seek the holy grail of the art market, the certificate of authenticity. With it, an artwork can be worth millions; single Pollocks, in recent years, have garnered well over $100 million. Without it, the work is worthless. There are so many alleged Pollocks for sale on eBay and in art galleries because people are willing to gamble they will hit the jackpot. But if you purchase a painting with a Pollock-like signature for a song, chances are it will be worth little more than its canvas and paint.

I began to imagine myself as one of the aspiring Pollock owners, maybe someone who inherited a painting from a recently deceased elderly aunt with a home in East Hampton. How would I go about authenticating it?

When I asked Samuel Sachs this question, he replied: "First of all, you would see if the painting is in the catalogue raisonné. That's what reputable dealers do. Barring that, it would help if you had a letter from Pollock or Krasner to your aunt saying, 'I'm so happy you have this picture.' That would be a good start, since it would establish the painting's provenance."

Of course, provenance. An unbroken chain of ownership from the artist to my aunt would verify that the painting is the real deal. Unfortunately, there was no letter from the artist to my imaginary aunt, nor was there a bill of sale from Pollock's gallery. Absent the documents that prove provenance, I was left with only one option, to submit the work to the International Foundation for Art Research.

The International Foundation for Art Research, known by its acronym, IFAR, is the go-to place for those seeking to sort the fakes from the real. Since its founding in 1970 as a nonprofit organization, IFAR has been dedicated to preserving the integrity of the visual arts. One of its services is authentication research, and eager owners have used it since the Pollock-Krasner Foundation terminated its authentication board. According to Dr. Lisa Duffy-Zeballos, IFAR's art research director, each year it receives dozens of requests from would-be Pollock owners, though it can only analyze less than ten, leaving many to wait for years to learn whether the painting they found in a thrift store or inherited from an elderly aunt is the real deal. To date, a couple of hundred alleged Pollocks have gone through IFAR's stringent process, and only a couple of them have been designated, in Duffy-Zeballos's words, "accepted works by Pollock." The most recent were two small sculptures, plaster sand castings with a wire armature inside that Pollock and his friend Tony Smith created. One was purchased by the Dallas Museum of Art from Smith's estate.[11]

IFAR believes everyone should be able to access top-rate authentication talent, not only the wealthy, so its fees are relatively modest. For my imaginary painting, the first step would be to submit a photograph and any provenance, technical, and art historical reports. IFAR then checks the catalogue raisonné and its records to see if this particular piece has turned up before. Apparently, many turn up repeatedly. The cost for this initial step: $400.

If my aunt's supposed Pollock was not in the catalogue raisonné, after IFAR's initial evaluation it may be a candidate for authenticity research. The painting would then be reviewed by specialists and conservators, and when questions arise, it might be sent out for tests, such as analyses of pigment and paint binders to see if the paint on the canvas actually existed when Pollock

was painting, or was on the market but never known to be used by Pollock. An anonymous authenticating committee chosen by IFAR would review the documentation and issues a report. The cost for this additional step: $2,600 plus the cost of tests.

So, I invest—or more accurately, gamble—three thousand dollars in the hope that the painting will hit the jackpot. The report on my imaginary painting comes back negative. I'm beginning to feel like many owners. Disappointed, angry. Maybe litigious.

"People are genuinely disappointed when they learn the painting they own is a fake," said Duffy-Zeballos, sympathetically. "You become part of the history of the artwork by owning it."

"What about a lawsuit?" I asked, remembering that the Pollock-Krasner Foundation had been sued a number of times.

"Every owner signs an authentication agreement," Duffy-Zeballos explained, "and it's served us very well. We've never been sued for an opinion."

IFAR is a relatively poor nonprofit, which makes it less a target for the lawsuits suffered by the relatively wealthy Pollock-Krasner Foundation. But no one is free. In June 2015 the New York State senate passed a bill affording art experts the same protection from frivolous lawsuits as other types of expert witnesses. If the bill ever becomes the law, it might raise the bar for lawsuits, but won't stop them. In the United States, anyone can sue anyone.

I asked Lisa Duffy-Zeballos whether she was able to spot a fake Pollock. She was quick to point out she is not a Pollock expert, but then told me: "When I open a package with a painting inside and the work looks dull, there's no life in it, you get a gut feeling it's not a Pollock. When you see a Pollock you get energized."

I took that in. I had seen genuine Pollocks, and images of many that weren't, and sometimes couldn't tell which were which. And, if I can't tell an authentic Pollock from an impostor, and most of the rest of the world can't either, why does it matter?

Duffy-Zeballos had a ready answer. "You need to keep mediocre work from tarnishing the artist's work. Authentic artworks show us the artist's development and achievement. Fake ones change our understanding of history."

IFAR has been at the center of some of the most audacious cases of purported Pollocks. In one case, IFAR was asked by two different owners to analyze the same phony Pollock.[12] The first arrived in 2013, along with an intriguing provenance. According to the story, Pollock had sent the painting to Fidel Castro to help finance the Cuban Revolution. The artwork was accompanied with photos of Pollock seated in front of the painting and Castro standing next to it. The application of paint to canvas, overall design, the misspelled names

in the letters, and the photoshopped images led IFAR to conclude "Castro's Pollock" was not only a fake but a poorly executed fake. Five years later, a different owner submitted the same painting. In the intervening years, it had acquired on the verso the initials "LxK" presumably referring to Lee Krasner, and an inscription "50-5/No 5" implying the painting was executed in May 1950. This was a telling addition since Pollock's actual *Number 5, 1950* is in the Cleveland Museum of Art.

Another case involved a man named John Re who was eventually convicted of selling $2.5 million in fake Pollocks, De Kooning, and other famous artists, some via eBay.[13] Re initially claimed he had discovered the works while cleaning out the basement of a deceased resident of East Hampton, George Schulte. In 2005 Re sent one of the alleged Pollocks for evaluation to IFAR, which studied and then rejected it as a Pollock, noting the painting was an "unconvincing pastiche" with an "unsubstantiated and highly problematic" provenance. In 2008–2009, two other paintings with a Schulte provenance were submitted to IFAR, and neither stood the test.

Two years later, IFAR learned that an individual had purchased forty-five purported Pollocks from John Re. IFAR insisted on reviewing the entire collection with Pollock specialists and conducting forensic sampling and analysis of pigments, binders, and other materials from selected works. The selected works were painted with the paints Pollock was not known to use, and most of them had binding materials that postdated Pollock's death in 1956, or the date ascribed to the work in question. If that wasn't damning enough, the entire cache of forty-five evidenced a "wearing homogeneity in palette, technique and physical properties uncharacteristic of Pollock." One painting in Pollock's classic drip style was consistent with his layering technique, but the dripped black armature was "too heavily described," the "yellow figure-like images" were different than Pollock's, and the white sections were painted over with a heavy brown veneer to artificially age it (see Figure 3.2).

In May 2015 Re was sentenced to five years in federal prison with an additional three years of monitored supervision, ordered to pay $2.25 in restitution to his victims, and to forfeit his submarine-like movie prop, Deep Quest. The court documents noted a total of seventy-four suspicious paintings, though there might be many more.

Around the time of Re's sentencing, I was on the hunt to see an actual fake Pollock, so I called the FBI's New York office to arrange to see one of the confiscated works. I was referred to the main office in Washington, DC. The agent with whom I spoke told me the public was not allowed to see them. Wondering why, I then called Robert Wittman, the founder and former head of the FBI Art Crime Team, whom I had met a couple of times. "Probably most of the paintings were destroyed," he said, "though they may have kept a

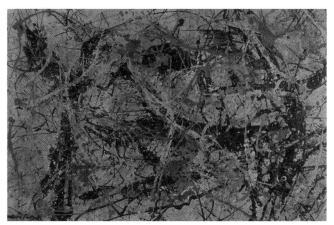

**Figure 3.2. Painting on fiberboard in the style of Jackson Pollock.
IFAR #11.08.**
Photo: Courtesy: IFAR.

few for undercover operations. Naturally, the FBI wouldn't want a picture of a fake they were using in an undercover operation to appear in a book where a criminal might spot it."

"There are a lot of fake Pollocks around," he continued. "When I was at the FBI, we had a case where thirty supposed Pollocks showed up in a Florida flea market. People knew they weren't real—they were selling for five hundred dollars each—but they wanted to own them to impress their friends. You know, like leasing a Mercedes Benz and pretending you own it."

There was one more stop in my quest to understand the connection between the one thousand two hundred artworks that are authentically Pollock and the unknown number that aren't: his studio. On a chilly day in May, I drove from Philadelphia to East Hampton and then up Springs-Fireplace Road—the same one Jackson Pollock drove on his way to his death—to the spot where he created his most memorable work, which is now a museum called the Pollock-Krasner House and Study Center. This National Historic Landmark includes the house, studio, and a couple of small buildings. Shielded from the busy road by a dense row of cedar trees and a tangle of bushes, the property opened up once I turned into the driveway. Behind the modest, cedar-shingled two-story house, the grassy lot runs down to preserved wetlands, with the wide Accabonac Creek beyond. It felt larger than its acreage, flat and spacious; it's easy to imagine Jackson Pollock placing a sheet of glass on a pair of stanchions to prepare for the final session of filming, as he did on the cold October day in 1950 when he flipped from artist to alcoholic.

Helen Harrison was waiting in the former garage that had been outfitted into a cozy office. A spare woman with a brown ponytail and gentle demeanor, Harrison had been at the Pollock-Krasner house for twenty-six years. I waited a few minutes while she dealt with a call, then asked her why there are so many fake Pollocks. Is it because it's easy?

"Why are there so many fakes of his work?"[14] she repeated. "Because Pollock's work is so very valuable, of course. But that doesn't mean they are easy to fake." Pollock's lines are the visual equivalent of handwriting. The marks are linear and they are applied in a penman-like way, although with full body motion. His lines are almost like those of a Japanese and Chinese calligrapher working on a large scale. "His work is very distinctive, in the way handwriting is distinctive," said Harrison.

Producing a plausible Pollock takes more than just duplicating his gestures. It also requires finding the materials that he used: the paints, the cotton duck canvas, and the Rivit glue that he sized with. Interestingly, some paintings from Pollock's time have traces of radioactive carbon, the result of the proliferation of nuclear bombing tests in the mid-1950s. If you were trying to fake the work now, the materials would give you away.

Over the years, many owners of purported Pollocks have stopped by, called, or emailed to ask Harrison to authenticate their paintings—in some cases a succession of owners have brought the same painting—and she's turned everybody down. She's not alone. Not only is Helen Harrison unwilling to authenticate Pollocks but so are many other experts. When one of them went out on a limb and authenticated a group of alleged Pollocks, she sparked a controversy that simmered for a very long time.

In 2003, the filmmaker Alex Matter found a package of paintings wrapped in brown paper and tied with string. It was among the artworks and letters that his father had left after his death in 1984. The paper packet carried the label "Pollock," written in Matter's father's hand. Herbert Matter was a graphic artist and photographer and Mercedes Matter, his mother was a painter and art teacher. Both were good friends of Pollock and Krasner, and the Matters owned two genuine Pollocks that are listed in the catalogue raisonné.

The parcel had been stored in a warehouse in Bridgehampton, New York, apparently placed there by Mercedes after her husband died. She died later but never told her son about it. Alex Matter assumed they were actually by Pollock, which was a reasonable assumption. Ellen G. Landau, who took Krasner's place on the authentication board agreed, which spurred the Pollock-Krasner Foundation into action. One of the authors of the catalogue raisonné told a *New York Times* reporter, "I've spent nearly half my life working on Pollocks and if Ellen Landau's opinion prevails, people will happily

buy them and they'll go into museums and books," he said, "but not the ones that I have anything to do with."[15]

In 2007, Harvard University Art Museum subjected three of Matter's "Pollocks" to scanning electron microscopy, Raman spectroscopy, and a slew of other state-of-the-art techniques, and found that all of them used paints that likely did not exist when Pollock was alive.[16] Landau then moderated her position in a 2007 catalogue essay that accompanied an exhibition of them at the McMullen Museum of Art at Boston College, but the paintings didn't die. In 2014, Cleveland's largest newspaper, *The Plain Dealer*, found five of Matter's purported Pollocks advertised as genuine on the website of Gallery 928 in Coral Gables, Florida.[17] The gallery later corrected the error.

If Matter's "Pollocks" didn't come from Pollock, where did they come from? Samuel Sachs shared a hypothesis. He initially thought Harry Pollock, an artist and drinking buddy of Jackson Pollock, could have painted the paintings, but Harry denied it. Sachs then remembered that Mercedes Matter had been a teacher. Maybe she gave her class the assignment of painting a Pollock—since anyone can paint a Pollock. The students went home, painted a Pollock-like painting, and brought them to class. Mercedes Matter then brought a couple of them to her home, and they end up wrapped in brown paper with the words "Pollock" on the label. Sachs's hypothesis may be plausible, but one will never know where the fakes came from. It will remain a mystery.

Harrison and my final stop was the converted barn that Pollock used as his studio. Preparing to enter the space, I exchanged my shoes for foam slippers . . . and then stood, spellbound. Much of the floor was covered with swooshes, splatters, and elegant lines of colors. Harrison pointed out traces of *Autumn Rhythm* and *Blue Poles*, two of the masterpieces he painted in the space. The floor had been hidden under the white Masonite boards Pollock had installed when he had the studio winterized in 1953. Krasner had later used the studio, and the Masonite boards had remained in place until she died, the site became a museum, and someone mentioned to the then-director that the original flooring was hidden underneath. The walls bear Krasner's marks; the floor is pure Pollock. It survived as the biggest Pollock of them all, perfectly preserved by a trick of fate.

I thought about the poured paintings. As I had read through the many books about Pollock and his work, it struck me that the critics had interpreted them in multiple, sometimes diametrically opposite, ways.

"That's what makes them so interesting," Harrison said. "You can read so much into them and your own view of them can change as you change because they are so subjective." Growing up in New York, she visited the MoMA as a child, teenager, and adult, and at each stage of life, her reactions

were different. As a child, she and her mother would wonder: "What is that?" As a teenager during the Cold War, she saw the poured paintings as "a sort of nuclear explosion, an existential representation of the Cold War. Now I see the rhythms and the energy seems so much more positive. So, whatever he was trying to communicate, as I changed, I took something different from it."

Unstable childhood. Early struggles to make it as an artist. Loyal helpmate. Immense celebrity. Decline, drinking, death. These are the facts, but they don't really get to the heart of the matter, his genius.

What does? Where is the real Jackson Pollock? Was there a link between his genius and his mental illness? Psychiatrists continue to debate whether mental illness augments or inhibits creativity, so there's no final answer from that quarter.[18]

Helen Harrison believes he created his art in spite of it. "There are a lot of mentally ill alcoholics who are total screw-ups and there are lots of artists who are perfectly sane. Some dysfunctional people have a little functional niche and art was Pollock's functional niche. He didn't drink when he worked. He focused. He concentrated. That was when he was the best of himself."

"Pollock was born to be an artist," she continued. "When he was in the studio he was fine. He said it himself. He said, 'painting is no problem. It's what you do when you are not painting that's a problem.'"

I'm not so sure. I wonder whether the artist's creative spark and alcoholism might be as symbiotic as joined Siamese twins sharing a torso. Pollock was either an outsider on the fringe of the room, silent and brooding, or he was the center of attention, raving drunk, beyond control. He would not or could not conform to the rules of school, of the WPA, of polite society. Didn't he care, or was he unable to fit in? Did his shyness, struggles with women, and drinking in some way serve his art? Did it fuel the fury coursing through his body, his fingers, brushes, and paint onto canvas?

Did the binge drinking, hangovers, and recovery that followed allow the emotional space he needed to recharge? Was his art cathartic, a way to live with the pain of being Pollock? Did Pollock drunk feed Pollock sober? Did the drinking cut him free from his emotional boundaries, enabling him to access the deep truth he took to the canvas? That truth was his alone; it came from his singular pain. Maybe no one can really replicate a Pollock because no one can replicate the pain that shaped it.

Ultimately, it doesn't matter whether Pollock's genius was in spite of, or because of his mental illness. The important thing—the thing that really matters—is his creative legacy. He drank and behaved egregiously and even caused a woman's death. But his work never lied. He stopped painting when he could no longer muster the immense emotional energy it took to channel

his soul onto canvas. As Samuel Sachs II said, "Pollock wasn't trying to 'do a Pollock.' He was doing what he did, and as a result his signature style is in his work."

Some may try to beat the system. They can go onto eBay and buy their own "Pollock," invest in art historians, forensic scientists, X-rays, and fractal analysis. They can take their alleged Pollock to IFAR; they can have an anonymous panel of experts carefully review documents and study the painting. And, they will end up exactly where Teri Horton, and Alex Matter ended up: with an unauthenticated Pollock and a broken heart.

Chapter Four

Two-Thirds Rembrandt

The young man sits solidly on his pale horse gazing out of the picture frame and into the gallery beyond. He's movie-star handsome, with dark eyes, curly shoulder-length hair, a straight nose, and resolute mouth, caught half in sunlight by the artist's brush. The rider wears a fur-trimmed hat with a red crown, a long buttoned coat with a sash around the waist, red leggings, and brown boots, and he is heavily armed with a bow, quiver of arrows, two swords, and a war hammer. The horse may be old, or may be pregnant; its legs, especially the hoofs, are slightly askew. Man and horse are riding through a brownish-gray landscape under a mottled gold-colored sky. A hazy background partially obscures a church, stream, a rocky hillside topped by a domed citadel, and what may or may not be some figures before a fire (see Figure 4.1).

This is *The Polish Rider* painted by Rembrandt Harmenszoon van Rijn in 1665 and it's captured the imagination of countless art patrons and connoisseurs since it arrived at Henry Clay Frick's Manhattan mansion from a castle in Galicia. The painting has been a point of contention for Rembrandt aficionados ever since. Some think it's a portrait of an actual person, with an abundance of hypotheses about who that person was; others believe *The Polish Rider* is an archetype, though there are disputes over whom or what he might represent. Some think the murky background was intentional, to convey a sense of mystery, while others argue it's murky because it was never finished. Some suggest Rembrandt painted only parts of *The Polish Rider*—although there is some debate over which parts are his—and that the rest was painted by an apprentice, though no one knows which one. Critics, connoisseurs, and art lovers continue to theorize about the rider's costume, armaments, horse, Rembrandt's signature, and even the varnish. If that wasn't enough, the canvas bears the scars of an eventful life. Over the course of the 350+ years since it was painted, *The Polish Rider* was packed up and moved

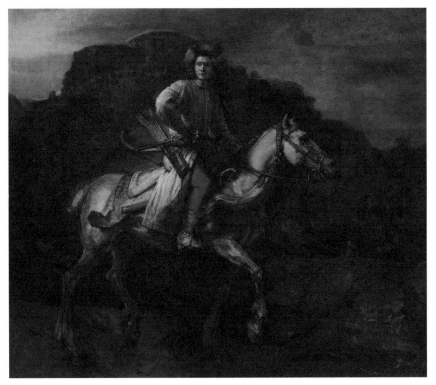

Figure 4.1. *The Polish Rider* **by Rembrandt Harmensznoon van Rijn.**

several times, pierced, cut, repaired, repainted, relined, aggressively cleaned, and repeatedly revarnished.

A Rembrandt not completely by Rembrandt? A significantly altered Rembrandt? A former director of the Frick Collection once referred to *The Polish Rider* as two-thirds Rembrandt. Is two-thirds enough to count as authentically Rembrandt?

Put another way, if Rembrandt time-traveled from seventeenth-century Amsterdam to today's Manhattan and stopped by the Frick, would he recognize the painting as his own?

In 1914, Henry Clay Frick, the renowned Pittsburgh steel baron, and his wife moved into their lavish new residence at 1 East 70th Street, across from Central Park. Today their home is called the Frick Collection and many of their possessions remain on display. It is a serene oasis in the bustling city. Frick had an appetite for European masters, an eye for excellence, virtually

unlimited funds, and a cadre of art experts and dealers eager to help. With these, he assembled a world-class collection of art, furniture, china, and other treasures, then carefully placed them throughout the rooms, courtyard, and corridors of the house. This is no mighty Metropolitan Museum that dwarfs the visitor in its cathedral-like spaces. Instead, the Frick is domestic and intimate. Every turn into every room offers up a personal encounter with another masterpiece: the delicious *Progress of Love: Love Letters* by Fragonard; a luscious portrait of the plump and contemplative *Comtesse d'Haussonville* by Jean-Auguste-Dominique Ingres; a tiny, very rare bronze lamp from sixteenth-century Italy, shaped like a boot and covered with tiny bronze naked children. We, the visitors, feel as privileged as Frick's guests were when he welcomed them in.

The Polish Rider has hung in the large, ornate West Gallery for more than eighty years, sharing the green velveteen walls with some of the world's greatest paintings from the Renaissance through the nineteenth century. The lined canvas is 134.8 × 117.1 cm. On my first visit, I stood as close to it as the vigilant guards would allow, spotting Rembrandt's faded signature, an R set in a painted rock, and then moved to a bench across the room. I followed the direction of the young rider's gaze across the gallery and imagined what he might be thinking. Would he find inspiration in *The Sermon on the Mount* by Claude Lorrain? Would he be wagering with the museum guard over whether Hercules would choose the bejeweled voluptuous blonde or the laurel-wreathed voluptuous brunette in *Choice between Virtue and Vice* by Paolo Veronese? Would he be curious about the contents of the large, ornate Renaissance-era chest set below his painting?

I then turned back to the painting. *The Polish Rider*'s detailed costume, armaments, and horse are characteristically Rembrandt: the white and red paint pulls your eye just where he wants you to look. What's missing, at least to me, is what I admire most—the distinctive Rembrandt-style face: the singular look of the eyes, the emotional connection wrought by the artist between subject and viewer. Next to *The Polish Rider* is Rembrandt's masterful self-portrait, painted, like *The Polish Rider*, in his later years. Here is Rembrandt at his best: the eyes are knowing, the face expressive, the brush strokes broad and decisive.

Looking at the paintings side by side, I wondered: What is it about *The Polish Rider* that drives so many to such expressions of ecstasy? The great Rembrandt connoisseur Abraham Bredius called it "one of Rembrandt's greatest masterpieces."[1] Robert Frye, who purchased it for Frick, called it "one of the world's masterpieces of painting."[2] British art historian Sir Kenneth Clark, whose television series *Civilization* brought the best of European art into our 1960s living rooms, called *The Polish Rider* "the most personal and mysterious of his later paintings."[3] "It was a painting that I worshiped when I was

an art history student in New York," Rembrandt authority and author Gary Schwartz told me.[4] These are only a small sample of the accolades. The painting's provenance files, which occupy a full five feet of shelves in the Frick's archives, are stuffed with articles, photographs, exhibition catalogues, letters, sketches, poems, and love notes.

And, when the painting's authenticity was questioned, it sparked a firestorm. Art historian Josua Bruyn, chairman of the 1968 Rembrandt Research Project, once commented in a book review that *The Polish Rider* "may be by an interesting Rembrandt student called Willem Drost rather than from the master's own hand,"[5] an assertion another scholar called "world news"[6] which, if he meant the art world, is no exaggeration. The controversy reached well beyond the art press and eventually led to a book, *Responses to Rembrandt: Who Painted the Polish Rider? A Controversy Considered*, by Anthony Bailey.[7]

I didn't get all the fuss. The man on the horse is as vacuous as a runway model. He may be a Rembrandt, but to me he's "Rembrandt lite." What was I missing?

In 1665, when Rembrandt painted what is now called *The Polish Rider*, he was facing financial ruin. Amsterdam was reeling from an economic recession that substantially curtailed new commissions from the organizations and wealthy burghers that made up his primary market. The artist had spent lavishly. He was carrying an expensive mortgage on his house and other debts. His creditors had begun to chase him.

This sorry state of affairs came about near the end of a spectacular career. Rembrandt had the good fortune to reach his prime at the peak of the Dutch Golden Age, when its cities were among the most prosperous in Northern Europe. The wealthy businessmen and the charities, social clubs, and other organizations they founded were eager to document their wealth on canvas. Foreign travelers often commented on the plethora of paintings. It seemed everyone owned some: merchants, tradesmen, and blacksmiths. Artists thrived in this environment. There were a thousand or more Dutch painters of the seventeenth century who produced museum-quality work. Paintings were the pop art of seventeenth-century Holland.

Rembrandt was born in 1606 in the prosperous port city of Leiden to a miller who was financially comfortable enough to send his son to Latin school. Rembrandt enrolled at the University of Leiden at age fourteen but soon left to learn his craft. He first studied with a local artist then moved to Amsterdam to join another's studio. A couple of years later, Rembrandt returned to Leiden, set up a workshop with a colleague, and began securing commissions. At age twenty-five, Rembrandt returned to Amsterdam.

In Holland's exuberant art market, Rembrandt stood out for his mastery of what the Dutch admired most: "houding," the careful balance of colors and tones that create the illusion of three-dimensionality. He was also exceptionally versatile: he produced self-portraits and commissioned portraits and "tronies," which are paintings of an exaggerated face or stock character. He painted genre scenes, landscapes, small- and large-scale history pieces. He worked in watercolors and oils, on wood and canvas, and he printed many of his own etchings and lithographs. While other artists specialized in a single genre or medium, he mastered them all.

Rembrandt may have thought his success would last forever, but larger economic and political forces conspired to end the idyll. In 1656, a year after painting *The Polish Rider*, he secured a "cessio bonorum," a respectable form of bankruptcy that kept him out of debtor's prison. He was forced to auction off his large art collection and sell his home and printing press. After he moved to a smaller house, Rembrandt's common-law wife and his son Titus started a company in which Rembrandt was an employee, to allow him to concentrate on his artistic output. A few years later his common-law wife died, leaving Titus to look after his father. Titus married in 1668, only to die seven months later, soon followed by Rembrandt himself in 1669. There was no official notice of his death.

Who exactly was the man in the equestrian portrait? Rembrandt is not known for painting horses, so it's an unusual work and art historians have studied it closely. Some of them start with its provenance.

The painting can be traced back to 1791, when Michael Kazimier Oginski, Lithuania's grand hetman, its highest ranking military officer, sent it to his cousin, the Polish King Stanislaus II, Augustus Poniatowski, along with a letter with these cryptic lines: "I am sending Your Majesty a Cossack whom Rembrandt has set on his horse. The horse has eaten during his stay with me for 420 German Guilders."[8] That was some 135 years after Rembrandt painted it, leaving a mysterious chasm in the provenance into which generations of art historians have jumped.

In 1897 Abraham Bredius, the eminent art expert who served as director of the Mauritshuis in The Hague, was invited to see the painting at the castle of Count Tarnowski and his family in Dzikow, Galicia.[9] The count had inherited the painting from his grandmother, Waleria Stroynowski, who thought it was a portrait of her great-grandfather, Stanislaw Stroynowski, a colonel in the Lisowski regiment. When the family realized that the painting dated from thirty years after Stroynowski's death, they lost interest in it.[10] In 1898 Bredius persuaded Tarnowski to lend it for an exhibition of Rembrandt paintings in Amsterdam where the public saw it for the first time.

Twelve years later, in 1910, at Henry Clay Frick's request, Robert Frye traveled by train to Tarnowski's castle to secure *The Polish Rider*, and then brought it to London, where a copy was made for the Count Tarnowski (it was later lost).[11] Frick then purchased the painting from Knoedler Gallery for $308,651, the equivalent of about $7.5 million in current dollars. According to Frick's record book, the amount included the cost of the painting, $293,162, a commission for Robert Frye of $14,162.50, duty charges of $25, and $850 for the frame.[12] By the time *The Polish Rider* arrived at Frick's mansion, it had been repaired three times, and the signature had probably been damaged.[13]

Among scholars, there seems to be general agreement that the rider is dressed and armed as a Polish militiaman, probably from a wealthy family. That's where the consensus ends. One authority believes he was a member of the Oginski family since they owned the painting in 1791 and family members, including two students with a militaristic bent, spent lengthy periods in the Netherlands. However, the years when the young Oginskis were in the Netherlands don't line up with the date of *The Polish Rider*. Others point to the young rider's idealized countenance as proof that he is an allegorical figure, perhaps a latter-day Christian knight off to fight the Muslim Turks, a champion of religious freedom, or Tamerlane, the mythical hero in a popular play that was staged in Amsterdam around 1655. Some think he's a Biblical figure: a young David, the Prodigal Son, a prefiguration of Christ. Ian Wardropper, director of the Frick Collection, hypothesizes he might not be any particular Pole, but rather an idealized one.[14] In the seventeenth century, Polish military men were much admired for their prowess, much as NFL quarterbacks are today. If Rembrandt wanted to make a fast guilder, there would be no subject of greater appeal than a handsome Pole riding off to battle.

If an Oginski family member commissioned *The Polish Rider*, he or his underling likely stopped by Rembrandt's house to pay for it, the same house you can stop by today. Except for the modern glass and concrete structure that hugs its exterior, the Rembrandt House Museum is almost indistinguishable from others along Jodenbreestraat, a canal street in the middle of Amsterdam. This popular tourist attraction interprets Rembrandt's life and re-creates the scale and texture of his environment when he was wealthy, successful, and Holland's favorite. The large townhouse accommodated his family quarters, workshops, and studios for him and his students, an art gallery, and his large and valuable collection of artworks, specimens, oddities, and other collectables. Commissions, student tuitions, sales of his prints, and an active retail operation paid the sizable mortgage.

The front of the first floor was devoted to business: selling Rembrandt's and other people's artworks. Customers were greeted at the front door and led into a large square hall that was filled with paintings like the ones that greet visitors today. A customer might then meet Rembrandt, negotiate a commission—maybe even for *The Polish Rider*—or buy paintings or prints.

Up a flight of narrow stairs was the room devoted to the artist's large and eclectic collection of paintings and prints by artists he admired, shells, animal bones, casts of Roman statues, armor and weapons, feathered necklaces, and other oddities and costumes, many of which appear in his paintings. We know exactly what Rembrandt owned because he listed every item in an inventory when he was forced to sell them to pay his creditors. At the top of another flight of stairs was the spacious, sunny room that Rembrandt used for his studio. The day I visited, an artist/interpreter was preparing the pigments Rembrandt would have employed. Each day his assistants mixed linseed oil and turpentine with minerals, flora and fauna: reds from iron and mercury; amber gold from pieces of amber; green and muddy brown from local earth; brown and black from animal bones; white from lead; ultramarine from lapis, so expensive it was reserved for the garments of Jesus and Mary. Rembrandt worked the paintings from rear to front, sometimes on canvas, other times on wood. An anatomical figure hung nearby, a reminder of Rembrandt's ability to portray the human body from the inside out.

Above Rembrandt's studio was the room where his apprentices and pupils worked, five or six at a time, no more than fifty in total over his working life.[15] Most came with prior training; and some stayed as long as fifteen years, paying fifty or more guilders every six months for the privilege of learning the master's secrets and replicating his distinctive style. The most proficient apprentices worked on his paintings. Did any paint a part of *The Polish Rider*?

Today we tend to think of a painting as either an original—by the artist—or a fake—by someone else. Rembrandt's contemporaries had a more nuanced view, which is revealed in the many terms for different shades of authenticity.

An "original" was the first painting, always made by the master. If it was the master's work alone, it was called "autographical." The next category was a "rapen," an original painting by one artist based on another artist's work; an especially expert rapen might be considered an homage to the master. Then there was a "pastiche," the Italian word for pastry, with bits and pieces copied from a number of paintings and combined into something new.

The term "copy" described everything from cheap trash and deliberate forgeries to highly sought-after artworks. In 1699 connoisseur Roger de Piles enumerated three type of copies: those that were faithful and slavish, those that were free and unfaithful, and those that were both free and faithful, the last one

being by far the hardest to detect. Sometimes an artist would duplicate his own painting because it sold well or another client wanted one for himself. Often apprentices copied their master's painting as part of their training; a copy good enough to fool an expert could launch a career. Some collectors especially prized quality copies of quality originals, since they demonstrated the artistry of both the artist and the copier. Other collectors feared that a copy might diminish the value of the original: one of them darkly cautioned copies should be "shunned like the plague."

Much like today, seventeenth-century art buyers often found it tough to tell the original from the copy. The 1607 minutes of Amsterdam's Guild of St. Luke, the city's professional organization of painters and related craftsmen, noted that laymen were duped because they could not tell copies and "rubbish" from good quality pictures. We must remember there were limited opportunities for art lovers to train their eye. Rembrandt's customers did not have the benefit of catalogues raisoneé, art books filled with high-resolution prints, virtual tours of museums, or other ways to see the larger body of an artist's work. They could only study the canvases they knew about or see them as reproductive prints.

Moreover, the image of the solitary genius creating masterpieces in his atelier didn't apply to Rembrandt or to many of his fellow artists. In fact, many paintings were creative collaborations. Sometimes the master laid in the overall design and painted the face, hands, clothing, and other significant parts, leaving the rest to apprentices, then adding his final touch. Sometimes outside artists were hired to paint elements in which they were proficient, like animals, lace, or flowers. An artist's signature didn't necessarily signify that he painted all of it. Rather, it guaranteed the work met his personal standards of quality.

Rembrandt signed *The Polish Rider*. So, whoever bought it knew it met the master's high standards, even if only two-thirds of it was by him and someone else had painted the rest.

How many paintings *did* Rembrandt paint? You may find it surprising to know there's no definitive number. Instead, there are many lists compiled by many experts over many years. John Smith's catalogue, compiled between 1829 and 1842, listed three hundred Rembrandts. Wilhelm Valentiener, a Rembrandt specialist, expanded the number to seven hundred. The catalogue prepared by Abraham Bredius in the mid-1930s enumerated 624 authentic Rembrandt paintings.[16] Soon thereafter, Jakob Rosenberg, a German art historian who had immigrated to the United States, published a list of 644 paintings, which excluded some that Bredius had authenticated and included some that Rosenberg felt were authentic but Bredius did not. In 1966, in honor of

the three-hundredth anniversary of Rembrandt's death, German art historian Kurt Bauch published a list of 562 Rembrandt paintings, and Horst Gerson wrote a coffee table book that contained 420 illustrations of Rembrandt paintings, 72 of which he considered doubtful. One authority posits that at one time or another, 6,000 paintings were attributed to Rembrandt, but no one really knows.

"There's fairly generous agreement about the number of existing paintings by Rembrandt: some three hundred fifty," Gary Schwartz told me. "The question, then, is how many were lost or destroyed." He estimates that Rembrandt painted five hundred artworks, basing the number on surviving works, suppositions about losses, and an output of about ten paintings per year.

But beneath the numbers lay a more fundamental issue: What counts as a genuine Rembrandt? Solving this conundrum was the goal of the Rembrandt Research Project, a multiyear, multi-million-guilder quest to produce the definitive list of Rembrandts by examining every known Rembrandt in the world.

The project's origins reach back to a notorious court case. Soon after the end of World War II, the Dutch government accused Hans van Meegeren, a well-known artist and art dealer, of selling many Dutch and Flemish masterpieces to Nazi Marshal Hermann Goering. The most egregious example of van Meegeren's treason was a well-known and much beloved masterpiece by Johannes Vermeer, *Christ and His Disciples at Emmaus*. During his trial, Van Meegeren argued he never committed treason, but rather had painted the Vermeer himself. He went on to explain that many of the Dutch Masters the Nazis acquired were actually van Meegeren's own fakes. To prove it, he returned to his prison cell and painted another ersatz Vermeer. Van Meegeren died before the courts could determine whether he was a traitor, an art forger, or both, but his shocking revelation resonated long into the future. It became a turning point in art authentication.

In 1956, Robert Haak, an assistant curator in the Rijksmuseum in Amsterdam, was helping to assemble the major exhibition in honor of the 350th anniversary of Rembrandt's birth. Haak was well aware of the van Meegeren scandal, since he had worked in an art business connected to the case. As Haak later told the story, he was looking at the hundred Rembrandts leaning against the wall waiting to be hung when he was struck by the "bewildering" differences in style and quality.[17] Could all of these actually be by Rembrandt?

Now, it should be noted that Haak's question carried a different resonance in Holland than it would have in the United States. Here, whether or not a painting is by the master may be an interesting question and is certainly a financially significant question, since a painting by the master is worth millions more than a copy. In the Netherlands, however, paintings, especially Dutch Masters, are a national brand. Most tourists count on seeing real Dutch

Masters; so fakes threaten the very fabric of Dutch identity, not to mention the Dutch economy. If van Meegeren could fool the experts, the thinking went, how many other Dutch Masters were fakes? Did the dubious paintings include some by Rembrandt, the most famous Dutch Master of all? The Organization for Pure Scientific Research, a Dutch government agency, invested millions of guilders to find out.

The Rembrandt Research Project, launched in 1968, was a postwar trailblazer: nothing on this scale had ever been attempted before. Its mission was simple and straightforward: identify the entire oeuvre of this seventeenth-century painter. In practice, it was fraught with problems. First were the logistical challenges of gaining access to the paintings and permission to study them, which could be difficult when an alleged Rembrandt was owned by a small museum or a private collection. Second were the methodological challenges. These included how to eliminate the inevitable bias of individual researchers, and how to secure comparable information on all paintings in order to allow comparisons. In an attempt to eliminate individual biases, the art historians traveled the world in ever-changing teams of two to see the alleged Rembrandts in situ. To attain comparability, the team focused on the concrete and measurable. Each canvas was regarded as an artifact: its physical characteristics were recorded, including measurements, paint surface, signature, canvas, and wood.[18]

From the beginning, the project sought out experts and technologies that could shed additional light. Dendrochronology, which documents the approximate year in which a tree was felled, was used to date the oak panels Rembrandt used for his early paintings. These tests verified that many paintings originally considered later imitations were actually painted on panels of authentic seventeenth-century wood—that is, painted during Rembrandt's time. X-ray photographs proved to be especially valuable in revealing the way Rembrandt laid out his compositions and executed various parts of a painting. Miniscule samples of the paints on the canvas were removed to determine whether the pigments and oils corresponded to those used by Rembrandt. Ultimately, the team determined that scientific tests, while helpful, were not conclusive. They could verify whether a canvas was painted after the seventeenth century and, thus, not by Rembrandt; but they couldn't conclusively prove that a canvas from the seventeenth century was one of his.

The third and final category of problems were political, the unintended consequence of embedding animus within the methodology. It all started when the team assigned a preliminary ranking to each artwork: paintings entirely in Rembrandt's own hand (category A), paintings not by the master at all (category C), and paintings about which they could not reach a firm conclusion (category B). The rankings were preliminary and confidential, but

some were leaked and sent shock waves through the art world. Curators and patrons were extremely upset when they learned their cherished Rembrandts were suddenly discredited. Owners saw the value of their assets plummet. Their anger was exacerbated when they realized the team had decided not to consult the owners before ranking their paintings.

Despite the methodological problems and growing controversy, the Dutch art historians soldiered on. The first three volumes of *A Corpus of Rembrandt Paintings* were published serially in 1982, 1986, and 1989 and covered the first seventeen years of Rembrandt's career, from 1625–1642. Since he painted until 1659, substantial portions of his oeuvre remained to be analyzed. But by 1989 the project had gone on for an unprecedented fourteen years, with no end in sight. Its methodology was challenged; its members were aging. Sadly, the collegiality that had characterized the team in earlier days had devolved into irreconcilable differences over attribution methods. In April of 1993, five of the members resigned, leaving the sixth, Ernst van de Wetering, to carry on.

In the sixth and final volume of the Rembrandt catalogues there is a poignant essay titled, "What Is a Rembrandt?" in which van de Wetering recounts the events leading up to and following the resignations. Over time, he writes, he had become increasingly uncomfortable with an authentication process that principally relied on the consensus of six Dutch art historians steeped in traditions of connoisseurship. While homogeneity may have expedited decision making, it also fostered a closed, self-referencing set of judgments. In addition, van de Wetering believed that the project had misjudged Rembrandt's artistic development by lumping his entire painting oeuvre together rather than looking at each genre separately. They also had a mistaken view of his style of production. Underlying the A, B, and C rankings was the assumption that every A painting was solely in Rembrandt's hand rather than a collaboration between master and assistant.

Once van de Wetering took charge, he set about fixing these problems. The contentious A, B, and C preliminary rankings were eliminated, and the painting's owners were given a chance to review entries before publication. Finally the initial all-art-historian team was replaced with consultants who were more fluent in current scholarship and sophisticated technical analyses.

In 2011, van de Wetering's newly constituted team published Volume IV of the Rembrandt Research Project. Volume V, covering small-scale history paintings after 1642, was published the following year; it included *The Polish Rider*. By the time van de Wetering reached Volume VI, he seems to have run out of steam. Instead of a catalogue, the volume is called an "overview." Instead of the detailed entries in the earlier volumes, this one contains only brief descriptions.

It has become something of an insider's game to discount the Rembrandt Research Project, and there are grounds to do so. The uniformity in training of the early team of art historians fostered homogeneity of method and results; there were limited divergent voices inside the room. And, ultimately, the project failed to deliver a definitive list of authentic Rembrandts. The team examined about six hundred paintings, and during the first phase arrived at a list of some three hundred authentic Rembrandts. During the second phase, Ernst van de Wetering and his team of art experts and scientists reattributed seventy of the formerly deattributed paintings. Since then, he has reattributed more. All of this subtracting and adding to the list of authentic Rembrandts has confounded some curators and confused some fans.

Despite these shortcomings, one must admire the project for the audacity of its quest. It was the first attempt to move beyond connoisseurship and systematically employ science and technology to the work of a single seventeenth-century artist. Its volumes span the most dynamic era of art scholarship, when it experienced a tsunami of new research and science. The Rembrandt Research Project both sparked and witnessed art authentication's evolution from an insider's game for upper crust connoisseurs toward a more egalitarian one based on science and technology.

If you spend time with Rembrandt experts, you'll soon find yourself in the middle of a very long-standing dispute between connoisseurs and material scientists over which field holds the advantage in art authentication.

The Frick's Ian Wardropper, who holds a PhD from the Institute of Fine Arts at New York University, proudly counts himself within the long tradition of connoisseurship. He certainly has an art connoisseur's demeanor: polished, sophisticated, and measured. When we met in Henry Clay Frick's lavishly appointed library, now assigned to the director, Wardropper described how he honed his eye. One of his graduate school professors, head of the drawings department at the Metropolitan Museum of Art, would lay out about a dozen drawings and ask his students to attribute them. "An excellent exercise to get into the mind of the artist and understand how the town, the region he's from, all of this played into the lines he put on the paper," said Wardropper, smiling. "Connoisseurship is an abstract art. It's not a science, but that's what I love about it."

The Polish Rider's files are filled with connoisseurship stories. Abraham Bredius, for example, upon first seeing the painting in a remote Polish castle, wrote in classic connoisseur-ese: "A single glance at the whole, an inspection of the technique that required no more than seconds, were all that was necessary to convince me at once that here, in this remote region . . . hung

one of Rembrandt's greatest masterpieces."[19] While few art historians would authenticate a painting solely on the basis of an epiphany, Wardropper and his colleagues continue to believe in the primacy of a good eye.

Milko den Leeuw, the Dutch art conservator and authenticator, thinks good science trumps a good eye. He is intense, kinetic, and dynamic. We met in the studio he shares with his art historian wife on the second floor of their townhouse in the center of The Hague's historic district, filled with the art books, computer terminals, easels, and equipment they use to analyze, authenticate, and sometimes restore artworks.

Den Leeuw is part of a growing cohort that believes that art authentication must combine the insights of material scientists, conservators, and art historians. He explained how it works. Material scientists, he said, analyze a painting's material: pigments, binders, canvas, and wooden supports. Conservators analyze an artist's techniques and the way the layers of paint are constructed. Art historians analyze the artist within the context of his or her era and values. "When you combine these three, you get very close to the reconstruction of what it is we're looking at," he said.[20]

Den Leeuw is also a believer in what he refers to as the "Wikipedia" approach to art authentication. By this he means a process that is collaborative, transparent, and easily accessible through the Internet. So, instead of the closed, art historian-led process of the Rembrandt Research Project, he imagines that future catalogues raisoneés will be group-sourced.

"Art authentication is a science, and in science, knowledge continues to evolve," he explained. When I asked where connoisseurs fit in, he said, "They don't. The connoisseur who is walking around and says this is right and this isn't, that's history."

Neither Ian Wardropper nor Milko den Leeuw would say, beyond a shadow of a doubt, that Rembrandt was the sole artist on *The Polish Rider*. Unless you were actually in the room when it was painted, they argue, there will always be some doubt. They also agree that *The Polish Rider* has some problems. Wardropper sees it "as an unfinished picture that has had probably involvement of another hand and an unfortunate conservation treatment in the 1950s." Despite this, he sees it is a masterpiece, able to holds its own among its world-class neighbors in the Frick's West Room.

Den Leeuw has another point of view. "It's simple," he said. "*The Polish Rider* was not finished. The layers are too sketchy. Because you're looking at unfinished layers, you are probably also looking at layers that were probably done by pupils." To prove the point, he handed me Nico Vandhoff's book, *Unfinished Paintings*, in Dutch. It contained an unfinished Rembrandt, an unfinished Durer, and an unfinished painting by Michelangelo that hangs in the National Gallery of Art.

Rembrandt might have left *The Polish Rider* unfinished because he didn't like the work or the sitter. Perhaps he was busy negotiating a "cessio bonorum" and had more important things on his mind. Maybe the buyer, perhaps a Polish nobleman, was impatient to leave Amsterdam. Unless an art historian discovers some telling evidence in an archive, the reason will remain another *Polish Rider* mystery.

The Rembrandt Research Project's art historians share Wardropper's and den Leeuw's opinion of *The Polish Rider*, basing their conclusions on very convincing evidence acquired through five laboratory examinations, X-ray images, and repeated viewings of the painting in situ. *The Polish Rider* entry in the project's Volume V contains exhaustive detail: the size and thread count of the canvas; the lining and stretcher; the dings and marks. Eight to ten centimeters are missing from the right side of the canvas, including Rembrandt's original signature, rendering the formerly oblong painting somewhat square. The canvas had been cut along the bottom, and another piece of canvas with a different thread count was glued into its place and later painted. In the 1950s, *The Polish Rider* was "aggressively" cleaned and restored.

The Polish Rider entry also quotes a catalogue of the Frick Collection from 1968: "Despite damage in limited areas, the general condition is good." The Dutch team didn't quite agree. They found the impasto slightly flattened, a number of tears that had been repaired, paint that was retouched, and a couple of holes had been filled in with separate pieces of canvas, which was in a process done so expertly that the damage is not noticeable. The painting contains blackish passages defining the contours, which are most likely the remains of overcleaning. And, while they admired parts of the painting, for example, the weapons "seem like a series of individual portraits done with meticulous precision," they thought the rider evidences "curious weaknesses in the construction and modeling. The thigh was too short and awkwardly attached to the buttock; the arms were too long; the bootleg was weaker than the foot." These areas suggested "a more limited pictorial intelligence," which might suggest the hand of a less-than-masterful assistant.

In the art world, a lesser work of an important artist is called a "Monday morning painting." You know: "Rembrandt lite."

From Rembrandt's house, it's a short tram ride to the Rijksmuseum, the gigantic Dutch national museum. I took it one rainy day to visit what many believe is the ultimate Rembrandt: *Night Watch*. It commands its own gallery, covering an entire wall almost floor to ceiling, and the figures are almost life-size, which makes these Dutch burghers all the more realistic.

The masterpiece is so fraught with incident that it makes the damage inflicted on *The Polish Rider*'s seem negligible. *Night Watch* was slashed in 1911 by

an unemployed cook, slashed again in 1975 by a deranged schoolmaster, and sprayed with concentrated sulfuric acid in 1990. These are only the most recent indignities it has suffered. In 1715, the painting was trimmed to fit into a certain spot on the wall, and it was later removed from its frame and rolled up before it was moved to a safe place during World War II. Like *The Polish Rider*, *Night Watch* has been touched up, varnished, revarnished, relined, aggressively cleaned, glued back together, and meticulously restored. The naked eye can't see any of this. But, one wonders, how much does *Night Watch* approximate the canvas from Rembrandt's workshop in 1636? And for that matter, how much does *The Polish Rider*? Did these paintings lose some of themselves over the years? How common is this?

My final stop on my *Polish Rider*–like quest was the Philadelphia Museum of Art to learn more about whether the damage suffered by *The Polish Rider* and *Night Watch* was common for paintings that survived the centuries. I met with Teresa Lignelli, senior conservator of paintings, one of the principal contributors to the exhibit then on display in which the back room talent—the conservators, scholars, and materials scientists—took center stage. It featured artworks donated by lawyer/art collector John G. Johnson to the Philadelphia Museum of Art and devoted considerable attention to restoration and attribution. Five paintings by Hieronymus Bosch, an especially weird countryman of Rembrandt, commanded one wall. Only one was an actual Bosch; others were by his contemporaries or were later work in the Bosch style. They fooled Johnson when he purchased them about a hundred years ago, and they fooled me, too.

As Teresa Lignelli and I sat near the entrance to the exhibit, I detailed the damage inflicted on *The Polish Rider*. "This is very common," she said. "Materially, paintings change, without a doubt. It's also very common for every Old Master in a museum to have significant work done on it."[21]

Paintings are living, organic objects, she explained. Pigments fade, some more than others; colors flake off. Some paintings were cut to fit a certain wall or an existing frame. In other paintings, sections were painted over to remove offensive elements; for example, fig leaves decorously hiding classical breasts or a penis. Almost all masterpieces in museums have been cleaned; and if it took place in the 1940s or 1950s, the cleaning might actually have stripped off or flattened the top layer of paint. The restorer might also have painted in missing portions and hidden the additions.

Art conservators like Lignelli are much gentler and less intrusive than their predecessors, combining their experience and expertise with the latest in detection technology. Before beginning the conservation, the canvas is X-rayed so that the conservator can see the layers of paint under the top layer. Sometimes, the remains of a former painting appear, or the outline of an arm or

other appendage, or an incision in the ground or primer marking the outlines of a body. The artist's brushstrokes appear in microscopic detail: the exact place where a stroke began and ended; the velocity with which the paint was applied; different sizes and types of brushes; different application techniques; different pigments, canvas weaves, methods of affixing the canvas to the frame, the frames themselves.

Some paintings are so damaged that only an art conservator could love them. Lignelli led me to the lovely *Enthroned Madonna and Child*, a grand fourteenth-century altarpiece by Italian painter Pietro Lorenzetti. She then showed me a photo of the painting before it was restored, a ghost of the one before me. Teresa Lignelli had almost magically brought it back to its original splendor. It took more than a year.

She began by studying the X-radiograph and seeing other paintings by the same artist. This information was used to determine the goal of restoration, which in this case was to conserve the entire painting and focus on the parts of it that enhanced its original purpose as devotional art. A nineteenth-century restoration and seven layers of varnish were removed. Then, using a technique called *rigatino*, in which miniscule lines are painted in, Lignelli started in smaller parts, then moved to larger areas, filling them in with the tiniest of brushes. The restoration was thoroughly documented and the paint was laid on top of a layer of varnish so that conservators could detect the changes and choose to remove them in the future. The *rigatino* is invisible to anyone viewing *Enthroned Madonna and Child* from the distance of an average viewer but immediately recognizable to those in the know.

"The aim of any restoration is to draw attention to the better-preserved parts of the picture. It's not to hide damage," Lignelli explained. Her meticulous *rigatino* point the viewer to the sections that survived the years, her work in service to the artist, not the viewer.

Is *The Polish Rider* two-thirds Rembrandt because one-third of the painting disappeared over time? Is it because someone other than Rembrandt painted a third of it? Is it a combination of the two?

While it was unusual, though not unprecedented, for Rembrandt to paint a man on a horse, neither the method of its creation nor its subsequent damage makes it unique. Dutch Masters seldom painted Dutch masterpieces on their own; their apprentices had their hands in it, too. Few paintings by Rembrandt or his contemporaries remain pristine. Many show the accidents, attacks, and well-intentioned but ultimately harmful intrusions visited on them over the centuries. Most early artworks we see in museums are only a fraction of what they started out to be. We might find this surprising, but the art world takes it as a matter of course.

And it's not only Rembrandt whose artwork was identified as his, then someone else's, then his again. Every important artist's work has been attributed, deattributed, and reattributed. Some reattribution is the product of new scholarship and scientific tests. A wildly voracious art market drives some of it, especially for the great masters. In the twenty-first century, *The Polish Rider* would probably bring hundreds of millions of dollars, many multiples of what Frick paid in 1911. In the fall of 2017, a painting titled *Salvator Mundi* that some experts attributed to Leonardo da Vinci was sold at auction for an unprecedented $450 million. Other experts whisper it may not be by da Vinci but by an apprentice; and, even if it were by da Vinci, so little of the original had survived that it would be virtually impossible to re-create his touch.

Which gets back to my original question: Would Rembrandt recognize *The Polish Rider* if he time-traveled from the past? I think he would, as a father would recognize a long-lost and much-changed child. He might remember how perilous the times were when he rushed to finish it before his wealthy Polish clients left Amsterdam. He might frown when he thinks about how his apprentices mucked up the background he so carefully sketched in. He might be appalled by the damage it suffered. He might be proud of this painting or he might hate it. But either way, he would know that, despite the mucky background, cuts, holes, repairs, awkward repainting, overzealous cleaning, and multiple layers of varnish, his work lives on.

Whether or not Rembrandt liked the painting or whether he would agree it's "Rembrandt lite" is not really the point. What's relevant is that *The Polish Rider* continues to spark controversy, admiration, and wonder. And that's the true mark of his genius.

Chapter Five

"Not Right"

It's a new chair made from salvaged wood or an old desk with new legs and feet. It's a stately mahogany Chippendale high chest topped with a nineteenth-century pediment that's not up to the quality of the rest of the piece. It's a Rhode Island bookcase with wood where glass ought to be or glass where wood once was. It's a tall case clock with a replaced face, replaced feet, and clockworks that its alleged clockmaker never constructed. You and I would call these antiques fakes; but we're not dealers, auctioneers, curators, or collectors. People who work in the field of decorative arts seldom use the word "fake." They use a more decorous phrase: "not right."

All of these not right antiques are "brown furniture," the term used in the decorative arts for wooden antiques that are finished but not painted. If you're interested in fake American antiques, brown furniture is a good place to start. There are many different objects, including clocks, chairs, tables, chests of drawers, bookcases, and secretaries—made from many different types of wood. There are many places to buy them—flea markets, country antique shops, tony galleries, auctions, and more—and many museums and historic houses in which to see them. Brown furniture is especially amenable to reproductions, replicas, and revivals, as well as "out of period" additions, enhancements, marriages, and other types of alterations of various magnitude and veracity.

I first became interested in not right brown furniture soon after becoming director of Philadelphia's history museum, then called the Atwater Kent Museum. One of the curators told me that a couple of years before I arrived some local antique dealers had been convicted of price fixing. That surprised me: until then, I imagined the professional ethics of antique dealers were as pristine as the objects they sold. Now I wondered: could some of their furniture

also be less than pristine? How did anyone tell the right from the not right? Did the degree of not rightness affect price? Did museums have different standards of perfection than private collectors did? How about dealers and auction houses: What did they do when they found that a piece of furniture had been altered?

With these questions in mind, I set out to see this particular slice of decorative arts through the lens of those who buy, sell, and study brown furniture. I was surprised to find there is much that's not right about the decorative arts.

It is important to note that it is not illegal or even unethical to sell brown furniture with replaced parts, new additions, fresh finishes, or even "marriages," in which parts different pieces are combined into one. There is also nothing intrinsically wrong with selling new versions of old items. Dealers sell, and customers buy, such items all the time. The problem comes when the seller sets out to dupe the buyer. If you buy an antique chair and the dealer says it's entirely original—that the legs are right, the finials and carvings are original—and that turns out not to be the case—say, the carving or legs have been added—it's a fake. If you buy a settee thinking it was made circa 1750, and it was actually made circa 1880 or 1980, then it is a fake, and the seller has committed fraud, and rather than calling it a "fake," those in the field use "not right" instead.

There is an abundance of phony Americana. How did it originate? Many believe it all began in a reconstructed Colonial house at the Centennial Exposition of 1876 in Philadelphia.[1] This, the first official World's Fair to take place in America, celebrated the one-hundredth anniversary of the Declaration of Independence in the city in which the nation was born. Ten million visitors, almost a quarter of the U.S. population, as well as multiple dignitaries, foreign and domestic, visited the Exposition to experience the wonders of the world and the best of American agriculture, industry, and ingenuity displayed in some two hundred specially constructed buildings on 285 acres of parkland.[2] Among the twenty-six buildings erected by different states, the New Jersey pavilion stood out. It was a reconstruction of the Ford Mansion, where General George Washington made his headquarters during the winter of 1779–1780, complete with a Colonial kitchen, period furniture, and costumed guides. Visitors were wowed.

In the celebratory setting of the Exposition, everyday items were transformed into cherished icons, their native simplicity suddenly more vibrant and appealing than the effete European styles from which they had descended. The Centennial Exposition opened Americans' eyes to the stylishness of Americana.

This patriotic epiphany soon moved beyond Philadelphia and across the country. Americans rediscovered abandoned farmsteads, city homes, and formerly elegant estates, purchased them for a song, and brought them back to life. Real estate developers built contemporary takes on hundred-year-old buildings with red brick facades and wainscoted parlors. Colonial Revival remains America's most ubiquitous residential style. It's everywhere, from modest developments to expansive "McMansions," some built on farmland where real Colonial farmsteads once stood.

Colonial-style homes called for Colonial-era furniture. The authentic pieces came from families who had used them for generations. The replicas came from furniture makers. The best of them were craftsmen who employed the same tools, techniques, and materials as the makers of originals, and because of this, the difference between originals and quality replicas are especially difficult to detect. By the 1920s and 1930s, when Henry Frances du Pont began buying brown furniture for his baronial mansion Winterthur and John D. Rockefeller was purchasing for Colonial Williamsburg, his re-created village, most of the acquisitions were from the seventeenth and eighteenth centuries, but some were later replicas.

Odessa, Delaware is so tiny that I drove through it three times before realizing I was there. It's little more than a few houses strung along both sides of a sleepy Main Street. I had come to historic Odessa to meet Philip Zimmerman, and with him, to look at a not right clock and a genuine tall case clock, both allegedly made by the same Colonial clockmaker, Duncan Beard. Zimmerman and I scheduled an entire day in Delaware exploring fakes: first at historic Odessa, then at Zimmerman's former employer, Winterthur Museum, which had recently opened an exhibit on the subject.

Philip Zimmerman does not look like a crusader on a mission to ferret out fake furniture. He actually looks like a museum director, which he formerly was, or a teacher and authentication consultant, which he currently is. Zimmerman is generally attired in the tweeds and blue blazers of the born-to-the-manor preppy and those who work with and for them. But introduce the subject of fake antiques and his erudite demeanor fires into righteous indignation. Zimmerman hates not right brown furniture with a fervor that many devote to politics these days, and for somewhat the same reason. It wounds him personally when museums intentionally deceive.

Perhaps his peculiar passion is, in part, a function of his background. Most decorative arts experts in Zimmerman's baby boomer generation come from families with long lineages and heirloom-filled houses. Not Philip Zimmerman: His family arrived in America much later, and his interest in collecting was uniquely his own. It began at age fifteen, when he spent the profits from

paper routes and other odd jobs to buy an 1884 Springfield long rifle. "I wasn't old enough to buy a gun," he told me, "so my mother agreed to buy it for me." This was not a normal action for a teenager.

By the time he entered Yale University, Zimmerman had the beginnings of an antique firearms collection. In college, he showed little interest in history, art history, or other subjects conventionally required for fledgling decorative arts curators, until he signed up for a part-time job photographing Yale's American furniture collection. His college job eventually led to a master's degree earned at Winterthur, one of the nation's premiere collections of early American antiques, and to a PhD from Boston University.

The field appealed to Zimmerman not only for the history and aesthetics, but also for the craftsmanship. Decorative arts allowed him to use skills from his teenage years, like mechanical know-how acquired in his high school shop class, and his eye for telling detail, gained from building his antique firearms collection. After his schooling, Zimmerman eventually returned to Winterthur and served for six years as director of its museum collections division. Now he works as an independent consultant and teacher, professions that suit his independent nature. His book on Delaware clocks is generally considered the best in the field. As someone who stands outside museums but understands how they tick, Zimmerman is free to express his refreshingly candid opinions.

I arrived soon after Historic Odessa's visitors center opened, and was greeted by a volunteer who directed me to an exhibit about the town. In its heyday, Odessa wasn't Odessa: It was a grain port town called Cantwell's Bridge—or Appoquinimink, after the Appoquinimink River that borders one side of town. The town was a flourishing grain port starting in the mid-eighteenth century , but it lost its prominence when farmers began to use the Chesapeake & Delaware Canal and the railroad to transport their products to market. In the mid-1850s, Cantwell's Bridge civic leaders decided to name the town after the famed Russian grain port of Odessa, but that failed to stop its decline. Sometimes what's bad for the economy can be good for historic preservation.

In the late 1930s, Odessa's charm as a kind of American Brigadoon gained some permanence through the actions of one man, H. Rodney Sharp. He had begun his career as a teacher in Odessa, and he fell in love with the quiet little village. Later, after a successful career at DuPont and a fortunate marriage to a du Pont daughter, Sharp decided to buy and renovate historic properties there. Over the next nineteen years, he restored nineteen properties, several of which his family eventually donated to Winterthur, starting in 1958. Winterthur managed the properties until 2003, and two years later, it transferred ownership to the newly created Historic Odessa Foundation.

The homes came with about thirty acres of outbuildings and gardens and a wealth of fine regional furniture, artworks, silver, and other rare antiques, many from the original families. Today the Historic Odessa Foundation operates with a small and dedicated corps of volunteers, student interns, part-time staff, and two full-time professionals, including the foundation's executive director, Deborah Buckson.

A seven-foot-tall walnut clock owned by the Historic Odessa Foundation stood near the entrance to the visitor center, and while waiting for Zimmerman, I looked it over. Pediment: wood with scrolls and columns. Case: walnut, with a fancier figured piece of walnut glued to the front. Dial: brass, with engraved numerals. Small plate, engraved, "Duncan Beard Appoquinimink." Hypothesis: Genuine Duncan Beard clock . . . but what did I know? I was not an aficionado of tall case clocks, let alone clocks by Colonial Delaware's most accomplished clockmaker (see Figure 5.1).

Tall case clocks, also called grandfather clocks, were the Ferraris of their time, objects of luxury, mechanical perfection, and style that signaled the owner's refined taste and expansive income. They were developed in Europe over a couple of centuries and arrived in America beginning in the mid-seventeenth century, at a time when Americans needed these objects to add structure to their lives. Clocks paced out the day and allowed their owners to track their activity and coordinate schedules. Clocks were also status symbols, customized to the aspirations of their owners. Anyone who made it in early America soon looked for somebody to make him a tall case clock.

Clocks are complicated objects, equally science and art. The science is inside, in the movement, gears, weights, and pendulums that propel the hands on the dial and ring the bell. The art is on the outside, in the engraved or painted dial, moon phase, and wooden cabinetry, each part with its own name: bonnet, pediment, waist, base, feet. In spite of their grandeur, tall case clocks are surprisingly fragile, since each of their many parts can be damaged. Sunlight fades the finish; a vacuum cleaner hits the feet; a cat scratches the case; the lady of the house decides to relocate the piece across the room, the heavy weight of the pendulum tips the clock forward, and it crashes to the floor. Today, the vast majority of tall case clocks—indeed, of all brown furniture—have replacements or alterations. Almost nothing survives the centuries unscathed.

Philip Zimmerman soon joined me, prepared to demonstrate how to authenticate a clock. He walked seven feet back from the clock near the front door, stopped, frowned, and folded his arms. "The first thing I do is to take in the whole, get a kind of impressionistic information and note possible anomalies," he said. In this case, he noted that the bonnet, pediment, case, and front panel were made of different grains and colors of walnut. He then

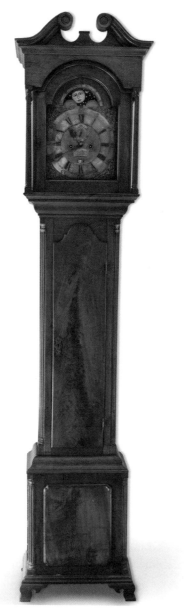

Figure 5.1. "Not right" tall clock in the style of Duncan Beard.
Historic Odessa Foundation

went in close. "You see this tiny little line near the waist?" he asked. "You ask yourself: what is this line for? It has no purpose unless this molding is a replacement, and the original molding came to this line." He looked closer: "Hmmm. The shape of the molding is out of step with the shape on other eighteenth-century Delaware clocks."[3]

All suspicious, I said to myself. I had noticed none of it.

"This looks like an eighteenth-century Delaware clock made by Duncan Beard," Zimmerman concluded. "The movement inside dates from the eighteenth century, but that's as far as it goes." The suspiciously different woods on the bonnet, pediment, case, and case panel strongly suggested that each element had been added to the original. The style of the pediment dated to some thirty years after the rest of the clock. The engraving on the face and moon dial was rougher and more rudimentary than Duncan Beard's graceful flourishes. But the most telling anomaly was the small metal nameplate on the dial. None of the clocks known to be by Duncan Beard has a plaque with his signature. Instead, all of them have his signature engraved on a brass arch above the moon dial.

Looking at the clock through this clock connoisseur's trained eye, I could see that this clock was wrong, wrong, wrong. In fact, the extent of alteration was much greater than a clock with replaced feet and a too-shiny finish, which may not be right but is considerably less wrong than this one. This clock was wrong in so many ways that it seemed to have been deliberately faked.

I was about to ask Philip Zimmerman why the foundation owned an ersatz Duncan Beard clock when Deborah Buckson arrived. A former museum educator who took on responsibility for Historic Odessa soon after it was founded, she has doggedly spearheaded the restoration of its structures, reclamation of its landscape, and expansion of its collection, one piece at a time, assuring that nothing gets in except objects and documents from Odessa, Delaware, or the six families that once occupied its houses. "Many people think we're a historical society that accepts anything, but we're not; we're a museum," she told me. The caliber of professionalism evident at the Historic Odessa Foundation raises it above most of its peers. "It's because of our Winterthur connection," she explained modestly.[4]

Museum directors are always on the lookout for rare and alluring objects that fit their mission; but when the mission is as narrow as Historic Odessa's, such objects are especially difficult to find. So, when one of the local families offered Buckson an original Duncan Beard clock, she immediately jumped at it. The family's remaining elder had moved into a nursing home in another state and had given the clock to an elderly friend for safekeeping; however, when the friend also moved into a nursing home, he called the woman's

daughters and asked them to pick up the clock. The daughters called Buckson and offered to donate the piece.

"I'd never seen the clock, but I knew it was local, so I agreed to pick it up," Buckson remembered. "But when I saw it for the first time, it didn't look quite right." Deborah Buckson had seen many Duncan Beards, and none had the metal plaque that this one had. She asked Philip Zimmerman to authenticate the piece.

Why would Buckson accept an antique clock she believed wasn't right? Weren't museums always looking to shed fakes, not acquire them? "Well, it can get tricky," she explained. "This is a very small, close-knit town and the family has long roots here. The family purchased the clock decades before from a local antique dealer whom everyone bought from. There are plenty of things that would fit into our collections in this community, and we don't want to offend in our efforts. We would never put this clock back on the market, since collectors might believe it's genuine because we owned it. Isn't it better to keep it and use it as an instructional tool?"

That made sense. Acquire the clock, because turning it away might discourage future donations. Label it as an alleged Duncan Beard rather than an authentic one. Use it to point out the difference between the two.

Now that we had looked at a phony Duncan Beard, it was time to look at an authentic one, on loan from Winterthur. Led by a chatty volunteer, Philip Zimmerman and I crossed Main Street, climbed some stone steps, and entered the Corbit-Sharp House. This National Historic Landmark is one of the nation's preeminent American Colonial homes, built circa 1774 by William Corbit, a farmer's son who became wealthy from a successful tanning business. Corbit filled his stylish new home with furniture from John Janvier, a local cabinetmaker. In the 1930s Rodney Sharp restored and modernized the house a bit and moved in, which is why it's now called the Corbit-Sharp House.

Once inside, Zimmerman and I admired the lovely parlor and examined the wallpaper and furniture: despite their age of two hundred–plus years, they look surprisingly new. We walked into the dining room and stopped in front of Duncan Beard's tall walnut case clock from the mid-1790s. As the clockmaker, Beard would have manufactured the movement and dial, ordered the case from John Janvier, and assembled everything. Then he would have engraved his signature on a brass band above the moon arch, verifying that it met his standards. One of the best-known Colonial-era Delaware clocks, it also has a distinctive provenance, having stood in the same spot in the same house since the day it was delivered. Zimmerman calls that "almost stunning" (see Figure 5.2).

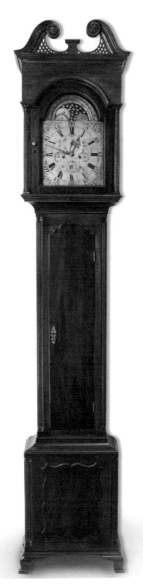

Figure 5.2. Tall clock by Duncan Beard, 1770–1785, Odessa, Delaware, mahogany, pine, glass, brass, silver, gold, tulip poplar, yellow pine, and iron. Gift of Mrs. Earl R. Crowe.
Winterthur Museum Collection on loan to the Historic Odessa Foundation, 1973-0119

A fake Duncan Beard clock sits across the street from an authentic Duncan Beard clock in a tiny village frozen in time. Standing in front of the original, the artistry of the genuine masterpiece came through: the lush grain of the walnut cabinet, the curved flourishes on the open-worked pediment, the lustrous silvered brass dial engraved with floral motifs, the delicious painting of a moon and star under the brass arch inscribed, "Duncan Beard Appoquinimink." Here was nine feet of clock, masterfully complementing the high-ceilinged dining room, a tribute to its wealthy, sophisticated owner. Corbit ordered it some 230 years ago, and it's been in the same place ever since.

When a private collector purchases something that's not right, he or she may be angry and embarrassed and demand their money back. It's more serious when a museum makes this kind of mistake. Museums are supposed to know their stuff. Nevertheless, every museum with Early American furniture owns some pieces that are not right.

In 1970, the Henry Ford Museum in Dearborn, Michigan, spent $7,000—or $45,000 in today's dollars—for what they thought was a seventeenth-century "Brewster" chair, a rare but well-known type of armchair with turned arms, legs, back, and spindles named for the Brewster family that donated Elder Brewster's original chair to Pilgrim Hall in Plymouth, Massachusetts. But Armand LaMontagne, a wood carver and part-time builder of homes and furniture, had actually made the chair some three hundred years after the *Mayflower*. LaMontagne and a friend had concocted the hoax after visiting a museum in Hartford, Connecticut. An official had overheard them criticizing the repair and refinish jobs on some of the furniture and asked them to leave.[5] That insult spurred LaMontagne to show he could stump the experts. He created an imitation "Brewster" chair. He gorged, scorched, and smoked it, sprinkled it with household dust, and covered everything over with the traditional wax finish. LaMontagne's helpful neighbor, who was in on the hoax, sold the chair to an antique picker, who sold it to a dealer. It eventually ended up at the Henry Ford Museum.

Some seven years after the purchase, rumors began circulating that the "Brewster" chair was not right. The museum refused to believe the rumors until LaMontagne himself revealed the holes in the leg posts, which he had deliberately drilled with a modern drill bit. An X-ray verified that the chair was a fake. Other museums would have buried the embarrassing incident, along with the chair, in the basement. Instead, the Henry Ford Museum, in a stroke of promotional genus, placed it on display. The public loved the fake: everyone enjoys it when someone in authority is cut down to size.

Polly and Stanley Stone of Fox Point, Wisconsin, were the victims of repeated frauds, many perpetrated by the same dealer.[6] The Stones began collecting brown furniture in 1946, and within four years had acquired twenty-

eight pieces. They then retained the services of a prominent Boston architect to design an elegant Colonial Revival home, named it Chipstone, and moved themselves and their collections into it. Later, it was discovered that some pieces were spurious. Among them was one chair constructed from parts of a number of period chairs, and a new armchair sold as an important antique; it followed the design and carved details found on chairs reputedly used by President George Washington during his time in Philadelphia.

By the time these fakes had been unmasked, Mr. Stone had died. Mrs. Stone could have stashed or sold the offending chairs, but instead she endowed the Chipstone Foundation to advance the field of decorative arts. Today the Chipstone Foundation annually publishes the scholarly journals *American Furniture* and *Ceramics in America* and supports professional education, public lectures, and exhibits. In 2002 the venerable Milwaukee Art Museum staged "Furniture Fakes from the Chipstone Collection."

In 1929, Henry du Pont purchased a stately eighteenth-century Chippendale mahogany chest of drawers topped with a nineteenth-century ornamental cartouche, for $44,000—or $634,000 in today's dollars—and proudly installed it in Winterthur's principal reception room. He later removed the nineteenth-century cartouche and replaced it with a more authentic-looking twentieth-century one. Later, other parts were restored. The chest had long been celebrated as an example of exceptional American cabinetry. Now, the Chippendale chest raises a provocative question: Did replacing the out-of-period nineteenth-century cartouche with a more accurate-looking but equally out-of-period twentieth-century cartouche add or detract from the authenticity of the piece?[7]

The Henry Ford Museum, the Stones, and Henry du Pont were neither incautious, imprudent, nor naive. They and their advisors simply lacked knowledge that is now available. Information about brown furniture has grown exponentially in recent years—from master's theses, doctoral dissertations, scholarly publications, and exhibitions. Science has also played an increasingly important role: since the 1960s Winterthur has used quantitative X-ray fluorescence, and ten years later it added a wood analyst to its staff. The X-rays and chemical analyses that enable Renaissance curators to detect the master's brushstroke, and Egyptian archaeologists to diagnose the disease that killed King Tut, are also used in the decorative arts.

But scientific advances and scholarly publications can only go so far in detecting fakes, and heated disputes continue. One expert declares an important eighteenth-century chair a fake. The piece is sold at Sotheby's as out-of-period and purchased by a distinguished museum. The museum sends the chair through a battery of laboratory tests and discovers it's from the eighteenth century after all. Or someone calls a chair fake because it its crest

rail was replaced, an assertion disputed by someone else because crest rails are often replaced and anyway no one can say whether the replacement was revealed to the customer who purchased it. A pie-top table worth thousands of dollars one day can be almost worthless the next, based on little more than the number and shape of its nail holes.

The art and science of furniture authentication came up during tea with Philip Zimmerman and his colleague Joshua Lane, Winterthur's curator of furniture. We had just toured the museum's special exhibit, "Treasures on Trial: The Art and Science of Detecting Fakes," which invited the public to test their eye against the experts. We saw a real and a knock-off Coco Chanel suit, a counterfeit Babe Ruth baseball glove, a bottle of 1787 wine that Thomas Jefferson allegedly purchased from a Parisian wine merchant, and a charming mid-nineteenth-century "primitive" painting by the twentieth-century artist Robert Lawrence Trotter, who spent ten months in jail for fraud. From the exhibit, I learned two important lessons: first, that anything valuable will be faked; and second, unless you see a real Chanel suit next to a not right Chanel suit, you could easily buy the wrong Chanel suit.

Sitting in Winterthur's sunny cafeteria, Zimmerman and Lane reminisced about Winterthur's not right brown furniture. There was the "wonderful little work table by Charles-Honore Lannuier," an important French-born cabinet-maker that some experts said was wrong and others said was fine. There was the questionable Connecticut three-drawer chest with carved shells on the top, once exiled from the collection, then reinstated when the signature of its obscure cabinetmaker was discovered. Mistakes continue to show up from time to time. Lane doesn't think this is necessarily bad.[8]

"Museums have long been viewed as the go-to source for the most accurate information," Lane explained, "so they would say, 'this is worthy' in an authoritative way. But my hope is that Winterthur, and the museum field in general, can be more flexible, can enter into conversations, rather than assert knowledge. I think we should be a place where people can come with questions about furniture and we will say, 'Well, this is what we know, but here's countervailing information, and maybe this is an area it's just not wise to take a definitive stand until more research is done.'"

I thought about all of this as I drove home: how antiques can be discredited and later resurrected, and how an authority's assertions can trump demonstrable evidence, especially if the authority is a staff member at an important museum. I also realized I had previously seen one of the treasures in the Winterthur exhibit at Joan Johnson's home. It was a *fraktur*, a highly artistic and elaborately illuminated folk art document penned and decorated by early Pennsylvania German immigrants. I gave her a call and was soon sitting in her sunny kitchen.

Johnson is a consummate collector who, with her late husband Victor, began purchasing *frakturs* and other early American furniture, paintings, and folk art fifty years ago. Gradually trading up to museum-quality objects, they eventually amassed a collection that fills the penthouse Johnson designed to replicate the Colonial-era core of their former suburban home. The *frakturs* are now pledged to the Philadelphia Museum of Art, where she is a trustee. Tall, lean, and elegant, with animated blue eyes and a crown of white hair, Johnson is in constant motion. Over lunch at her antique country table, I asked the high-speed octogenarian to explain the different roles played by dealers, auction houses, and antique shows. We started with dealers.

Johnson has encountered many dealers over the years, and will only buy from reputable dealers, relying on other collectors and trustworthy dealers to point out the suspicious ones. "The dealers I trust will say, 'Joan, this is one of the finest examples I've seen. But I want you to know it has a replaced back, or the feet are finished out, or whatever is the matter.' I will still buy it if I love it, though I expect to pay a price that reflects the fact that it has mistakes."[9]

Auction houses follow a different model. They represent the consigner, not the buyer; so, it's buyer beware. The auction business has changed dramatically over the years. In earlier times, Johnson was often the only nonprofessional in the audience; but since the 1980s, auctions have been filled with collectors, many of whom are as well schooled as the professionals in their fields of collecting. Auction houses are not legally required to buy back items if they are found to be not right, but some occasionally bend the rules and will reluctantly refund money and take a piece back in order to maintain their reputations and foster goodwill with important customers.

Finally, Johnson and I discussed antique shows. She is something of an expert on the subject, having served on the board of the Philadelphia Antiques Show for five decades. To illustrate the challenges these shows present, she told me about a secretary "with great lines" but a large rat hole in the back panel. Johnson first saw it at a country antique shop. Later, she discovered a very similar secretary at the Winter Antiques Show in Manhattan; but the Manhattan piece sported two eagles, a lustrous finish—and the same rat hole in the rear. Here was irrefutable evidence the secretary had been "improved" to inflate its value. Did the dealer know it was not right? Did he improve the piece?

Manhattan's Winter Antiques Show is considered one of the nation's best. It has a committee of distinguished antique dealers who vet every piece in the show. That included the secretary in question. How had they been duped? It is obvious to Joan Johnson. No committee of experts, however distinguished, will devote the time and stamina needed for the adequate vetting of each

of the hundreds, maybe thousands of items on offer at the Winter Antiques Show. Nor could any committee include experts in all of the many genres of art and decorative arts. At Johnson's insistence, there is no such committee for the Philadelphia Antiques Show. Such committees may give the mistaken impression that every object in the show is indisputably genuine.

While I was navigating the world of decorative arts, Philip Zimmerman continued to send me articles about fakes. Soon after visiting Joan Johnson, he pointed me to an especially egregious example in the online edition of *Maine Antique Digest*, a respected weekly that covers the antiques business well beyond Maine.

In January 2015, on the opening night of Manhattan's Winter Antiques Show, a curator and some trustees of a museum in Hartford, Connecticut, the Wadsworth Atheneum, fell in love with a Civil War memorial secretary offered by Allan Katz, one of the most reputable dealers in the business.[10] Many such objects were made after the Civil War to commemorate a person, place, or event. This piece was called the Bingham family secretary. According to family lore, some surviving members of Connecticut's Sixteenth Infantry had made the secretary in 1876 to honor Wells Bingham and his brother John, the latter having died during the battle of Antietam in September 1862. The eight-foot-tall secretary was made of walnut, oak, and maple, bedecked with inlaid patriotic mottos and emblems and crowned by a clock topped with a carved American eagle.

Seduced by its patriotic iconography and poignant backstory, the Wadsworth's leadership decided on the spot to buy the piece, priced at $375,000.[11] It was soon displayed in the Atheneum's American Decorative Arts galleries and featured on the museum's website as a symbol of Connecticut soldiers' heroism.[12]

As it turned out, the piece was too good to be true. It was an especially beautiful and skillfully constructed fake by Harold Gordon, a Massachusetts antiques dealer and craftsman. He had embellished not only the piece, but also the story behind it. Gordon had taken an ordinary secretary and, over a couple of years, carved and crafted every piece of its decoration. He then added the patina of age, inside and out. To enhance the appeal of the secretary, he invented the story that the piece honored an actual deceased member of an actual Connecticut Civil War troop. Gordon then sold the made-up Civil War memorial chest and its made-up backstory to Allan Katz.

When the *Maine Antique Digest* unmasked the fraud, Gordon confessed to the crime, saying he was desperate for cash. He expressed remorse and apologized to Allan Katz. Gordon didn't have much choice, since the *Digest* story included two photographs, both taken in his living room. One image showed

an ordinary mid-nineteenth-century secretary, the kind you might find in a country flea market. The other depicted the same secretary in the same location, but now converted into a stunning Civil War memorial. A month later, the *New York Times* published a story with the headline, "I Cheated, says Woodworker Who Fooled the Antiques Expert."[13] In it, Harold Gordon reiterated his remorse. Allan Katz confessed he had been duped, and offered to buy back the offending item from the Wadsworth Athenaeum, which he later did. The Atheneum told the *Times* it had been alerted to a potential problem by an anonymous source in late 2016, that it had investigated, and that by late 2017 had removed the object from public view.

Most readers of the *Digest* and *Times* would think the museum acted expeditiously to root out the fraud. Not according to some in the trade, who choose to remain anonymous. They say they repeatedly called and emailed the "before" photo to the Wadsworth's leadership almost eighteen months before the Atheneum took the secretary off display. They question the Wadsworth curator's statement to *Maine Antique Digest* that the museum could not remove the piece from the floor without consulting scientists, conservators, and other experts. They see this as stonewalling, arguing that a professionally trained curator should have been able to spot the fake without the aid of outside experts.

One might sympathize with a museum that was so thoroughly duped. After all, the patriotic secretary was sold by one of the nation's most respected antiques dealers at one of the nation's most respected antiques shows. Moreover, a panel of antiques dealers vetted the secretary, as they do with every item in Manhattan's Winter Antiques Show. The piece was rare and beautiful, with a seemingly airtight provenance. There were rumors that other potential buyers were lurking around. There was a need to act fast, or this Connecticut treasure might be gone. On the other hand, there are well-known procedures to guard against such enthusiasm: curators to verify the authenticity of objects and research provenance, acquisition committees to determine whether to invest in them, and boards to make the final decision. Some argue that even a capable curator and board of trustees could find themselves deceived in the absence of indisputable photographic evidence of the type that turned up in the Wadsworth case; others point out that Civil War artifacts are known to be especially dicey and demand special diligence.

In January 2019, Harold Gordon pleaded guilty in US District Court in Connecticut to one count of wire fraud, which carries a maximum term of imprisonment of twenty years. Although the Wadsworth Athenaeum may have suffered some embarrassment, Gordon will pay for his crime.

On a sunny April day, I drove back to Winterthur to tag along with students in a George Washington University graduate class on connoisseurship. The

professor, Oscar Fitzgerald, organized this field trip each year to show how connoisseurs develop an eye for brown furniture. The students, aged mid-twenties to mideighties, included a former curator who wanted to open her own antiques shop, a perennial student meandering toward another degree, a couple of people training for curatorial positions in historical house museums, and a former accountant who had gleefully left spreadsheets behind for a career in decorative arts. As we gathered around Fitzgerald, he laid out our mission. We were at Winterthur, he said, to see some excellent brown furniture and some not right brown furniture, and to compare the two. "You have to look and look and look and look, that's the secret, and eventually you get a sense of what's right and what's not," he said.

Curator Joshua Lane started things off by leading us into a gallery devoted to a survey of American furniture. He stepped up on a platform next to an "exuberant" desk and bookcase from the mid-eighteenth century with extensive floral and eagle-head inlays. It was made by Nathan Lombard, a rural craftsman with a love of detail and the endless patience to carve tiny channels into the cherry wood facade, cut up tiny slivers of light and dark wood, and insert them into the channels he had made. Lane showed us how to distinguish cherry wood from mahogany; the two woods can be confused because they are of similar shades of red. He explained that the hidden parts of a piece, like the dovetailing and secondary woods inside drawers, can reveal how a piece of furniture was made, who made it, and where it came from. After almost an hour spent with a single desk and bookcase, he hadn't finished pointing out all he knew, but said we had to move on.

In the afternoon, Donald Fennimore, a legendary former curator, enthralled the class by showing how a classic chair design was employed in the eighteenth century, replicated in the nineteenth century, and reinterpreted in the twentieth. The chair in question, from the early nineteenth century, was based on an ancient Greek chair that survives today only as an image on Greek pottery. You can't really call any of the reinterpretations "fakes," since they were not made with an intention to deceive.

The day ended with a guided tour of Winterthur's 175 period rooms, which are filled with thousands of exceptional objects, the cream of Americana, set perfectly in many different types of settings. When the docent was asked to point out fakes in the period rooms, the only one that came to her mind was a less rare nineteenth-century version of a more rare eighteenth-century chair. The other objects that aren't right are kept in the study collection and used to help students train their eye.

The following week, I received a quick lesson in valuation when Joan Johnson took me to Freeman's auction house to preview its annual auction of American furniture, folk, and decorative arts. Freeman's is the oldest continu-

ously operating auction house in the country and, for anyone interested in old stuff, a beloved institution.

"This is good, this is good, these are good pieces but the finish is all wrong and the hinges have been replaced," Johnson said as she led me around the room, then up to a Chippendale walnut tall case clock. The catalogue noted that it was made in Philadelphia by the clockmaker John Wood at around the time when Duncan Beard was crafting his clocks in Odessa, Delaware. Freemans set the estimate at four to eight thousand dollars, which Johnson characterized as purposely low, since auction houses often undervalue pieces in order to attract as many buyers as possible to the auction itself and to spark excitement and perhaps a bidding war. The condition report noted that the piece had been drilled with holes, renailed, refinished, stained inside and out, scuffed, and had its glass replaced. Despite all these alterations, the clock sold at auction for fifteen thousand dollars.

How could a tall case clock with so much damage and alteration be worth so much? For one thing, the clockmaker was well known and the provenance stellar. Accompanying the clock was a handwritten note, with typed transcript, tracing it through seven generations in the same family. These documents trumped its condition, which was to be expected in a clock of its age.[14] It wasn't a Winterthur-caliber clock, with a value that could run into the hundreds of thousands of dollars, but it was good enough to warrant a substantial investment.

The field of decorative arts is a complex choreography of museums, private collectors, dealers, auction houses, and antiques shows. Sometimes a collector will buy an item from one dealer, discover it's not right, and sell it to another dealer without revealing the not right elements. Sometimes a dealer will spin such a captivating tale around a piece of brown furniture that even a museum is duped. According to some insiders, museums continue to sell their mistakes back into the market, where the pieces might dupe another unwitting buyer, though less frequently than in the past. Cynics may see the field as singularly corrupt. Others may view it as another example of American enterprise.

Philip Zimmerman, the authenticity crusader, finds all of this disturbing. He bemoans what he calls the "myth of perfect survival":[15] the quest for pristine and perfect antiques untouched by the hand of time. In his article, "Truth or Consequences: Restoration of Winterthur's Van Pelt High Chest," he wrote, "Changes to an object that make it 'not right' need not be repugnant or deceitful to compromise its value as an genuine bearer of meaning, historical information, or aesthetic intention. Innocent but incorrect alterations, when they remain undetected and unreported, can have the same unsettling effect upon the viewer as they may represent a three-dimensional falsehood."

Zimmerman argues that individuals place a value on perfection because museums do. Because collectors and museums demand perfection, dealers are incentivized to satisfy the demand. Because virtually nothing survives the centuries intact, dealers replace broken parts with bits and pieces harvested from old wrecks, and cover dull surfaces with smooth and radiant finishes. Almost magically, second-rate chests of drawers become magnificent icons and ugly duckling tall case clocks become elegant Duncan Beards.

Is it possible, Zimmerman speculates, to turn the traditional value proposition on its head? Is it possible to value history and rarity more than beauty— in effect, to reimagine an object of beauty so that it is defined as an object that wears its age with dignity rather than as the brown furniture equivalent of a woman with a face-lift? Could the Wadsworth Atheneum's not right chest, the Ford Museum's not right "Brewster chair," and Historic Odessa Foundation's not right Duncan Beard clock be reinterpreted as examples of the market's pressure to achieve the unachievable and perpetuate the myth of perfect survival? In these times of false truth and fake history, transparency is a clarion call to which museums would do well to attend.

What I came to realize, much to my surprise, was that brown furniture that isn't right is actually treasure in disguise. Fakes allow museums to excavate cellars and attics for pieces that are rare and rich in provenance rather than traditionally beautiful. Not right brown furniture reveal how our ancestors actually lived with a desk, chair, or table; how it was damaged and repaired; and how it nevertheless continues to bring joy. They reassure people like you and me that our old chest of drawers can even be more beloved because it bears the scratchy autograph of a naughty eight-year-old.

What would it take for antiques to be prized more for the depth of their stories than the glitter of their surfaces? It might mean teaching connoisseurship students like those in Oscar Fitzgerald's class to prize the real damage over the ersatz enhancements. It might require museum boards to adhere to the acquisition policies and practices specified by professional societies. It might require museum curators to highlight alterations to brown furniture, much as archaeologists insert blank shards into ancient pottery in places where the original fragments are missing, and much as art restorers use distinctive brushstrokes to fill in missing sections of Renaissance paintings. Not right brown furniture also shines a light on the sometime murky world of dealers, auctioneers, curators, and collectors, a high-stakes, ever-changing game driven by guile, status, reputation, and money. One hopes that every student, curator, board member, and donor of every museum, of whatever size, will eventually attain the professional standards of the biggest and best, but that might take years.

In the meantime, I recommend investing in brown furniture—as long as you're cautious. Since the Great Recession of 2008, prices of early Americana have dropped by half or even more. While the very best continues to be pricey, there are remarkable bargains for those who do not mind a couple of dings, new finishes, or replacements. The buying public is currently more interested in midcentury modern, but fashions fade and taste is cyclical. Today, a handmade Colonial era table at Freeman's or an antique shop costs little more than a factory-made counterpart at IKEA. Go for the antique: it could become your grandchild's most valuable heirloom.

Chapter Six

Dreaming Nuremberg

There's a postcard in Nuremberg's municipal archives with an illustration from around 1830. It depicts tourists at the ancient ramparts of the Imperial Castle: a woman in a bell-shaped coat and feathered hat, a man with a spyglass to his eye, a tour guide next to him pointing out the sites. Nearby two children play with a dog, and a third stands looking over the city. We see them from the rear, as if we were standing behind them and sharing their view. The panorama of the city stretches below. Medieval streets, narrow and winding, are lined with row homes, their steep roofs pitched front to back and pierced with dormer windows. Two twin-towered churches rise high above the streetscape. Beyond lies the Pegnitz River, then the hinterlands (see Figure 6.1).

Some 180 years later, I am the tourist on the ramparts, my jeans and T-shirt considerably less elegant than my nineteenth-century counterpart. Now, my guide is Armin Glass, who specializes in tours of twentieth-century Nuremberg. From this perch the panorama looks remarkably similar to the postcard version: the same syncopated rooflines, winding streets, the twin towers of St. Sebald and other grand churches. Yet, if this bird's-eye view still evokes medieval Nuremberg, down below it's a different story. Much of what's there did not exist before 1950 (see Figure 6.2).

When I first visited old Nuremberg in the mid-2000s, I didn't realize how much of it was relatively new. The ancient stonewall circling the old city, the massive Imperial Castle on the cliff, the narrow streets, and the half-timbered houses all seemed untouched by time. How had Nuremberg escape the Allied attack that had leveled so many other German cities in the closing days of World War II? Why did this one survive? I found the answer in the Germanic National Museum, which was located near my hotel. Actually, the city within the medieval walls had not survived. In fact, it had been virtually destroyed

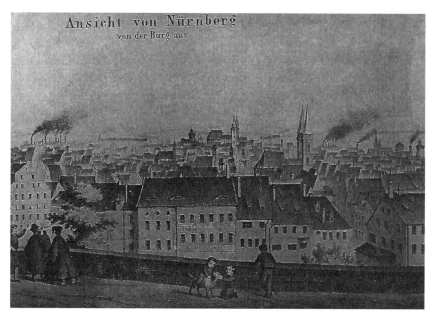

Figure 6.1. Old Nuremberg skyline, circa 1830.
Courtesy: Stadtarchiv Nuremberg, Germany

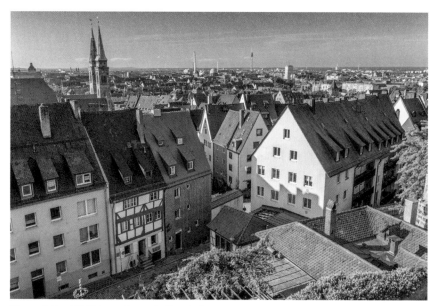

Figure 6.2. Old Nuremberg skyline today.
GettyImages Plus/Sean Pavone

by repeated Allied bombing, beginning in 1944 and climaxing on the night of January 2, 1945.

But if Nuremberg's medieval core had been demolished, what had led me to believe this reconstituted city was real? Did Nuremberg intentionally seek to create this impression, propagating a myth of a medieval city? How much of the old city had survived the war, and how much was postwar reconstruction? Frankfurt, Mainz, and other cities had built modern replicas to replace their ancient churches, public buildings, and homes. Was it the same in Nuremberg?

A few years ago, I returned to learn more and discovered that the real Nuremberg was much more complicated, a city shrouded in layers of myths created by successive generations. In the medieval period, it was the spiritual home of the Holy Roman Empire, known as the First Reich, or reign. In the nineteenth century, it was the poetical birthplace of German Romanticism. From 1923 to the outbreak of World War II, it was the mythical epicenter of the National Socialist Party that celebrated Adolf Hitler and the Third Reich. In 1945, when it hosted the Nuremberg Trials, the city became the aspirational focal point of a new world order. Most recently, it recast itself as the epicenter of human rights. Each of these dreams, each of these fantasies are embedded in the living city. Nuremberg is a city of rock and stone, wood, glass, and concrete. But as I came to realize, it is also a city of dreams, what historian Stephen Brockmann has called an "imaginary capital."[1] At critical moments, powerful people have imagined their own Nuremberg, projected their fantasies onto the material city, and shaped it to fit their dreams.

Nuremberg is not the only city of dreams; other places have also been fundamentally shaped to fit fantasies of how they ought to be. Take, for example, Colonial Williamsburg, which was a sleepy Virginia village before the great wealth of John D. Rockefeller Jr. transformed it into an American shrine. According to Robert Wilburn, former director of the Colonial Williamsburg Foundation, Rockefeller was motivated by a sentimental patriotism and nostalgia for what he thought was a better time. He envisioned Williamsburg as a celebration of America's greatness and a place to learn the lessons of the past. To a significant extent, he made this vision come true.[2]

Since the 1930s, visitors to Colonial Williamsburg have been able to imagine themselves living in its most illustrious era: when it was the capital of colonial Virginia, the wealthiest and most influential of the thirteen colonies. The illusion is made even more powerful because the occupants—at least those seen by visitors—wear what appears to be authentic period clothing, work at authentic crafts, and cook more or less authentic seventeenth- and eighteenth-century food. Some of them parade through the town's wide streets dressed as colonial soldiers. And the fantasy has continued to expand.

When Rockefeller first arrived in the 1920s, there were eighty-eight original buildings in the town. Now there are 602 structures, few of which actually date from colonial times and most of which are meticulously researched replicas. Williamsburg, in other words, began as a real place but was "colonialized" into something else. When I visited in the 1970s as a graduate student and again in the 1980s as a tourist, I knew it was built from an illusion. Nevertheless, I was seduced by Rockefeller's nostalgic, patriotic dream.

Williamsburg is a living heritage site and Nuremberg is a living city, but both mine their mythic pasts. Both harken back to their most glorious periods: in Nuremberg's case, its golden age, the late medieval/early Renaissance period, when it was rich and cultured and a Free Imperial City of the Holy Roman Empire. Like Williamsburg, Nuremberg's later reinventions were motivated by national pride and the tourist industry. In both, the cityscape becomes three-dimensional propaganda, the real and the replicas evoking an imagined history.

It was with these thoughts in mind that I returned to Nuremberg to timetravel into its past. I wanted to walk the city of the 1830s tourists, to see the city celebrated by Hitler, to enter into the immediate aftereffects of Allied bombings, and to find the remnants and reminders of all of these cities in the city of today. I wanted to understand how its residents lived its majesty, its long quiescence, and its terrible legacy, and how that legacy was cast, recast, and perhaps even redeemed.

On a June day in 1793, Ludwig Tieck and Heinrich Wackenroder, on holiday from the university in Erlanger, were hiking through the Bavarian countryside when they happened upon a perfectly preserved medieval city, ringed with largely intact defensive walls. Set on a jagged cliff high above the city, a medieval castle complex overlooked the ancient, meandering streets, halftimber houses, and majestic two-tower cathedrals. Wackenroder's letter to his parents in Berlin captured the ecstasy of the moment:

> My amazement of this city knows no bounds, because there's not a single new building in it—just countless old ones, from the 10th century onward, so one is completely transported into olden times and always expecting an encounter with a knight or a monk or a burgher in old-fashioned costume, because new clothes simply don't fit the style of the city's buildings.[3]

For these romantic young men, Nuremberg was a dream come true: an intact fairy-tale village that had slumbered for centuries, just awaiting their arrival. Two years later, Wackenroder shared this fantasy in *Confessions from the Heart of an Art-Loving Friar*,[4] a wildly popular book that served as inspiration for the German Romantic movement. The book also

launched old Nuremberg's transformation from derelict village to tourist destination.

The Nuremberg that Tieck and Wackenroder rediscovered was indeed intact, but not because of a witch's spell. What they imagined as something out of a Grimm's fairy tale was actually tattered and run down, with dirty streets and dilapidated houses with privies in their courtyards, a result of neglect, conservatism, and imprudent decisions.

On a sweltering July day, I followed the path of Tieck, Wackenroder, and the 1830s tourists up the steep cobblestone road leading to the main entrance of the Imperial Castle. Once the property of emperors and kings, the massive stone edifice is now owned by the city of Nuremberg. The castle courtyard was filled with parents chasing toddlers, starry-eyed honeymooners, and giggling teenage girls, all sweating in the summer sun. I stopped to rest on a wide stone wall, sharing the space with three panting older women, then wondered how they had managed the climb.

The Imperial Castle is a series of buildings, towers, courtyards, and gardens, the oldest dating to around 1200, built on the foundations of an earlier settlement. Over time, the castle complex expanded and changed shape, adding, subtracting, and adding again, as Nuremberg grew from a small settlement into a major metropolis.

It was cool inside the castle. I walked a flight of stone stairs to its gray granite Romanesque Chapel, which was actually two chapels, one on ground level, and the other on the floor above it. A masterfully carved wooden crucifix hung in the choir of the upper chapel near medieval religious statues and paintings. Down a corridor was a large hall with an exhibit about the building and the Holy Roman Empire. Holy Roman Emperors were elected by the College of Electors, a group of nobles, and once elected, required to hold the first Imperial diet in Nuremberg. The star of the exhibit was a replica of the famed Imperial Regalia: a gold and enameled crown, golden scepter, sword, and cross that were transformed into sacred relics when Charlemagne, founder of the Holy Roman Empire, was canonized in 1165. The Regalia were smuggled into Nuremberg in a shipment of fish in 1424, and displayed once a year in the Main Market Square. At the end of the eighteenth century, the city fathers, fearing an invasion by the French, smuggled the treasures out of the city and they ended up in Vienna.

Although it lacked mineral resources and navigable rivers, Nuremberg's prime location along an east-west trading route and relative autonomy as a Free Imperial City appealed to travelers and merchants. By the fifteenth century, there were forty to fifty thousand inhabitants,[5] making it one of the largest cities in German-speaking Europe. Medieval Nuremberg boasted an impressive array of houses, churches, public buildings, bridges, and man-

sions; its residents included wealthy businessmen, distinguished families, religious luminaries, philosophers, and artists. Nuremberg was the home of Hans Sachs, shoemaker, playwright, and poet, whose songs were performed at the annual festival of *Meistersingers*, a singing competition among craft guilds. Albrecht Dürer lived here, a multitalented artist whose engravings, woodcuts, and books on geometry, architecture, and the human body were celebrated well beyond the city's walls.

During its medieval period, Nuremberg stretched from Imperial Castle cliffs to St. Sebald, its oldest parish church. Saint Sebald, Nuremberg's patron saint, was a hermit who probably lived in around the eleventh century and was considered a saint in his own lifetime because of the miracles he performed. After he died, pilgrims continued to visit his grave. In 1237, the city built a church on the grave's site and later expanded it to accommodate those seeking the saint's miraculous intervention.

On a steamy Nuremberg evening, I attended an organ concert in St. Sebald and listened to heavenly music filling the majestic nave. The church is a masterpiece of stained glass and soaring spaces, built to transport parishioners from their quotidian lives to the spiritual realm. Carved into the cool gray stone of the church, hung on the walls, and nestled in its shrines are statues, altars, pews, and pulpits decorated with delicate tracery, gold leaf, and other adornments, many donated by wealthy families to assure their place in heaven. Other carvings are darker in spirit. A life-sized statue set high on the wall looks like a prince from the front, but from the back his cape opens to reveal a body devoured by worms. Another depicts Jews sucking at the teats of a female pig, an animal Jews consider unclean, an icon of the anti-Semitism that is almost as old as the city itself. Saint Sebald's greatest treasure is the saint's tomb, a half-Gothic, half-Renaissance masterpiece forged by a master craftsman between 1508 and 1519. I slowly circled it, admiring its miniature apostles, saints, mermaids, and dolphins. Inside its openwork cage is the silver-plated casket that holds Saint Sebald's actual bones—or the bones of somebody else from the eleventh century. Every fifteen years, the casket is opened to check the condition of his mortal remains.

St. Sebald was originally a Catholic church but switched allegiance in the sixteenth century when the city became Protestant. Nuremberg is proud of its early adoption of the Protestant Reformation only eight years after Martin Luther published his Ninety-Five Theses. In other cities, zealous Protestants removed Catholic icons and artwork. In Nuremberg, wealthy donor families, though Protestant, insisted these Catholic treasures remain in situ.

Near St. Sebald is the Main Market Square, the center of Nuremberg's local life. The square features number of landmarks: the "Beautiful Well," a miniature gothic church tower from the fourteenth century, and Our Lady's

Church that occupies the spot where the Jewish ghetto and a synagogue once stood before locals destroyed them in the twelfth century, soon after an imperial decree that Jewish buildings that stood in the way of progress could be demolished without compensation.[6] Over fifty years, Nuremberg citizens murdered almost one thousand two hundred Jews and exiled the rest. Some Jews were later allowed to return, only to be expelled again in 1499, and again when Hitler came into power.[7]

In 1806, when the Holy Roman Empire dissolved, Nuremberg was annexed to the newly created kingdom of Bavaria. Its king, Ludwig I, a fan of Wackenroder's medieval fantasy, called Nuremberg the "German Pompeii of the Middle Ages" and designating the dilapidated Imperial Castle as one of his official homes. To ensure the medieval character would never change, Ludwig established the world's first office of historic preservation and appointed Carl Alexander Heideloff as architect.[8] Heideloff restored the medieval fortification walls and landmarks and added neo-Gothic elements. King Ludwig did not like the neo-Gothic, so never lived in the city.

While planning the trip to Nuremberg, I had emailed Dr. Thomas Schauerte, director of the Nuremberg City Museum and he was my first stop when I arrived. We met at Fembo House, an elegant sixteenth-century mansion that is Nuremberg's oldest remaining Renaissance building. Schauerte is himself elegant, with the chiseled features and reserve of a college professor. According to Shauerte, Nuremberg survived the centuries as Germany's largest walled city because it was spared the massive fires that destroyed many others. In most cities, the roofs on row houses ran from side to side, which allowed the fire to jump from one building to another. Here, the municipal government insisted that roofs run from front to back with a wall separate each from its neighbor, thus retarding the spread of sparks and flames. Nuremberg was also spared the destruction of war. When faced with invasion by the Swedish army in 1634 and the revolutionary French army in 1796, instead of fighting, the city fathers prudently surrendered.[9]

Yet, perversely, the most important reason for old Nuremberg's survival was its poverty. "Although the city's famous walls withstood all sieges," Schauerte told me, "it never regained wealth again until the advent of the industrial revolution." Moreover, as trade in Europe became more international, Nuremberg's merchants refused to modernize commercial practices. During the Renaissance and Baroque periods, as progressive cities lavished their wealth on structures and streetscapes, Nuremberg was largely left behind.

By 1790, when Wolfgang Amadeus Mozart visited Nuremberg, he declared it "hideously ugly."[10] But within a few years, Tieck and Wackenroder, youthful outsiders, had reimagined the dark streets, derelict buildings, and vine-wrapped fortification walls as a German Romantic dreamscape. By the

time the tourists on the postcard arrived in the 1830s, Nuremberg was a must-see destination. Intellectuals and artists seeking a connection to an authentic German identity found it embedded in the Nuremberg of Dürer, Hans Sachs, and their contemporaries. It remained the most Germanic of all German cities, stuck in a mythical, medieval past.

The myth of medieval Nuremberg captured the imagination of Henry Wadsworth Longfellow, whose rhapsodic poem, "Nuremberg," praises the "quaint old town of art and song/Memories haunt thy pointed gables, like the rooks that round them throng." It inspired Bram Stoker, author of *Dracula*, who wrote the story "The Squaw" after visiting the famed Iron Virgin in the Imperial Castle, an iron figure with doors that open and reveal the wall of daggers inside, sharp enough to pierce a human body—it was actually a fake. It also inspired Richard Wagner, who passed through Nuremberg in 1861. Less than six months later, he completed his opera *The Master Singer of Nuremburg*, which extols Nuremberg as the embodiment of German morals and a symbol of nationalism. The rhapsodic responses of such visitors might have initially surprised residents, but they quickly caught on and began actively promoting Nuremberg as a tourist destination.

Was this romantic dream of old Nuremberg authentic? The postcard image from the 1830s holds the answer. At first glance, it portrays an authentic medieval town. Look closer and you can spot factory chimneys spewing black smoke across the Pegnitz River. While the walled town remained relatively unchanged, greater Nuremberg grew into the largest and most powerful industrial metropolis in Bavaria. Germany's first railroad originated there in 1835; the railroad, in turn, attracted other new industry. "Nuremberg is said to be the place where the first warehouses were built," said Schauerte. "There were catalogues as early as 1800, and you could order wares from them, much like Amazon today."

Tieck and Wackenroder's medieval Nuremberg survived not because the city fathers planned for it, but because they didn't. Because of their prudence, the city sidestepped the consequences of wars. Because of their conservatism, the city missed the benefits of international trade. While Nuremberg's stagnation was the unintended consequence of circumstance and bad luck, its revival was an act of will. It took an outsider's eyes to imagine the faux medieval city that King Ludwig I and his architect created: their Germanic, romantic, Nuremberg dream.

There's a photograph from around 1933 that shows crowds gathering in Nuremberg's Main Market Square to watch platoons of soldiers salute Adolph Hitler. Beginning in 1923, National Socialist Party members poured

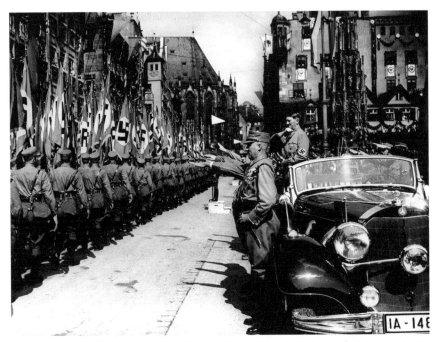

Figure 6.3. Adolf Hitler reviewing Nazi Party members in Main Market Square, 1938.
Courtesy: Stadtarchiv Nuremberg, Germany

into Nuremberg each September. As their numbers grew, they left an indelible mark on the city (see Figure 6.3).

Hitler chose Nuremberg for very calculated reasons. Located near the center of Germany, Nuremberg was easily accessible, large enough to accommodate crowds, and had a long record of anti-Semitism that continued up to the 1920s when Willy Liebel, an early member of the Nationalist Socialist Party was elected mayor. His election proved that voters shared his view and cemented the Nazis's control over a city that had once, if fleetingly, been a center of unionism and democracy. Equally important was Nuremberg's significance as the quintessential German city. Along the winding medieval streets, parks, churches, and landmarks, visitors could experience Germany's Golden Era, and return home with souvenirs crafted by and for the community of the people, what the Nazis called the *Volksgemeinschaft*.

The Nazis made Nuremberg the spiritual capital of the Third Reich, its cityscape the backdrop for its mesmerizing spectacles. At the rallies, Aryans paraded in perfect formation—Nazi youth, SS, SA, laborers, soldiers—among ancient churches, gothic statues. Buildings were hung with party banners and

festooned with flowers; mothers dressed in traditional costumes lifted their babies for the Führer's blessing.

The annual rally of the National Socialist Party was carefully orchestrated to connect the Nazis' Third Reich to the illustrious First Reich of the Holy Roman Empire. To emphasize the connection, Nuremberg's streetscape became even more medieval. Private owners of fifteenth and sixteenth century buildings were "persuaded" to peel off later facades to reveal the "old German" originals. Modern structures were medievalized with half-timbered fronts and pitched roofs. Dilapidated medieval fortifications and walls were repaired and stripped of encroaching vegetation. New footpaths were added along moats and trenches to create unobstructed views of Nuremberg's military heritage.[11]

Buildings around the Main Market Square, renamed Adolf Hitler Platz, received special treatment. The Telegraph Building, built in 1870, received a makeover with a faux half-timber facade and anti-Semitic murals. The central city was also "purified," a pseudo-hygienic term used by the Nazis to refer to removal of all traces of Jewish life. A Jewish synagogue, which Mayor Liebel called "the worst building sin of past decades," was demolished in 1938, shortly before that year's rally began. The Neptune Fountain, donated by a Jewish hops merchant, disappeared from the Main Market Square, and streets and plazas lost their Jewish names.

Buildings used during National Socialist Party rallies were altered for Hitler and the party faithful. Albert Speer, Hitler's favorite architect, renovated the interior of the 1905 Art Nouveau Opera House in fascist neoclassic style and "beautified" the Art Nouveau Lupitpoldhain by adding a monolithic entrance with huge Nazi insignia that was flanked by a curtain wall of long Nazi banners.[12] Architect Rudolf Esterer stripped the Imperial Castle's nineteenth-century neo-Gothic elements to "purify" it into what he imagined to be its original appearance. A crowning moment came in 1938, after the annexation of Austria, when Hitler ordered the Imperial Regalia returned from Vienna to Nuremberg for permanent display. In 1941, the city administration proudly acclaimed that municipal funds were partially responsible for the restoration of approximately four hundred buildings, a civic investment that paid off in revenues for hotels and restaurants during party rallies and throughout the war years, as soldiers on leave brought their sweethearts to beloved old Nuremberg.

As each successive rally attracted more of the faithful, it became clear that Nuremberg's old city was no longer adequate. Outside the walls, in Greater Nuremberg, was a large pleasure park with a man-made lake and zoo. Once Hitler consolidated power, he appropriated the park for the annual rallies. Hitler considered himself a student of architectural history and

often imagined himself as a master builder.[13] He certainly understood how architecture and landscape could heighten spectacle. The Führer ordered Albert Speer to create a landscape that would heighten his cult, demonstrate the might of the Third Reich, and celebrate the *Volksgemeinschaft* at the center of the Nazi myth.

The pleasure park, renamed the Rally Grounds was designed for the exclusive use of the party faithful, a dramatic setting for mass celebrations, solemn commemorations, and displays of force. It was only used for one week a year, which seems stunning, given the scale of investment required to construct such monumental structures. Speer's plan was never fully realized, but what remains today is overwhelming, extraordinary, and absolutely unique. The Nationalist Socialist Party Rally Grounds is, by far, the largest ensemble of Nazi architecture still in existence.

Speer appropriated iconic classical buildings, bloated them to massive size, and embellished them with sleek, modernistic elements. Clad in marble and granite, the faux Greek temples and Roman coliseums were meant to last for a thousand years and eventually to crumble into picturesque ruins. The dramatic elements—gigantic banners, spellbinding lighting, vast fire pits, gigantic Nazi insignia—dwarfed the public; the massive podiums where Hitler stood reinforced his majesty. The Rally Grounds were designed to accommodate as many as 350,000 of the party faithful and inspire them to the service of the Nazi cult. This was Speer's genius: architecture as propaganda.

One perfect summer day I took the Number Nine tram from Nuremberg's Central Station for twenty-minute ride to the Rally Grounds. The route passed through a Nuremberg seldom seen by tourists: blocks of nondescript shops interspersed with modest housing, an industrial park, a hotel. The tram passed the white, mausoleum-like transformer building that supplied the Rally Grounds with the extremely high wattage needed for the blindingly bright theatrical light before reaching Congress Hall. The building was inspired by the Roman Coliseum, which Hitler had seen while visiting Benito Mussolini in 1938.[14]

Four luxurious Viking Cruise buses pulled up alongside Congress Hall to deposit their cargo of eager tourists. The Rally Grounds and its Documentation Center are Nuremberg's most popular destination, attracting approximately 280,000 per year, many of whom are Americans. Every Bavarian student, police cadet, and soldier is required to visit here.

The Nationalist Socialist Party Rally Grounds span eleven square kilometers, or 4.5 square miles, an area so vast that only the young and intrepid can cross it on foot. Others prefer to ride the tour bus operated by History for Everyone, a thirty-year-old nonprofit organization that has led Nuremberg's efforts to interpret the Nazi era and other complicated aspects of its past. As the

bus drove from Nazi landmark to Nazi landmark, riders watched film clips of *Triumph of the Will*. It was an indelible experience: the eighty-year-old images leap off the screen and into the landscape where they actually happened.

In 1932, Hitler commissioned filmmaker Leni Riefenstahl to document the 1934 Party Rally. The resulting film, *Triumph of the Will*, is a propaganda masterpiece; many consider it the best ever produced. After the war, Riefenstahl argued that *Triumph of the Will* was not propaganda but rather an accurate depiction of actual events; but the footage shows otherwise. Riefenstahl, afforded full access to all of the rituals of the Party Rally's eight-day extravaganza, positioned her sixteen cameras to heighten the action and imbue it with a secular spiritualism. The film is shot from the perspective of a single spectator so the viewer becomes part of the fun and mesmerizing pageantry.

As the film begins, an airplane soars over old Nuremberg. Through the clouds, the city's landmarks emerge as if in a dream: the medieval wall, Imperial Castle, St. Sebald with its two Gothic towers. Down below goose-stepping soldiers carrying swastika-embellished flag parade past half-timbered buildings. The plane flies over the Nationalist Socialist Party Rally Grounds with its city of tents, barracks, and food stations. Hitler youth cavort barechested, then transform into Aryan knights, their right arms outstretched in undying allegiance to the Führer.

The film takes the viewer to Zeppelin Field, named after the inventor of the inflatable aircraft. Here, Speer built a venue for huge performances. Tens of thousands once sat in its grandstands, called the Zeppelin Tribunal, which were topped with a huge structure decorated with a Nazi swastika banked on both sides by Roman columns. In front of the Tribunal the white cube-shaped podium that the Führer used to review troops and exhort the crowds still stands. During night rallies, 130 huge floodlights threw swords of light into the sky. The Zeppelin Tribunal is the largest intact example of Nazi propaganda architecture (see Figure 6.4).

Although it was never finished, the massive horseshoe-shaped Congress Hall remains the largest building in the Rally Grounds, with an auditorium that could hold fifty thousand Party Congress delegates on its main floor and another two thousand four hundred on its immense stage. The building stands in a marsh adjacent to a lake, its massive weight requiring twenty-two pilings to support the structure. Fourteen hundred laborers worked on the building, completing the shell to a height of almost eighteen feet before construction was halted.[15]

The annual National Socialist Party rallies incorporated familiar elements of ancient religious processionals, folk traditions, and parades. Its most hallowed ritual took place at a repurposed World War I memorial in Luitpold Grove. On the seventh day of the rally, Hitler and his entourage solemnly

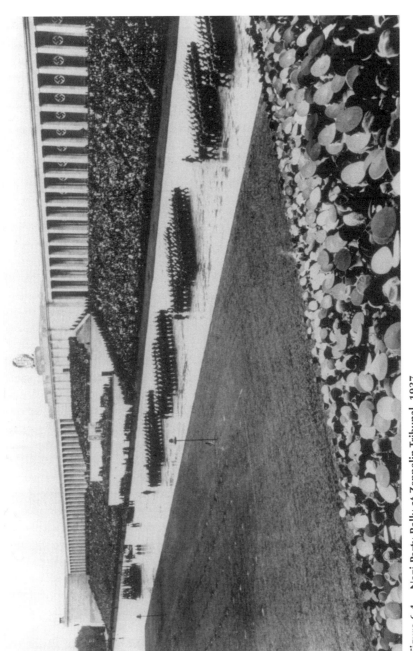

Figure 6.4. Nazi Party Rally at Zeppelin Tribunal, 1937.
Courtesy: Dokumentationszentrum Reichsparteitagsgelaende, Nuremberg

walked through the ranks of one hundred and fifty thousand SS and SA storm troopers, then passed the massive grandstands, which were flanked by huge golden eagles. The Führer ascended the war memorial's granite steps to pay homage to the martyred dead of the nation and the party. The events captured in *Triumph of the Will* brought me a new understanding of how millions of Germans could fall into the Nazi dream.

Speer's plans called for some structures that were never started, like the humongous German Stadium, and others were never finished. The Great Road, a wide avenue running from the Rally Grounds to Nuremberg's Imperial Castle several kilometers to the north, was nearly completed but never used. In the summer of 1939, Hitler canceled the annual party rally since Germany was about to attack Poland, and construction stopped. Hitler never used it again.

Nazi Nuremberg lasted only six years, from 1933 to 1939. The Third Reich is long gone, but the potency of its dream lives on.

On the night of January 2, 1945, Royal Air Force (RAF) bombers dropped 2,300 tons of explosives onto the walled city of old Nuremberg, a shocking thirty-eight tons for every square meter.[16] In less than an hour, 92 percent of the streetscape was destroyed, one hundred thousand residents left homeless. The day before, it had been a charming old community. The day after it was a ghost town. Nine hundred years of history and architecture were wiped out in a single night.

As Armin Glass led me through the city, he stopped in front of a row of buildings, opened the notebook he was carrying, and showed me the same spot immediately after the bombing raid. Exploded landmarks. Entire city streets incinerated. Huge sections of the Imperial Castle shattered. In one photo, women living in cave-like structures hang their laundry out to dry. In another, locals carry on their lives in an apartment building with its front wall blown off. St. Sebald was crushed to a fraction of its formerly majestic height, its two towers sliced in half, its roof shattered in pieces on the floor. The area surrounding the church was called "Sebald desert," a fitting description of its bleak emptiness (see Figure 6.5).[17]

Nuremberg's virtual annihilation was exceeded only by Dresden's a couple of days later. Both acts of destruction were part of the Allies strategy of "saturation bombing": target towns, destroy industry, demoralize residents, and force unconditional surrender. The Allies recognized Nuremberg's strategic importance as an industrial and transportation center, but more important still was its significance as the spiritual center of National Socialism. The Americans bombed the munitions factories and rail lines. The RAF almost wiped Nuremberg from the face of the earth. An American major who was there at the time later wrote, "I know that (the Germans) had asked for it, but this

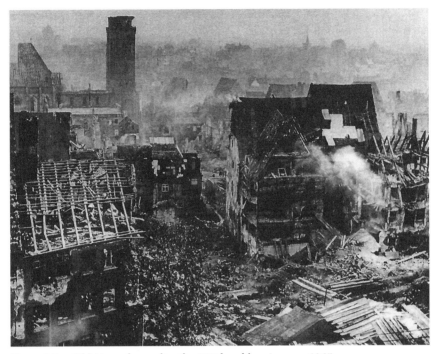

Figure 6.5. Old Nuremberg after the RAF bombing, January 1945.
Courtesy: Stadtarchiv Nuremberg, Germany

kind of total destruction is beyond reasoning. . . . It is absolutely ghastly, is it justified to reply to their mass-murder by our mass-murder?"[18]

What accounts for such excess? Armin Glass is among those who believe the shocking extent of destruction was an act of cruel retribution. A year before, British bombing commander, Arthur "Bomber" Harris, had sent RAF fighters to bomb Nuremberg. The raid failed, 95 RAF planes were destroyed and 545 airmen died. This time, the RAF came to crush the city.

As the bombing ended, Nuremberg residents emerging from tunnels and bomb shelters found a wasteland. Single structures jutted from rubble at odd intervals, saved by a combination of luck and concerted citizen action. Residents risked their lives to extinguish fires that erupted at Dürer's house, so it made it through—miraculously—as did his statue. A handful of other important landmarks survived, some intact, others partially so. St. Sebald, Adolf Hitler Platz, and much of the medieval wall suffered damage but were not destroyed. At the Imperial Castle, early Romanesque and late Gothic sections were left virtually unscathed, though the rest lay in ruins.[19] Oddly, the Nazi Rally Grounds were not bombed.

Conditions were desperate, but Nuremberg refused to surrender to the Allies. Mayor Holtz, trapped in the police station, ordered his men to continue fighting, then committed suicide. On April 16, three months after the bombing, American troops entered the old city, soon greeted by snipers in St. Sebald's towers. The Americans bombed the towers, sparking a firestorm so fierce that it melted the sandstone. The city fell soon afterward.

On April 20, 1945, Hitler's birthday, GIs hoisted the American flag up a flagpole in the hastily renamed Main Market Square. Within a few weeks, the giant Nazi swastika looming over the Zeppelin Tribunal was blown up, and the Rally Grounds became an American army installation. The Great Road, intended for Nazi military parades, was repurposed into a runway for American aircraft, and American soldiers moved into the former SS barracks. The American army remained in Nuremberg and most of southern Germany for almost half a century.

Within a month, American troops were surveying Nuremberg's buildings and streets to assess the damage. The United States Strategic Bombing Survey's decorously named Morale Division interviewed civilians, who might not have been candid discussing their morale.[20] As Glass told me, "The locals didn't feel they were being rescued. The Allies were the invaders."

That same April, the Allies designated Nuremberg as the site for the war crimes trial of the most senior surviving officials of Nazi Germany. Although its medieval core was in rubble, much outside its walls remained more or less intact. This included the Palace of Justice, a prison that could hold one thousand two hundred inmates, and a hotel to accommodate press and trial personnel. Soon fifteen thousand prisoners of war were cleaning the streets of rubble, carrying it to the Rally Grounds, and piling it into a hill.[21]

The Nuremberg trials were intended to bring Nazi leaders to justice, and by doing so, establish the precedent of official culpability for crimes against humanity. The precedent resonated through the decades that followed, a model for war crime tribunals throughout the world. And, though no one realized it at the time, the Nuremberg Trials became a critical turning point for Nuremberg.

With so little surviving, Nuremberg faced a monumental decision: What kind of city should it become? This question was critical throughout much of postwar Europe, which had suffered massive damage by the Allies, the Axis, or both. Germany, especially damaged, desperately needed the Marshall Fund dollars designated by the Americans for European reconstruction.

In 1949, the newly established Federal Republic of Germany sponsored a German Building Exhibition in Nuremberg that brought together practical rebuilding solutions from all corners of the nation. Cities presented a variety

of approaches to reconstruction. Frankfurt, for example, replaced narrow, winding streets with sleek roadways in order to expedite traffic and facilitate growth. This was made possible because the city, not individuals owned all vacant land. Other towns opted to replicate entire streetscapes, or, like Dresden, to reconstruct only a few buildings, as a reminder of what was lost.

Nuremberg's solution to its future was more nuanced, some say, because of the novel civic process that shaped it. The city invited architects to submit master plans for the medieval city, and then invited citizens to submit their own designs. Then the proposed plans were discussed at a series of town hall meetings. The one that was ultimately selected established a series of guidelines that were intended to carefully balance Nuremberg's historical character and its need for new development. First, the city would restore to their original appearance the few major buildings that survived, even in tatters. Second, the basic design of the original pedestrian city with its parks, public squares and narrow winding streets would be preserved. Third, to the extent possible, all new construction in the old town would conform to the visual nomenclature of the medieval city. Each new building would occupy the same footprint as its predecessor, with the same window alignment, traditional pale yellow facade, and front-to-back pitched roof.

Finally, Nuremberg would reject replicas. The city was adamantly opposed to a false, sanitized version of its past, what historic preservationists called "Disneyfication." As other German towns sought the comfort of nostalgia, Nuremberg reached for authenticity. In fact, there was only structure that was entirely re-created: one of the Imperial Castle towers, an exception made to retain the castle's original shape.

The postwar guidelines succeeded in maintaining old Nuremberg's distinctive appearance and, ironically, became the reason why tourists, me included, mistakenly think that the postwar cityscape is actually old. The guidelines also led to some ingenious compromises. In the middle of town stand three adjacent row houses with slightly different heights, window alignments, and sizes that appear to be three separate buildings but are actually a single warehouse with especially long floors. There is also a modern structure built around the intact nave of a destroyed monastery church. Marriages of old and new can be found throughout the old town, for example, postwar buildings that retain their medieval courtyards; new buildings with traditional bay windows that had been removed and hidden during the war and later restored, sometimes to their original home.

Beginning in 1940, a small band of residents removed paintings, sculptures, stained glass, and other art treasures from churches, houses, and public buildings and secreted them to the vast tunnels that ran under the castle hillside, used as an art bunker. Once used to store beer, these tunnels were cool

and dry: conditions that fragile objects require. The entrances to the art bunker were sealed and the facade disguised as an antique shop. Few knew about the art bunker until after the war, when the precious objects were removed and returned. One of the most important treasures to emerge was actually from Poland, a medieval altarpiece by Veit Stoss that Hitler appropriated at the beginning of the war. It later returned to its home in Krakow.

St. Sebald suffered major damage during the war. Its entire nave crashed to the floor during the RAF attack on January 2, 1945. But because of parishioners' foresight, much was saved. Many of St. Sebald's cherished stained-glass windows and artwork, which had been removed for protection and stored in the art bunker, were returned to their original locations. The twin towers have returned, supported by a web of steel invisible from the outside. St. Sebald's tomb was too heavy to move, so during the war, a wooden box was built around it to protect the saint's mortal remains in its silver plate coffin. The wooden box was later replaced with a fire-resistant brick shell, which ultimately saved Nuremberg's patron saint from obliteration. Now visitors can tour the art bunker and then walk to St. Sebald nearby to admire the recovered artwork and see the photo exhibit depicting its destruction and almost miraculous resurrection. Only a trained eye can detect the subtle color shifts that differentiate old stones from new.

In 1949, Nuremberg celebrated its survival when citizens gathered among the rubble to celebrate the reopening of the Dürer House, the first landmark to be restored. Over time, some buildings the Nazis medievalized returned to their earlier appearance.

Still, it is surprising to learn that much of today's Nuremberg was the work of former Nazis. Until the late 1960s, former members of the Nationalist Socialist Party filled many top posts in government and business, not just in Nuremberg, but also throughout Germany. Some had been more active party members than others and, thus, more culpable. Nuremberg had its share of the culpable. Rudolf Esterer, who "purified" the Imperial Castle for Hitler before the war, was retained to restore it afterward. The city's excellent post-war master plan was, in part, the work of Heinz Schmeissner, a Nazi, though, according to some, not a practicing one. Before the war, Schmeissner was a member of the team that built the National Socialist Party Rally Grounds and medievalized the old city. During the war he was a member of the secret cadre that built air raid shelters, established the art bunker, and moved treasures into it. He was instrumental in hiding the Imperial Regalia in a secret vault, and, after the war, he went to jail for two years rather than reveal its location. Eventually, another local revealed its location and the Allies sent the Regalia back home to Vienna. But that does not diminish Schmeissner's

civic sacrifice. "Sure, he was a Nazi, but look at the good he did," said Armin Glass. "We must appreciate his work for this great old city we have today."

By the mid-1970s, the greatest threat to old Nuremberg had shifted from bombers and tanks to bankers and developers who sought to remove prewar buildings that stood in the way of economic progress. The 1973 Bavarian State Historical Preservation Law, Germany's first heritage conservation legislation, halted most of the destruction, though the threat remained. Around this time, a group of private citizens launched Friends of Old Nuremberg to preserve, restore, and re-create its old buildings. The Friends have raised millions of euro, reconstructed about eighteen structures, and restored old bay windows and statues that were removed during World War II.

The Friends are rightly proud of their accomplishments in bringing back Nuremberg's former glory, one building at a time. Some historic preservationists wonder whether the Friends actually prefer faux replicas to authentic preservation. A case in point is the Peller House, one of Nuremberg's few Renaissance palaces and an architectural masterpiece that once anchored an upscale neighborhood. The palace was crushed during the war; only the first story, an interior courtyard, and a partial staircase survived. In 1955, a modern top was built on top of the Peller House and a modern building was built next to it. Then, a second floor was built that extended from the Peller through the adjacent building and was used for a while as the city archives. Later, the Friends of Old Nuremberg raised millions to restore the elegant ground floor of the Peller House. Now they want to remove the exterior of the second floor, circa 1955, and replace it with a replica of Peller's original Renaissance facade. Some preservationists disparage this an example of "Disneyfication," arguing that the 1950s addition also tells an important story, this one about postwar Nuremberg.

The Friends disagree. "There were three thousand buildings in the old city before the war," explained Karl-Heinz Enderle, the Friends' volunteer director. "Only three hundred survived. We are reconstructing only a tiny fraction. It's such a small number."[22]

Another point of contention is a long-lost fresco by the great Albrecht Dürer that once filled a wall in the Great Hall, located in Town Hall, where the city council met. The mid-fourteenth-century building, including Dürer's fresco from the sixteenth century, was incinerated during the RAF bombing. Recently, a series of color images of the fresco from the Nazi era was discovered, which brought the issue to the fore. The Friends and the tourist interests now want to repaint the mural, arguing that it will add to the city's medieval charm. The preservationists adamantly oppose the plan, arguing there is insufficient documentation to assure that the new fresco will authentically

reproduce Dürer's original.[23] The democratic, sometimes contentious process that shaped postwar Nuremberg continues.

Then there are the Nazi Rally Grounds.

It may be hard to imagine that four square miles of parkland and monumental structures could be ignored for thirty years, but that is essentially what happened. The municipal government owned the Rally Grounds, and over time returned some parts to the pre-Nazi, recreational use, and used other areas to store city vehicles and holiday decorations. No one wanted to acknowledge the Nazi past, to acknowledge its historical significance.

The Bavarian State Historic Preservation Law listed the Nazi Rally Grounds as a heritage site, worthy of preservation for its fascist style of architecture and significance as a "witness of the past." Yet in 1976, city council voted to remove the distinctive wall of columns atop the Zeppelin Tribunal's grandstand, arguing that it had decayed and become dangerous. The field itself was turned into football fields, as the city continued to resist efforts to reveal its Nazi connections and preserve its Nazi architecture.

In 1987, Nuremberg's city council endorsed a proposal from a private developer to turn Congress Hall into a shopping center and leisure destination. A local citizens' initiative successfully fought back, arguing that the site should be preserved as a warning from the past. In the years that followed, the citizen groups became stronger and more vocal. In the 1980s, a small display was installed in a dark corner of Congress Hall; in the 1990s discussion began about how to offer well-designed exhibits. This eventually led the government to develop the Documentation Center, Germany's first venue devoted to the interpretation of National Socialism, the name chosen to signify that this is not a typical museum, celebrating the past, but rather a place of learning and contemplation.

Designed by Austrian architect Gunther Domenig, the Documentation Center is a corridor of glass and steel that slices into the north end of the mammoth Congress Hall, its transparency a striking counterpoint to Congress Hall's neo-Coliseum. Florian Dierl, director, Documentation Centre and Nazi Party Rally Grounds, walked me through the Center's permanent exhibit, titled, "The Topography of Terror," which interprets the entire sweep of National Socialism and its devastating effects, especially on Jews, Roma, Communists, and other concentration camp victims. I learned, for example, that concentration camp slaves excavated the German limestone used to build the Rally Grounds' gigantic structures. They were worked to death, which was viewed as an expedient way of disposing of these "undesirables."

Nazi Nuremberg extended from 1933 to 1939, but the Documentation Center's interpretation extends to the end of the war, including liberation of the concentration camps. When it opened, this was Germany's only museum

about the growth and impact of Nazism, but now many others exist. Dierl believes it is important to use this exhibit to deepen the story and contextualize the site. That is why he is leading the development of a new permanent exhibition that will illustrate that widespread support of the Nazi regime wasn't merely the result of a seductive propaganda machine but of millions of Germans taking advantage of the economic and career opportunities it provided for them. "A politically and socially unified 'People's Community' was not a propaganda hoax but a genuine aspiration of the regime as well as 'ordinary' Germans," said Dierl.

The Rally Grounds represent a massive problem that Dierl confronts daily. As we stood on a balcony looking out over the site and deteriorating Nazi structures, he explained the dilemma. Should they be preserved as the last surviving examples of their type? Should they be left to rot, as a symbol of the deserved destruction of the way of life they represent? Should they be stabilized so that future generations can see—or use—them? Should only parts of them be restored?

"Zeppelin Tribune and Zeppelin Field are among the few remaining relics of the National Socialist era, and as such, they represent the ideological driven self-empowerment so many Germans were prone to in the 1930s and early 1940s," Dierl said. "It is important to keep the remains intact in order to warn future generations about the illusions of authoritarian politics which, in the past, led to a catastrophe, and which, would do once again if given a chance" (see Figure 6.6).

The federal government has affirmed its responsibility for the site, and the city had pledged millions of euros for preservation of the Zeppelin Tribunal. But there is much, much more that needs to be preserved, and quickly, or the Rally Grounds and the critical story embedded in its structures, will be lost to future generations.

Near the end of my stay, I returned to the Imperial Castle with a more discerning eye. Below was the same panorama: the same rooflines, church towers, and winding streets that charmed the 1830s tourists on the postcard. But now I could spot the few authentic survivors among their faux, flat-fronted neighbors. Down the steep castle cliff, I walked along Tawers Street, with its picturesque ensemble of twenty-two craftsmen's houses, most with half-timbered facades, a Friends project. I passed the medieval statues, distinctive bay windows, and metal plaques noting the date of buildings' destruction and restoration, mostly in the 1960s and 1970s. I stopped by an "eco-fair" featuring a robust array of local produce, international food vendors, and organic products. It occupied most of the Main Market Square, which, during the holiday season, is transformed into the world famous Nuremberg Christmas

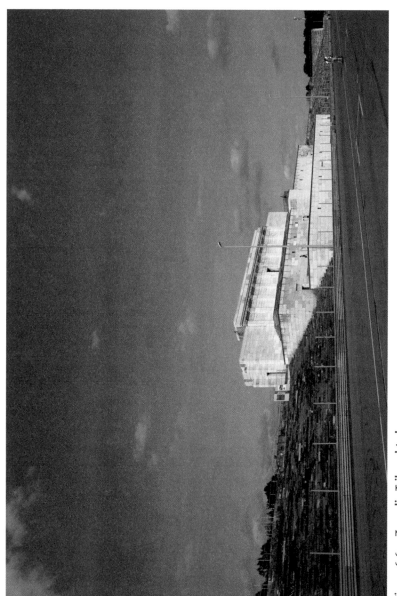

Figure 6.6. Zeppelin Tribunal today.
Courtesy: Dokumentationszentrum Reichsparteitagsgelaende, Nuremberg.

Market, a tradition four hundred years old. I bought a plate of traditional Nuremberg bratwursts, each the size of an index finger, then meandered through the faux medieval crafts village around the corner from my hotel, where tourists purchase Nuremberg's famous gingerbread, toys, and medallions. All of it is authentic, since the crafts must be produced locally.

I ended the trip at the Germanic National Museum. Along one of its sides was an unusual sculpture: a row of thirty stark columns, each engraved with one of the United Nations Articles of Human Rights, in German and numerous other languages. Near the columns is a tree symbolizing the languages not represented on the columns. This sculpture and tree, titled the *Way of Human Rights*, was created in 1993 by Israeli architect Dani Karavan to commemorate Nuremberg's singular role as the founding city of the modern conception of human rights. Two years later, Nuremberg awarded the first International Human Rights Award. In 2000, UNESCO awarded the City of Nuremberg its prestigious Award for Human Rights Education to honor its exemplary work in promoting peace and respect for human rights. Nuremberg now calls itself the City of Peace and Human Rights, and there is a municipal human rights department that sponsors conferences, film festivals, and curricula.

I thought about how my Nuremberg experience had led me well beyond the simple dichotomies of real versus replica, and reconstruction versus restoration, and into what these concepts mean and why they matter. Nuremberg is the heartland of the German-ness, a vision so powerful that it transcended centuries. It is the dream of the Holy Roman Empire, symbolized by the Imperial Regalia; the dream of the quintessential German medieval city, described in a romantic piece of literature, captured in *The Meistersinger*, embraced by King Ludwig I, and enhanced by his preservation architect. It is Hitler's dream of the Third Reich, celebrated in *Triumph of the Will*'s depictions of the medievalized streetscape of the old city and the Nazi neoclassical monumentalism of the Rally Grounds. It is the City of Human Rights symbolized by the Palace of Justice and commemorated in the *Way of Human Rights*.

Today's Nuremberg is all of these. It struggles to serve the tourist, advance the economy, and preserve its own sense of integrity. It tries to balance the myth of authentic Germanism and the country's actual, sometimes painful past. And, its citizens, as citizens of a democracy, continue to argue over what kind of city they want it to be.

Chapter Seven

Authentically Barnes

It's 1996 and I'm standing in a dim, somewhat shabby gallery trying to puzzle out the odd assortment of items on display. On one wall, a small painting of a nude by Pierre-Auguste Renoir hangs over Renoir's *Bathers and Maid*, which is hung above an eighteenth-century American painted pine chest with a brass candlestick and salt-glazed stoneware pot. Two landscapes by Paul Cézanne and two by van Gogh are hung on either side of *Bathers and Maid*. Surrounding them are iron implements: andirons, hinges, a lock mechanism, a doorknocker.

This is very odd. Most museums display works by a single artist or from a certain historical period together. Not here. Here, there are paintings from wildly different eras and artists hung together; not only together, but in balanced arrangements. Moreover, the usual descriptive text panels are missing. In fact, except for small metal plaques with the name of the painting and artist affixed to the picture frames, there's nothing to tell what the wall arrangements mean.

I wander from room to room struck by the overwhelming abundance of outstanding art and crafts, wondering why there are so few visitors. As it turns out, I'm one of the fortunate few allowed to enter this mysterious treasure chest packed with art, the Barnes Foundation, located in a 1925 mansion in suburban Philadelphia that Dr. Barnes built for $550,000 (see Figure 7.1).

Twenty years later, I'm standing in what appears to be in the same gallery with the same art and objects placed exactly as they were in 1996. Even the burlap wall covering, wooden floors, and floor-to-ceiling windows appear the same. This time the space is clean, crisp, and flooded with light: the artists' colors are literally jumping out of the canvases; the reds are redder, the blues more vibrant. The gallery is bustling with art aficionados, tourists, and ordinary Philadelphians posing for selfies, quieting babies in strollers, and chatting with friends in front of the mysterious wall arrangements. This

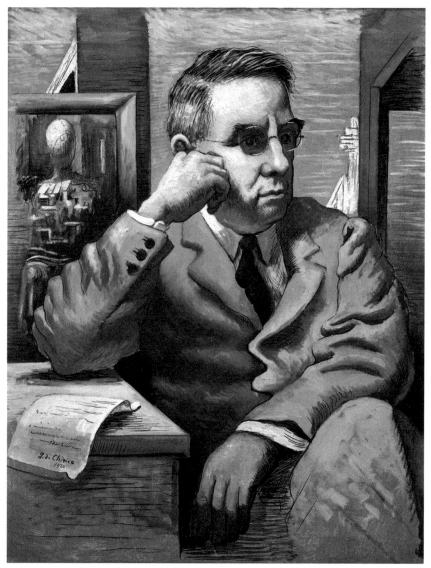

Figure 7.1. Giorgio de Chirico (Italian, 1888–1978). *Dr. Albert C. Barnes*, 1926. Oil on canvas, 36 1/2 × 29 in. (92.7 × 73.7 cm) BF805
Image © The Barnes Foundation, Philadelphia

time I'm among the hundreds of thousands who have come to the epicenter of Philadelphia's museum district to see the new Barnes Foundation, which opened in 2012 and cost the Commonwealth of Pennsylvania and various philanthropies one hundred million dollars (see Figure 7.2).

On the surface, much about the new and the old Barnes seem the same. Like the old, the new Barnes delivers a one-of-a-kind art experience in a singularly impressive building. Like the old, the new overwhelms visitors with its quantity and variety: 181 Renoirs, 69 Cézannes, 46 Picassos, 59 Matisses, and 18 Rouseaus, not to mention the Asian, African, and American Indian art and artifacts, furniture, and ironwork installed in the seemingly endless ring of galleries. Like the old, each room of the new Barnes features Dr. Albert C. Barnes's unusual arrangements of paintings, what he called "ensembles."

But they're not really the same. The old Barnes occupied a Neo-Classical gem set inside a twelve-acre arboretum. The new Barnes is a meticulous replica of the interior of the old set inside a sleek structure on a five-acre city block next to the ten-lane Benjamin Franklin Parkway. Moreover, the new Barnes features all of the accouterments of a twenty-first-century museum—gift shop, café, restaurant—amenities that Dr. Barnes would have never permitted.

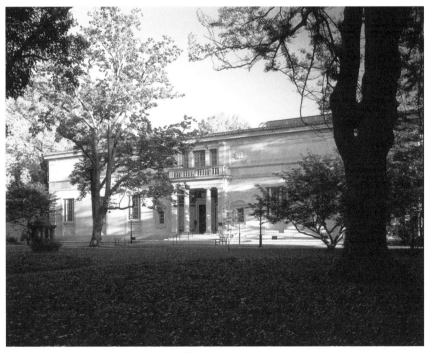

Figure 7.2. Main Entrance of Cret Gallery, The Barnes Foundation, Merion, Pennsylvania.
Image © 2019 The Barnes Foundation/Photo by Michael Perez

How the old became the new is quite a story—in fact, two stories, or rather the same story told from two different perspectives. The first, portrayed in the documentary film directed by Don Argott, *The Art of the Steal*,[1] paints the Barnes move as a self-serving conspiracy perpetrated by powerful philanthropists, tourist officials, and politicians that broke the founder's will, ignored his desires, and ripped his precious gallery out of its natural habitat. The second, touted by many of the same philanthropists, tourist officials, and politicians, celebrates the new Barnes as an exceptionally generous civic gesture that elegantly solved its seemingly intractable financial and political problems and realized its founder's deepest desire to bring his remarkable treasures to the ordinary people he wished to serve. Both the critics and the celebrants use Dr. Barnes's own words to buttress their point of view. This is easier than you might think. Over his lifetime, Barnes wrote a whole lot of words, some of them contradictory.

But whether one subscribes to the first theory, the second, or a part of both is irrelevant since there's no doubting the new Barnes is a success. It's financially solvent for the first time in decades. It's a must-see attraction that jumped the needle forward on Philadelphia's aspirations as an international cultural destination. Thousands more visitors can be accommodated, thousands more school students can visit, the adult education programs are oversubscribed, the restaurant, events business, and gift shop are thriving, and the building and surrounding landscape are breathtakingly beautiful. In 2006, fewer than 70,000 were allowed in the old Barnes. Ten years later, 265,000 visited the new.[2] All of this while preserving Albert Barnes's singular and idiosyncratic art ensembles and continuing his singular and idiosyncratic approach to art education.

No question, it works. But beneath the glow of success lies a quandary that continues to tug at me.

How much of Dr. Barnes survives in the new Barnes Foundation? Does it still advance his mission, his vision, and values? Is it still, as he wished, an educational institution in which students learn by studying original works of art? Or is the new Barnes an art museum with a particularly robust education program? What's authentically Barnes here, what's not? Should we care?

I've come to explore these issues by talking to those who created the new Barnes and those who work there, and through it, explore a bigger issue: the connection between museums and authenticity. What makes one museum authentic and another not? Is it the objects in the collections? The building it occupies or the look of the galleries? The exhibits and programs? Or is it something entirely different? The Barnes Foundation seems perfect for exploring authenticity, since there's so much that changed . . . and so much that hasn't.

This isn't my first encounter with the Barnes Foundation, since I knew the old one as a patron and wrote about it in the early 2000s for my first book, *Lost in the Museum: Buried Treasures and the Stories They Tell*. I had always been curious about Dr. Barnes and why so few knew about this remarkable art collection. At the time, beyond legal documents, there were only a few trustworthy sources available on Dr. Barnes or his foundation. He left a significant body of correspondence, but little of it was available because it had never been inventoried. There were Dr. Barnes's own publications in which he elucidates his philosophy and pedagogy. There were also a couple of gossipy memoirs that painted him as a contentious crank with a good eye for art, and delighted in relating his egregious behavior and vituperative correspondence with art professors, art critics, and museum directors. These describe Dr. Barnes's decision to assign ultimate control over the board, and thus his remarkable holdings, to Lincoln University a historical African American university, and characterize it as a mean-spirited gesture to thumb his nose at the establishment.

Now, twenty years later at the new Barnes Foundation, I was struck by how much of the story had changed. Barnes was no longer a crackpot: he had been resurrected as a social pioneer and educational visionary whose pedagogy is especially salient today. How had this happened? I then visited the new Barnes library and found that his correspondence was thoroughly inventoried with a finding aid available online to researchers worldwide. Not only this, but there is now a growing body of credible scholarship. These newly available sources revealed his canny collecting strategy and his surprisingly rich connections with some of the great intellectuals of his day. They revere the doctor for his creativity and egalitarianism, the ensembles cleverly constructed templates that allow each visitor to access his or her personal art experience. Perhaps most surprising, the archives document his long-standing admiration for African American culture, love of African art, and correspondence with leaders of the Harlem Renaissance. His selection of Lincoln University was not vituperative, but rather a continuation of his friendship with its president and relationship with its students.

I couldn't help but wonder: Is the new Barnes Foundation authentic because it looks like the inside of the old Barnes? Is it a replica, and thus by definition not authentic?

That line of thinking led to a search for other significant cultural sites that were alternatively viewed as authentic or replicas. In the World Heritage Center's definition of authenticity, for example, a structure is considered authentic if its use and function, traditions and techniques, location and setting, and spirit and feeling survive, for example, the Jingu Shrine in Japan's Ise City. It is a cherished part of Japanese culture. It's also completely rebuilt

every twenty years, which renders it eternal. Japanese people have worshiped at Jingu Shrine for two thousand years, and it is said Emperor Temu (reign 673–686 CE) determined the twenty-year cycle of renewal.[3] Is the shrine authentic or a replica? Our Western notion of authenticity is a cultural construct; in many other cultures authenticity means something very different.

With a new perspective, I was able to look at the Barnes Foundation, in fact all museums, with a different view. For museums, authenticity is not found in the building, collection, exhibitions, or program: these change over time. Rather, authenticity is rooted in the core mission, what the World Heritage Center refers to as its "spirit and feeling." If this core mission survives even if the rest changes, then authenticity follows. If a museum strays too far from the "spirit and feeling" that inspired its founders, it becomes something different, something its founders might not recognize or even reject.

Each of the 35,000 museums in the United States started with a unique mission, but not all of them remained true to it. Some drifted from their original mission because the population has changed so much that it's no longer relevant. Some were left behind when their long-time supporters changed their philanthropic priorities. Some have not recovered from the Great Recession of 2008, when attendance tanked, endowments dropped, and charitable dollars dried up. It's tough to remain authentic when you can't pay the bills.

Here's the conundrum: to hold to the core mission, a museum must be financially solvent. But financial necessity can compromise the mission. There are many examples of those that have strayed. A science and technology museum that replaced science experiments with theme park–like simulations and immersive experiences to sell more tickets. A natural history museum that removed exhibits about global warming in order to retain certain corporate sponsors. An art museum that sold its most beloved and valuable paintings to cover operating costs. A historical society with documents and artifacts that shed the artifacts and thus half of its founding mission.

Boards of trustees are responsible for institutional survival, so tend to endorse such survival tactics. They also bear the brunt of attacks from founding families, loyal members, wealthy donors, museum associations, and the media. Sometimes disputes over mission and money end up in a state court that has jurisdiction over charitable trusts. When it does, the judge often decides in favor of the museum rather than outside petitioners. When I recently asked an assistant attorney general who had tried many such cases why, he explained that the judge would favor a museum's petition to sell its collections, break its bylaws, or override its founders' expressed wishes when it best serves the public interest. Serving the public interest is a different standard than

whether you or I believe a museum is wrong or right, or whether it meets the ethical guidelines of the American Alliance of Museums, Association of Art Museum Directors, Association of Science-Technology Museums, American Association of State and Local History, or another professional organization, all of which have slightly different ethical guidelines.

These examples are not theoretical. All of them actually happened recently. The Barnes Foundation encountered many of the problems faced by its peers and more: internal dissent, insurmountable deficits, decades of debilitating court battles. Despite all of this, it remained faithful to its founders' vision. How that came about is embedded in its story.

Dr. Barnes built the Barnes Foundation's home at the end of what is now Latches Lane in Merion, one of the greenest and loveliest Philadelphia suburbs. Paul Cret, who at the time was a professor at the University of Pennsylvania's school of architecture and an accomplished architect, designed it to his client's specifications. While it looks like an art museum, the Barnes Foundation is actually an educational institution in which art is used to advance social betterment. This was Barnes's mission and passion and he was able to advance it because he was brilliant, dogged, and very wealthy (see Figure 7.3).

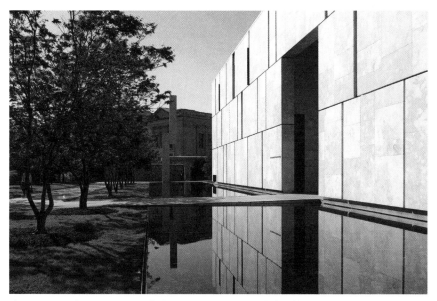

Figure 7.3. The Barnes Foundation Exterior View, Philadelphia, 2018.
Image © 2019 The Barnes Foundation

His is the Horatio Alger story of a poor boy who with perseverance and enterprise, attained riches and fame. Born in working-class Philadelphia in 1872, by the time he was thirty-six, Barnes had secured a medical degree, studied chemistry in Germany, and founded a company around a single drug, Argyrol, which he vigorously marketed until it become the international drug of choice for preventing infant blindness. Along the way, he bought out his partner's interest, started a new business, and moved himself up the social ladder by marrying the wealthy and cultured Laura Leggett. He was wildly successful, worth millions.

The newlyweds decided to build their home in Merion. Rather than take part in the social scene of other wealthy and leisured Main Line neighbors, Dr. Barnes, who always felt himself an outsider, decided to explore education, philosophy, and art. His interest in art led him to reconnect with a former high school friend, the artist William Glackens. Barnes sent him to Paris to purchase paintings on his behalf. Later the same year, Barnes himself went to Paris to try his luck. Over time, primarily relying on his own eye, he acquired an important collection of artwork. Barnes's particular interests were Impressionists, Post-Impressionist, and early Modernist paintings. He also purchased medieval manuscripts and sculptures; Old Masters paintings; Mediterranean and Asian antiquities; Native American ceramics, jewelry, and textiles; Pennsylvania German decorative arts; wrought iron implements; and sculpture from the Sudan, the Ivory Coast, the Congo, and Gabon from the ninth to the seventeenth centuries.

Early on, Barnes brought his art into his Argyrol factory. Using original paintings, he conducted daily two-hour seminars in which his employees would leave their workspaces, listen to their employer's lecture, look at the artwork and discuss philosophy and art. In 1917, Barnes enrolled in a postgraduate seminar at Columbia University taught by the philosopher John Dewey. They became close friends and educational collaborators. Dewey's theories of experiential education and social transformation of the common man led Barnes to expand the seminars into an experiment in art education. In 1922, he attained a charter from the Commonwealth of Pennsylvania for an educational institution dedicated to promoting his passions for art and philosophy and his wife Laura's interest in horticulture. That same year he hired Professor Cret to design a suitable space.

We know how Cret approached the assignment from the articles he wrote before and after completing the building. He described it as creating an "educational institution in which is conducted research in art, more particularly modern art and its derivations from earlier art."[4] Because Cret believed art could best be seen in spaces that took a cue from the artist's studios in which they were created, he insisted on large windows that let in natural light. Tak-

ing his inspiration from "old Italian palaces," he designed a symmetrical Beaux-Arts interpretation of an Italian Renaissance villa.

Visitors to the Barnes Foundation drove to Merion, past the mansions on Latches Lane, then through a gate and into the lush arboretum. They entered the rose-colored limestone building, through a modest entry flanked by Cubist-inspired bas-reliefs by Jacques Lipchitz and large panels with African motifs. Behind a small foyer was a large central room with a circuit of modest-sized rooms of different dimensions to avoid monotony.[5]

Up a flight of stairs were additional galleries, these partially lit from skylights. Huge windows and a balcony brought natural light from the garden to illuminate the interior. The burlap wall coverings, wooden floors, and subtle wooden moldings focused attention on the artwork. "All told," Cret wrote, "the effect was rather as if a large private residence with a remarkable art collection had been thrown open to the public."[6] Despite constant criticism from his contentious client, Cret completed the building in February 1925.[7]

On the walls of the new building, Barnes arranged his paintings and objects into "ensembles," carefully crafted groupings that reinforced the formal details of paintings: the handling of paint, the interplay of colors, the use or absence of traditional drawing, and the composition of a work. The symmetrical ensembles were intended to reveal new and unexpected relationships among the paintings, furniture, pottery, and other crafts. His interest was not the artist's life, the historical context in which it was painted, or even the subject depicted, but rather in how the artist arranged paint on canvas. This was an educational institution, not a museum, and descriptive labels and texts were a distraction. Albert Barnes was not only an art collector; he was also the creative force behind the entire enterprise. The pieces he so carefully purchased, and the unique ensembles he assembled reveal his aesthetic, his pedagogy, and his aspirations.

Ultimately Barnes aspired to promote democracy. What he characterized as a "scientific" and "objective" method of looking closely, identifying formal patterns among the different works, and expressing what they saw taught Barnes's students about art, but also much, much more. Students would also improve their critical thinking and become more productive and participatory members of a democratic society. The lectures and discussions he began in the factory, and required reading of the dense and daunting *The Art in Painting* (1925), became the core of the curriculum. Outside, in the arboretum, Laura Barnes taught courses in horticulture that fostered the same appreciation of form, composition, line, and color as her husband's courses did inside.

Classes were free of charge to deserving students, defined by Barnes as "plain people, that is, men and women who gain their livelihood by daily

toil in shops, factories, schools, stores and similar places"—similar to his factory employees, and not very different from his childhood neighbors. At the Barnes Foundation, students always came first. Others could only visit by invitation or with his written permission, and only when classes were not in session.

After establishing the school and curriculum, Barnes eagerly sought to extend its benefits to students beyond the foundation's walls. He failed to persuade his alma mater, the University of Pennsylvania, other colleges, as well as the Philadelphia Public Schools, to adopt his curriculum. He also failed to educate the public: a 1923 exhibition of seventy-five of his paintings and sculpture at the Pennsylvania Academy of Fine Arts sparked outrage among Philadelphia's staid art lovers, one of whom called the paintings "immoral, destructive and dangerous," in the *Philadelphia Inquirer*.[8] Furious, Barnes retreated back to Merion and took to writing scathing letters to those who shunned him.

In the course of writing my first book, Kimberly Camp, then executive director of the Barnes Foundation, gave me access to the original bylaws, board minutes, trust indenture, and all of the amendments to it. Between 1922 and January 1951, Albert Barnes amended the trust indenture ten times, so the documents track the decades-long evolution of his views. During his lifetime, he would hold exclusive control over curriculum, collection, and enrollment. After his death, no changes could be made to the collection or ensembles. No artwork could be brought in for temporary exhibits and none could leave the premises for exhibits elsewhere. Nothing could be sold. No fund-raising events could be held; no admission charged. The thing that changed was the most important of all: who controlled the board of trustees, and thus the collection. In the final amendment, written soon before his death, Barnes assigned Lincoln University the power to nominate candidates for board vacancies of dead or incapacitated trustees.[9] That decision set the stage for much that followed.

In 1951 Dr. Barnes was killed when a ten-ton truck hit his car on his way back from Ker-Feal, the farm he had purchased in the 1940s and used as a weekend retreat. Laura Barnes succeeded her husband as president of the foundation. Within a year, it was embroiled in the first of a series of lawsuits with its neighbors to increase the number of visitors. The suits extended over the next thirty years.

By 1989 Mrs. Barnes and Violette de Mazia had died, all of the foundation's original trustees had either died or resigned, and control passed to trustees nominated by Lincoln University. Soon thereafter, the trustees appointed one of its members, attorney Richard Glanton, as the foundation's president. By this time the original endowment had been substantially depleted: Glanton

needed to find other sources of revenue. He petitioned the Orphan's Court of Montgomery County, Pennsylvania, which has jurisdiction over charitable trusts, to break Dr. Barnes's strictures: to increase visitation, sell fifteen of the foundation's paintings, and to take some pieces of art on an international tour. Visitation was increased but not enough to make an appreciable difference in revenue because of push back from the neighbors. Selling artwork was out of the question. But the judge did allow the tour. In the early 1990s the court granted permission for the foundation to mount what turned out to be an extraordinarily successful international exhibition of eighty-one masterworks. The tour garnered worldwide acclaim for this hidden treasure, but failed to eliminate the financial problems.

The tour netted seventeen million dollars. Twelve million was used to renovate the dilapidated galleries and install the climate-control and security systems. The remaining five million dollars was placed in a court-controlled fund designated for future building repair. None of it could be used for operating expenses, which had skyrocketed: the electric bill alone grew twelvefold after the new climate systems were installed. Each time the foundation asked the court to increase visitation, the neighbors claimed that cars and tour buses would blight their quality of life. The lawsuits cost millions, further depleting the endowment.[10] The foundation could no longer cover operating expenses, let alone care for the collections, which had been conservatively valued at six billion dollars.

Kimberly Camp served as the first professional museum director for seven years. During her tenure, the Barnes launched its first full-scale effort to catalogue and stabilize the artwork, assess the collection, restore Ker-Feal and the Barnes Arboretum, establish a fund-raising program, and work with the board to establish policies to make it more financially sustainable. Unfortunately, Camp was unable to provide the level of care and attention such world-class treasures deserved.

By 2000, Glanton had been replaced by Dr. Bernard Watson, a distinguished former foundation executive who was determined to find a better future. Drawing on his stature and contacts, he was able to forge a promising agreement among the Pew Charitable Trusts, the Lenfest Foundation, the Commonwealth of Pennsylvania, and City of Philadelphia to save the Barnes. These partners promised to donate and raise one hundred million dollars—considerably more than the organization had ever seen—but only if two conditions were met. First, the trustees needed to approve moving the Barnes Foundation's galleries away from its litigious Main Line neighbors and into Philadelphia. Second, the trustees needed to expand from the five members, four of whom were appointed by Lincoln University, to a total of fifteen. Lincoln would appoint five trustees, and ten would be at large

members appointed by the board. The at-large members would presumably bring stature, wealth, and connections. If these terms were met, the Commonwealth of Pennsylvania would provide a capital grant for building construction that would be matched by grants from foundations and individuals. Philadelphia city government would donate a site in the museum district, the Benjamin Franklin Parkway near the Rodin Museum, Academy of Natural Sciences, Franklin Institute, and Philadelphia Museum of Art.

The proposal sparked considerable anger among former Barnes Foundation students, Merion residents who had changed their minds and now wanted the foundation to remain in place, and many ordinary Philadelphians, which was to be expected since until recently, Philadelphians have not been known to cotton to what the Judge referred to as "a bold new venture." In Philadelphia, new isn't necessarily better. Tradition can trump progress. For example, until 1984, there was an unwritten "gentleman's agreement" that kept developers from constructing buildings taller than the hat atop the statue of William Penn on City Hall: a mere 450 feet. Another example: some locals continue to mourn the move of the world-class Philadelphia Orchestra from the lovely pre–Civil War era Academy of Music to the acoustically superior Kimmel Center just two blocks away. This civic conservatism goes a long way toward explaining why so many locals were so angry about the Barnes Foundation's move from Merion to Philadelphia.

Despite opposition, in September 2002, the Barnes Foundation petitioned Orphan's Court to amend the indenture and bylaws, a proposal that clearly ran afoul of Dr. Barnes's intentions, and infuriated some long-term supporters. Two years later, after an exhaustive trial that featured extensive fact-finding, long legal briefs, and ten days of expert testimony, Judge Stanley Ott issued an opinion. The move to Philadelphia, in his words, "represented the least drastic modification of the indenture that would accomplish the donor's desired ends."[11]

Ott based his decision on three findings. First, he found that the foundation could not afford to remain in Merion. Opponents to the move stated the Barnes could generate sufficient revenue by selling non-gallery assets, but the valuations proved too low. Second, the Judge found that the move to Philadelphia was financially feasible because one hundred million dollars could be raised to build the building, but only if the board consisted of "well-connected, highly influential people." This required tripling the current board of five trustees to fifteen. Finally, the court found it would be possible for the foundation to sustain the new Philadelphia museum as well as the arboretum and house in Merion and the Chester County farm, Ker-Feal. Judge Ott also wrote in his opinion:

> By many interested observers, permitting the gallery to move to Philadelphia will be viewed as an outrageous violation of the donor's trust. However, some

of the archival materials introduced at the hearings led us to think otherwise. Contained therein were signals that Dr. Barnes expected the collection to have much greater public exposure after his death. To the court's thinking these clues make the decision—that there is no viable alternative—easily reconcilable with the law of charitable trusts. When we add to this revelation to The Foundation's absolute guarantee that Dr. Barnes' primary mission—the formal education programs—will be preserved, and, indeed, enhanced as a result of these changes, we can sanction this bold new venture with a clear conscience.

Said another way, in his ruling, Judge Ott sought to preserve the original mission, the "spirit and feeling" that Dr. Barnes embedded in his foundation. Ott sought to keep the Barnes as authentic as possible.

In 2005, Kimberly Camp resigned, and the following year the newly expanded board of fifteen trustees hired Derek Gilman as executive director. The job seemed a perfect match with his interests and talents. At the time, Gilman was director of the Pennsylvania Academy of the Fine Arts, but had always loved the Barnes and knew it well since he lived close by and visited it often. He also had built and expanded museums so knew the process and challenges.

Gilman knew the new Barnes needed to bring the founders' vision into the twenty-first century and assure its sustainability. That meant spaces were needed to generate income and accommodate school groups as well as many types of visitors. He also recognized that visitors sought an experience akin to the Merion galleries. The world was watching to see if the new Barnes got it right.

According to Gilman and Aileen Roberts, chair of the board's building committee, the team continually kept Dr. Barnes in mind, though they were not obliged to. Judge Ott presented few legal constraints beyond ordering that the collection be hung the same as in Merion. The lead funders, Pew Charitable Trusts, Lenfest Foundation, and Annenberg Foundation, were essentially hands-off. With license to choose the best lead architects, after a lengthy process, they selected Tod Williams Billie Tsien Architects and Olin Partnership, landscape architects. The architects invited Fisher Marantz Stone Partners on board as lighting consultant.

How to preserve the essence of the old Barnes in a twenty-first-century museum? The architects fashioned an elegant solution: keep the original intact and build around it. Conceived as a "gallery within a garden and a garden within a gallery," the new Barnes is actually designed as two buildings: a replica of the original Barnes, which insiders refer to as the "treasure chest," set inside a larger structure, the two connected by a translucent canopy that casts natural light during the day. The exterior and the interior of the larger structure are made of the same Israeli limestone, though with

different finishes. The exterior wall of the treasure chest is also faced in Israeli marble. The gate is made from bronze rods with a syncopated pattern of circles and rectangles welded to them. These separates the treasure chest from the larger building.

Behind the gate, the collection is presented in a twelve thousand square foot structure that replicates the dimensions and shapes of the original Merion spaces. The ensembles, wall covering, floors, and moldings are essentially the same, as are Cret's large wooden windows, now painted metal. In Merion, yellow drapes often covered the window to protect the paintings from light damage, but they cast a yellowish tint that dulled the colors. In the new, tinted and reflected glass layers were used instead, part of the technologically sophisticated combination of natural and artificial light that illuminates the galleries.

"Would Dr. Barnes approve?" I asked Gilman. "Well, we know from Barnes's correspondence with Cret that he wanted a state of the art gallery," he said. "So, we had a pretty strong sense if he were re-doing it, he would say, state of the art lighting."[12]

Beyond some subtle updates of molding, flooring, and essential but invisible security, there are two significant additions. First, there is a small interior garden—"the garden within the gallery" that is inserted between two galleries. It not only lets in more natural light, it is also a respite for those following the circuit of densely packed galleries. Second, some classrooms are inserted in the circuit so students can study Dr. Barnes's treasures using Dr. Barnes's method without interfering with the more casual visitors' enjoyment.

Outside the treasure chest, in the larger structure, the team had virtually unlimited latitude and added virtually every type of space contemporary museums need: classrooms and seminar rooms, a 150-seat auditorium, a special exhibition gallery, a painting conservation studio, a library, a restaurant, a coffee bar, and administrative offices. The most dramatic feature in the larger building is a vast and perfectly proportioned court, which is used for concerts, fund-raisers, cultivation events, break-dance lessons, and weddings. The income sustains the core mission.

In a nod to Laura Barnes and environmentalism, the building is built green. It incorporates a system that collects rainwater for site irrigation, and an infiltration basin that allows water to infiltrate back into the ground. This and other sustainable design elements brought the building the prestigious LEED platinum certification, making it the first museum in the United States to achieve this, the highest possible designation.

Recently, I stopped by the Olin Partnership's cluttered beehive of an office to hear Laurie Olin's approach to the Barnes Foundation's landscaping. "I knew

the site because I had worked on a master plan for Benjamin Franklin Parkway," he told me. "There was an awful building on it, a city prison called the Youth Detention Center that the city tore down to make way for the Barnes." His challenge was to "give the visitor a sense of I've left the city and I'm going somewhere else."[13] Not easy on a small, urban lot surrounded by skyscrapers, a Whole Foods, and the main branch of the Free Library of Philadelphia.

"When we're out in the city, we develop instinctive animal behavior in which we shut down a lot of incoming information because there's too much stimulus and too much noise, and too much distraction in a city," he explained. "It overwhelms the senses. But, when we're in a museum, we've got to put that aside. You've got to open it up so people are more appreciative, more sensitive, more visually astute, more aware. The landscape is designed to calm people so they can be at their most receptive."

The next day I stopped by the Barnes to see whether it worked. I parked on Twenty-First Street, the side with the building's mechanicals and loading docks, then turned the corner onto the Benjamin Franklin Parkway, and walked down the block. In front of me was what Olin called the "forecourt." Inspired by Laura Barnes's gardens, the landscape architects replicated its Franklinia trees, confers, and Japanese maples, then added an infinity pool where children cooled their bare feet on this hot summer day. Olin's signature wooden benches flanked the pool, looking like the upside down canoes he might have remembered from growing up in Alaska. Behind the pool were ledged walls where homeless people dozed, and nannies shared space with tourists studying maps.

Near the pool a path ascended past stepped planters, each with a shaggy evergreen, and met at the top another path running perpendicular. At the juncture of the two paths stood an eighty-foot-tall stainless steel sculpture, "Barnes Totem, 2012," by Ellsworth Kelly. The path led alongside the Barnes's Israeli limestone wall, one side fronted by a reflecting pool running its entire length, the other by red leaf Japanese maples. The path turned left, leading visitors past a frosted glass wall, and up to the imposing wooden doors.

Throughout the public spaces are evocations of Barnes's collections and interests: Cubist bas-reliefs; African motifs in the ironwork gate; Kente cloth design in a tile insert on the floor, and in woven tapestries on the benches and sofas. To assure that each visitor can see the artwork, the Barnes regulates the number allowed in the galleries during busy times. Volunteer docents stand ready to lead tours and share Barnes lore.

"Are the old and new Barnes different from the perspective of an ordinary visitor?" I asked a docent named Paulette Rackow who had taught in both.

"Yes, they are different because we've 'opened up,' there's not a closed, restricted atmosphere, and we're able to service so many more people." She

thought for a minute. "Just like Dr. Barnes wished: everyone, not just an elite group of people."

"You go into a room and look at one of the teaching ensembles on the wall, he's got iron work, he's got pottery, he's got furniture together with the fine art, a Renoir, a Cézanne," she continued. "It's a very objective way to look at a painting, a scientific and objective method. I like it because in most museums it's a 'show and tell.' Here, it's a 'show' but it's not a 'tell.' Barnes wants you as an observer to 'tell,' to make comparisons. The bottom line, he wants you to look."

I thought about Rackow's comments while wandering through the galleries. Even after slogging through Barnes's books, I never really understood what he was trying to do. There was an especially peculiar ensemble in Room Five South comprised of a painting formerly attributed to Hieronymus Bosch, circa sixteenth century; a nude woman by Renoir, circa nineteenth century, showing her plump, rosy behind; Gerard David's *Crucifix with the Virgin, Saint John the Evangelist and Mary Magdalene*, circa fifteenth century; and a wooden yarn winder and a hammered iron hinge, perhaps late nineteenth, early twentieth centuries, both with slightly anthropomorphic heads and extended arms. What did it all mean? What was Dr. Barnes trying to say? Two young women wearing staff insignia walked by, and I asked them to explain. They stopped, tipped their heads, and one said, "It's the arms. Christ on the cross has his arms outstretched, in more or less the same way that the iron hinge and yarn winder do" (see Figure 7.4).

I finally got it. Dr. Barnes was not interested in teaching what the painting or yarn winder depicted, who made them, or when they were made. Instead, he wanted the viewer to see the similarities between them, in this case, outstretched arms. This is the puzzle behind the ensembles. Solving it is so easy a child could do it; a factory worker or other "ordinary person" who has never been in a museum could do it. You don't need to be an art connoisseur or historian to solve the puzzle; in fact, those trained in art might miss the obvious. Though there are many more layers to his philosophy and pedagogy, this is basically it. Obvious. Scientific. Objective.

"How do we build on Dr. Barnes's very focused, very specific approach to what I think of as a 'facilitating' art experience,"[14] mused Thom Collins, the Barnes current president and executive director. "How could we bring these visual literacy skills in reading these actual objects against the context of when they were created?" I had stopped by one last time to meet Collins and hear about his aspirations. He is a Philadelphia native who left the area after graduating from Swarthmore College, held a string of increasingly important positions in significant art museums, and happily returned back home. "Such a healthy institution, well-endowed, well-staffed, so there's a potential to grow," he told me smiling. The new Barnes opened with a fifty million dollar endowment.

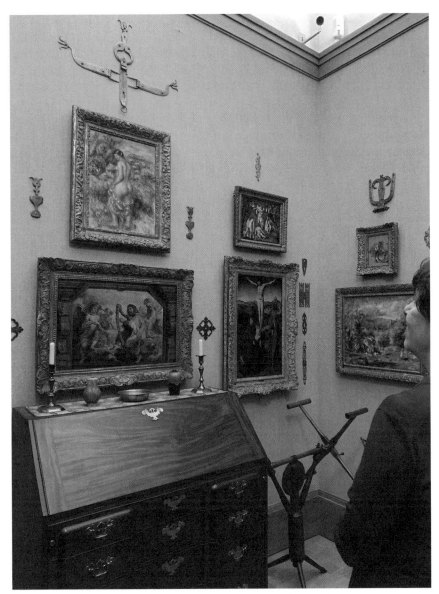

Figure 7.4. The Barnes Foundation, Ensemble in Room Five South.
Courtesy: Nancy Moses

Like his predecessor, Derek Gilman, board member Aileen Roberts, the design team, docents, and everyone else, Collins sees his role as bringing Dr. Barnes's values and visions into the contemporary world. I asked him: "How much of Dr. Barnes remains in the new Barnes? Is it an authentic experience?"

"Well, that depends on your view of authenticity," he answered, then went on to explain that authenticity is linked to identity, and the identity of the Barnes is different for everyone who has experienced it personally or knows about it. Someone who watched *The Art of the Steal* may see the Barnes in a different light than someone who read his books or graduated from the school.

According to Collins, Dr. Barnes was clearer than most museum founders about the mission, his intention, and his expectations for the education program and its students. But the place evolved; it was never entirely "frozen in amber," though it may have appeared that way to some. Dr. Barnes continued to acquire artwork and objects to fill in his ensembles and he always moved them around. His policies changed: initially, art students were welcome, but that later ended. After he died, neither the ensembles nor the curriculum changed but the student body did: it shrunk and became largely white and middle class. The physical plant changed; it deteriorated. The Barnes Foundation in 1925 when it opened its doors was very different from the Barnes in 1951 right before he died, and the Barnes in the 1980s and 1990s.

And it continues to evolve. Barnes's original curriculum is still taught, but there are also a wealth of short classes and longer courses. Visitors continue to ponder the ensembles but soon they will be able to dig deeper using a downloadable app with visual recognition technology. New technology will enable visitors to snap images of pictures and objects and receive curated information about them, as well as upcoming classes and events. There are art-making and break-dancing events, stroller tours for art-loving moms and tots, symposiums for graduate students, and education programs for grades one through twelve.

I asked Collins: "Is this an educational institution that allows in visitors or a museum with a particularly robust educational program?"

"Both," he said, diplomatically. Many attend classes or docent tours, but even those that don't sign up are exposed to Barnes's philosophy. Recently, staff tracked the way casual visitors move through the galleries. The most surprising finding was that when visitors are part of a group, which they typically are, they tend to linger in front of the ensembles to discuss what they see. Collins would argue the ensembles still simulate the same kinds of dialogue that Dr. Barnes intended to stimulate, even for those who don't attend the classes.

Collins and his crew are excited to make the Barnes a place where everyone feels welcome, especially those who live close by. Philadelphia has the highest poverty rate of any large city in the nation. It is also a minority majority city.

"One part of Dr. Barnes's story that has largely disappeared was his real commitment to diversity, inclusion, and social justice issues. It impacted his collecting, the way he organized the ensembles, his educational and cultural philanthropy. It brought him into a dialogue with the Harlem Renaissance. Go to the archives and see great programs of African American musicians. If properly unpacked here, they give us multiple points of contact with new audiences."

There are jazz concerts, family days with hands-on activities, daytime programs for tots, discount or free admission for some school groups. Dr. Barnes's commitment to Lincoln University and its students is realized through classes and paid internships.

"This is the institution Barnes established," said Collins. "Our mission is the same mission that he defined for the institution in 1925 when it opened, exactly the same today.

"We're always asking ourselves: what would Dr. Barnes have done, because this is his institution and we believe in his fundamental commitment—progressive education, diversity, inclusion, social justice. We aren't just doing this because we have to observe the letter of the law. We do it because we believe in these things."

What's authentically Barnes about the new Barnes Foundation? After almost insurmountable financial problems, depleted coffers, angry neighbors, and controversial decision to leave its home for a tony downtown address, does it remain true to its core mission, its "spirit and feeling"?

Undoubtedly the new Barnes is very different from the old. Some who cherished the seclusion and specialness of the old Barnes might mourn their loss and distain the kinetic energy, sometimes massive crowds, and commercialism of the new. Others might find the outdoor pools and interior garden of the new Barnes calming and refreshing, and relish the buzz, international visitors, and inviting menu of things to learn, do, see, buy, and eat. They might enjoy meeting art lovers at member receptions and touring the temporary exhibits, carefully constructed to contextualize the permanent collections. A hundred years ago, conservative Philadelphians found Dr. Barnes's artwork outrageous and dangerous. Now they're mainstream.

To my mind, the new Barnes is not a slavish replica of the old, but rather as an exhilarating reimagining that moves its founder's values, aspirations, and creative contributions forward. At the same time, I miss the old Barnes's secret delight of discovery, the feeling of encountering a treasure trove that's only yours. Thom Collins assured me there are times when the tourists and school children have left for the day and it's possible to silently ponder the ensembles. That's helpful information, but the magic of the authentic experience is gone.

I wonder: Is the loss so important when measured against the gains? A fabulous building in the epicenter of cultural Philadelphia. A vibrant institution instead of one that's shabby and dying. A healthy bottom line instead of expanding deficits. A community that welcomes and celebrates it. A lived commitment to honor what mattered most to Dr. Barnes: his art, his ensembles, and their efficacy in democratizing education.

He was complicated: a pugnacious autodidact determined to follow his own instincts, which also made him impossibly inflexible, and often blind. But in spite of his egregious behavior and unconventionality, his institution and its mission survived when so many others have fallen or strayed. In fact, the Barnes Foundation may be one of the most authentic museums around.

What would Dr. Barnes think of all this? Though people speculate, there's obviously no way to know. I like to think he would be absolutely gobsmacked to find himself celebrated as a creative genius and social visionary in a city that once shunned him.

Chapter Eight

Dinosaur Tales

Two gigantic dinosaur skeletons stand side by side in Pittsburgh's Carnegie Museum of Natural History, their long tails high in the air, their long necks curved toward each other in an imagined Jurassic waltz. One of the creatures is named *Diplodocus carnegii* and the other *Apatosaurus louisae*, in honor of famed industrialist Andrew Carnegie and his wife Louise. Posed on platforms with Upper Jurassic greenery, you can almost imagine them roaming the hills and flatlands of what later became the western United States. Their deaths, some 150 million years ago, were a tragedy for them but a boon for humankind, since these dinosaurs can now reach through the eons and tell us their stories (see Figure 8.1).

Some 314 miles away, in Petersburg, Kentucky, two juvenile animatronic dinosaurs cavort in a diorama in the Creation Museum—next to two animatronic children at play about six thousand years ago. Posed in a lush, Garden of Eden–like setting, you can almost imagine the children leading these dinosaurs home as family pets. These constructed dinosaurs also tell stories, but stories very different from the ones told by the Carnegie specimens. The Petersburg dinosaurs are meant to remind us of the unchanging truth of the Bible and the Gospel (see Figure 8.2).

I knew the Carnegie skeletons from school visits in the 1950s. In the museum's mammoth Dinosaur Hall, *Diplodocus carnegii* and *Apatosaurus louisae* were side by side, their bones posed as stiff as sculptures with their long tails on the ground. Nearby *Tyrannosaurus rex* rose high on its hind legs, its evil teeth barred, its nasty claws spiking from smaller front paws. To a child, the huge dinosaurs were jaw-dropping scary, right out of *Godzilla*. They came to life in the awe-inspiring murals that surrounded the gallery, not as flickering images on a movie screen but as real creatures that actually lived.

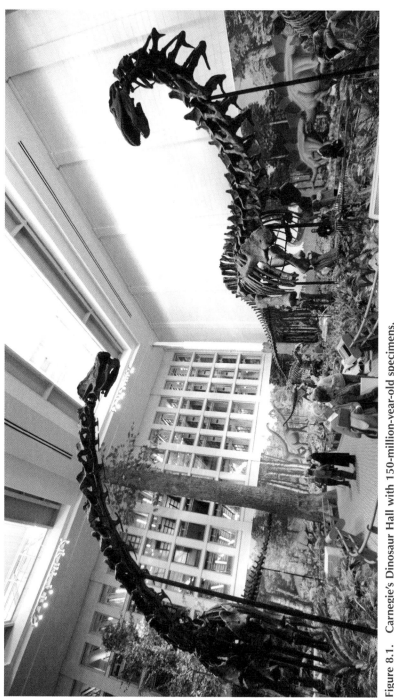

Figure 8.1. Carnegie's Dinosaur Hall with 150-million-year-old specimens.
Image © Carnegie Institute, Carnegie Museum of Natural History

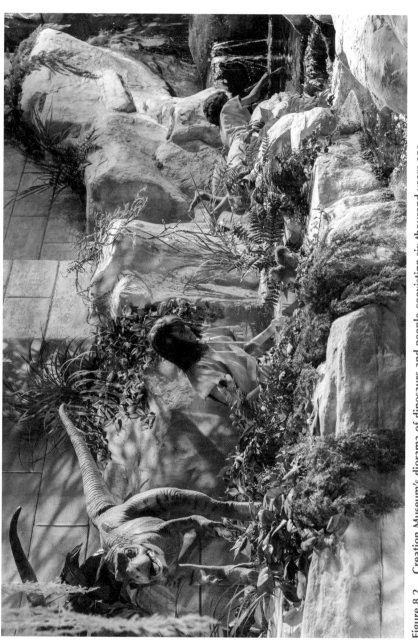

Figure 8.2. Creation Museum's diorama of dinosaurs and people coexisting six thousand years ago.
Courtesy: Answers in Genesis

The museum's modern Dinosaur Hall, called "Dinosaurs in Their Time," is organized chronologically so that you can walk through time—very ancient time—and visit creatures along the way. It's friendlier and more informative with simplified vocabulary, cheerful graphics and invitations to touch the bones, which makes it a place where children smile at the skeletons rather than run screaming from the room. Even the dinosaurs appear very different: *T. rex* has been tamed into a more horizontal version. Even more surprising is the new, scientifically improved *Apatosaurus louisae*. Sixty years ago, it sported a square, bulldog-ish skull with splayed teeth. Now, its skull is more horse-like with pencil-like teeth and looks like its *Diplodocus carnegii* neighbor.

My return to Dinosaur Hall was spurred by a question I've been considering for some time: When it comes to the world of science, how do we know what's false and what's real? This is one of the most politically contentious issues of our times. Does global warming exist? Do vaccinations cause autism? Did evolution really happen or is it only a theory? Every day it seems there's something new. Either advocates are bludgeoning each other with reams of research that support their version of the truth or a new scientific discovery is turning last year's truth on its head.

I thought I might find an answer in dinosaurs. People love dinosaurs, though no one really knows what they looked like, since no one was around hundreds of millions of years ago when these behemoths walked the Earth. Despite this small problem, generations of paleontologists have looked at dinosaur fossils, imagined them in three dimensions, and installed them in natural history museums. How did they know which bones went where? Did the bones tell the scientists how their owners stood and walked and moved? Was it obvious, or did paleontologists have to guess?

As it turned out, these questions are at the heart of paleontology, a science where the evidence, once unearthed, has been interpreted, reinterpreted, and re-reinterpreted. Sometimes fossilized bones from a nest of dinosaurs were initially thought to be from a single animal. Sometimes a single animal's front bones, middle bones, and backbones were thought to be from three different ones. Sometimes the bones from one species were later discovered to come from two different species. To a nonscientist, paleontological truth might seem an ever-moving target. To practitioners, it's just science in continuous evolution. Paleontologists are used to having their hypotheses refuted by new evidence.

That's how scientists work—but not all scientists. There are some creation scientists who believe in the unchanging truth of the Bible. In their view, God created dinosaurs and humans on the sixth day of Creation, which they date to approximately six thousand years ago. Some creationists believe that most

dinosaurs, like most other creatures, died during the great Flood. The only ones that survived were those lucky enough to have a bunk on Noah's Ark.

Scientifically trained paleontologists look to geologic evidence to describe the origins and extinction of dinosaurs; strict creationists look to the Bible. To paleontologists, dinosaurs illustrate science as continuous evolution. To strict creationists, dinosaurs illustrate the unchanging truth of scripture. The two types of scientists look at the same evidence—dinosaur bones—but from very different points of view. Who has it right?

With these questions in mind, I set off to find the truth—or something approximating the truth—about dinosaurs. It was an interesting, enlightening, and, at times, very strange journey.

Pittsburgh glistened in the sunlight of a perfect fall day when Matthew Lamanna reacquainted me with *Diplodocus carnegii* and *Apatosaurus louisae*. They were two of his favorites. Lamanna, the Carnegie's Assistant Curator of Vertebrate Paleontology, is one of those fortunate people you occasionally run across who decide at age four that they want to become paleontologists when they grow up and end up living their dream. By the time Lamanna was in elementary school, he was building miniature dinosaur dioramas and giving lectures to his schoolmates. After graduating from Hobart College, he went to the University of Pennsylvania to study with the great paleontologist Peter Dodson. When the Carnegie job became available in 2004, he jumped at the chance to lead the first renovation in almost a hundred years of one of the world's great dinosaur halls.

The entrance to "Dinosaurs in Their Time" is located beyond the geology gallery. There are a remarkable abundance of specimens, beginning with those from the Triassic Period, the first of the three time periods that make up the Mesozoic Era, or Age of Dinosaurs. Nearby were dinosaur and dinosaur-like fossils from a rock unit called the Newark Supergroup, including an evocative skull of the crocodile-like reptile *Rutiodon carolinensis*. Beyond these was an immature *Camarasaurus lentus* still embedded in rock, head held high, tail waving like a prancing pony. I walked by a platform where two *Tyrannosaurusi rex* appeared to be chatting about the museum visitors who stood chatting about them. In the next room toddlers were excavating fossil replicas, observed by a phalanx of small fossil mammal skeletons set behind a stroller parking lot.

"This museum, without exaggeration, has one of the best dinosaur collections in the entire world," Lamanna said proudly as he led me into the Jurassic Period gallery.[1] He then explained that, in modernizing the exhibits, the Carnegie sought to highlight their rich collection of real fossils and tell the public when replicas were filling in gaps. They organized the halls chronologically,

beginning with the oldest dinosaurs—about 230 million years old—and ending with the youngest, geologically speaking. "*T. rex*, for example, is about 66 million years old. That means it lived closer in time to *us* than it did to *Apatosaurus louisae*, which is about 150 million years old," Lamanna explained. To give the public a more accurate view, the new Dinosaur Hall displays the specimens within replicas of their original environments. The sciences of paleobotany and paleoenvironmental reconstruction were used to replicate the appropriate plants—ferns, conifers, ginkgoes, cycads, and more—and even the Jurassic soil in which they once grew.

"Most of the dinosaurs you see in this gallery come from the same rock layer at the same site, which is now the centerpiece of Dinosaur National Monument in Utah," Lamanna said. "Some studies that have investigated how this site came to be suggest that the rock layer formed over the course of just a few months to a few years." He stopped for a minute and smiled.

"The interesting corollary is that some of the dinosaurs you see here—the actual, individual, dinosaurs—could have encountered each other when they were alive."

It took a while for that to settle in. These actual dinosaurs might have met up at a Jurassic watering hole some 150 million years ago. Ancient geologic time is so mind-blowingly—well, ancient.

We sat on a bench next to *Diplodocus carnegii*. The skeleton measures eighty-four feet long. When it was alive, the animal weighed about twelve tons.[2] "This was the first dinosaur skeleton to arrive at the Carnegie," Lamanna said. "One of our paleontologists named it *Diplodocus carnegii* after the man whose initial inspiration and financial support led to its discovery. It's become our mascot; we call it Dippy."

We then approached Dippy's companion, *Apatosaurus louisae*. This one was seventy-six feet long and fifteen feet tall at the hip. When alive, *louisae* weighed as much as five bull elephants, considerably more than a live *Diplodocus carnegii*. "This one came out of the ground virtually complete," Lamanna said. "It was the first specimen our paleontologists found at what's now Dinosaur National Monument in Utah."

Lamanna mentioned that *Apatosaurus louisae* had changed appearances four times. The skeleton was installed in 1915 without a skull until 1932 when it was topped with the wrong skull, which was then replaced in 1979 with the proper one. For about a hundred years it faced straight ahead with its tail on the ground. Now it's graceful and dynamic, neck curled, tail in the air. Later I wondered: What accounts for these changes? Bad science? Deceptive paleontologists? Or was there something else at play?

In 2004, as Lamanna and his team were reimagining dinosaurs in prehistoric settings, other evolutionary scientists were battling it out with religious

fundamentalism in a courtroom some two hundred miles away. In October of that year, Dover Area School District of York County, Pennsylvania, changed its high school biology curriculum to require that "intelligent design" be taught as an alternative to evolutionary theory. Intelligent design argues that certain features of the universe and living things are better explained by an intelligent cause—by which they mean the Creator—than by what they refer to as an "undirected process" such as natural selection.[3]

In December 2005, a federal judge ruled against the Dover School District. The ruling stated that it was unconstitutional to present intelligent design as an alternative to evolution, calling intelligent design a religious viewpoint advancing "a particular version of Christianity."[4] This time-accepted scientific theory trumped religious dogma.

Paleontology is a relatively recent field of science compared with very old disciplines like astronomy and medicine. Although people from time immemorial had found strange bone-like stones scattered on the ground or buried in the earth, scholars date the birth of paleontology to 1666, when fishermen brought a giant shark ashore near Livorno, Italy, causing a sensation. The local duke, a curious type, ordered the rotting carcass shipped to Florence so that anatomist Niels Steensen could dissect it. No one had ever seen a giant shark up close before, but people had seen mysterious "tongue stones," some embedded in rock. Steensen observed that the teeth of the huge beached shark were very much like the tongue stones. Could tongue stones actually be teeth from sharks that lived eons ago? If so, how did they turn into stone? How did they get inside rocks?

In an astounding leap of scientific imagination, Steensen hypothesized that the ancient sharks must have died on a soft bed of sediment, and the sediment must have hardened over time, encasing them in rock. Slowly, minerals replaced the tooth tissue, though the shape of the tooth remained intact. Steensen then went farther. He hypothesized that the sediment was soft because it was mixed with water. He believed this mineralization process occurred at the time of either the Creation or the Flood.[5]

By the nineteenth century, paleontology was moving from scriptural precepts to evolutionary theory when, in 1859, Charles Darwin published *On the Origin of Species, by Means of Natural Selection, or the Preservation of Favoured Races in the Struggle for Life*, the foundation of evolutionary biology.

The year before, thirty-five dinosaur bones had been unearthed in a marl pit in Haddonfield, New Jersey, more than had ever come from the same animal. When the bones arrived at the Academy of Natural Sciences in Philadelphia, paleontologist Joseph Leidy concluded that the front legs of the dinosaur, which he named *Hadrosaurus foulkii*, were shorter than the back legs, sort

of like a kangaroo. Ten years later he and sculptor Benjamin Waterhouse Hawkins mounted *H. foulkii* as the world's first three-dimensional dinosaur skeleton in a kangaroo-like pose, erect on its back legs with its long tail on the ground. The public flocked to see it, serving as early testimony to our enduring love of dinosaurs. For the next fifteen years, the academy had the market for dinosaur replicas cornered, as major institutions in Europe and America purchased their own remarkable creatures.

Ever since *Hadrosaurus foulkii* has remained a star attraction at the academy. Currently, replicas of its thirty-five bones are displayed in their original kangaroo-like stance in Dinosaur Hall. An imagined model of the entire animal, complete with colored skin, is posed in a more scientifically accurate horizontal position in a central hallway. The original *H. foulkii* fossils are stored behind the employees-only doors upstairs, nestled in a pristine white enamel cabinet reserved for cherished "type specimens." Type specimens are the gold standard against which all fossils purported to belong to this species are judged.

I stopped by to visit the replica bones, imagined dinosaur, and authentic fossils of the same ancient animal, then stopped in a traveling exhibit of colorful anatomic dinosaurs. My destination was one of my favorite spots: the academy's library, one of Philadelphia's most memorable spaces, more or less preserved in its original state. A glass case held one of the few remaining Double Elephant Folios of Audubon's *Birds of America*, the pages turned weekly to reveal another avian masterpiece. Gold-framed portraits of former academy presidents lined the teal-colored walls and peer down on researchers working at well-worn oak tables.

A librarian brought me the second addition of *The Dinosauria*, the definitive work on dinosaurs coedited in part by Peter Dodson, Matt Lamanna's professor at the University of Pennsylvania.[6] This weighty tome of eight-hundred-plus pages is packed with terminology that only a paleontologist could love. The long entry on *A. louisae* describes the Carnegie's skeleton as the type specimen for *Apatosaurus*, which is a sauropod, defined as a long-necked plant-eating dinosaur, and one of the largest animals ever to walk the earth. Sauropod translates from the Greek as "lizard footed," though *A. louisae's* are more akin to those of an elephant, sturdy enough to support its tremendous weight.

Taxonomically, the genus of *A. louisae* is *Apatosaurus* and the species is *Apatosaurus louisae*. Taxonomy might seem boring, but it's actually very interesting. To illustrate connections among, and characteristics of, different animals, scientists have constructed what they refer to as the "tree of life." Animals with similar characteristics are arranged along their taxonomically relevant branches. Dinosaurs—more taxonomically accurate Dinosauria—

share a branch of the tree of life with a number of animals including birds and bird-like creatures.

Although the term "tree of life" sounds scriptural, it is actually based on the scientific theory of evolution. Not everyone subscribes to this theory. According to Pew Research Center's 2015 Religious Landscape Study,[7] 34 percent of all Americans reject evolution, saying humans and other living things have existed in their present form since the beginning of time. In contrast, the majority of Americans, 62 percent, believe human beings evolved. Of those, 35 percent believe it was due to natural processes and 25 percent believe that a Supreme Being guided the process.

There is no such doubt in *The Dinosauria*. It states that *A. louisae* and *D. carnegii* lived in the upper Jurassic Period that spans geologic time from approximately 161.2 to 145.5 million years ago. This was a particularly prolific dinosaur-producing period, not only with sauropods but also with theropods, thyreophorans, ceratopsians, and ornithopods roaming the earth, and marine reptiles such as ichthyosaurs and plesiosaurus and *Archaeopteryx*, the first known bird. The term Jurassic comes from the Jura Mountains on the border of France and Switzerland, where rocks from this period were first found. Today the name is best known for the beloved dinosaur movie, *Jurassic Park*.

In the early days of paleontology, there was some confusion about which dinosaurs were which. For example, most scientists knew *Apatosaurus* as *Brontosaurus*.

This confusion reaches back to the contentious early years of dinosaur discovery that many refer to as the Bone Wars. In 1877, both Edward Drinker Cope of the Academy of Natural Sciences and Othniel Charles Marsh of Yale University proudly announced their discoveries of the first gigantic, quadrupedal North American sauropods. Bone hunters had discovered specimens of these large, four-legged animals in the Morrison Formation, an extensive Jurassic-era deposit that stretches over much of the American West.[8]

Marsh and Cope were the leading paleontologists of their day—and bitter enemies. Despite very limited evidence, both of them rushed to publication to claim the honor of announcing the first large sauropods from North America. In 1877, Cope published a very brief description of *Camarasaurus*. Marsh, working from skeletal fragments, published brief descriptions of four animals he named *Apatosaurus*, *Brontosaurus*, *Morosaurus*, and *Diplodocus*.

Marsh was exceptionally observant. Many of his descriptions turned out to be surprisingly accurate, though some were eventually proven wrong. He believed that *Brontosaurus* and *Apatosaurus* were different genera of the same species. He thought both looked like *Camarasaurus*, and all of them had boxy, almost bulldog-shaped skulls and big, broad, spoon-shaped teeth.

Because Cope and Marsh were viewed as infallible, the next generation of paleontologists clung to their theories. In fact, it took twenty-four years to overturn Marsh's hypothesis that *Brontosaurus* was a distinct sauropod. In 1903, with more specimens than were available earlier, paleontologist Elmer Riggs determined that *Apatosaurus* and *Brontosaurus* was actually the same sauropod. Since the name *Apatosaurus* came first, it became the creature's scientific name. Despite this correction, *Brontosaurus* lived on in the public imagination. This accounts for *Danny and the Dinosaur*, the *Flintstones*, and the 25-cent stamp issued by the United States Postal Service in 1989. Matt Lamanna attributed this enduring confusion to branding. "*Brontosaurus* means 'thunder lizard,'" he told me. "It's so big, you can just imagine this kind of animal shaking the ground as it walks. *Apatosaurus*, which means 'deceptive lizard,' isn't as exciting."

Soon after the *Apatosaurus/Brontosaurus* controversy was resolved in the early 1900s, another dispute emerged, this time about what *Apatosaurus* looked like. Because of this uncertainty, *A. louisae* was installed as a headless skeleton in Andrew Carnegie's natural history museum.

Andrew Carnegie and his family arrived in America as poor Irish immigrants. Through diligence, luck, an instinct for opportunity, and a brilliant head for business, he rose quickly and eventually became one of the world's richest men. Carnegie made much of his fortune in Pittsburgh and was determined to use his wealth to improve society, especially for the workingman. He believed that free libraries would enable workers to better themselves, much as Carnegie had bettered himself. In 1891, he offered to build and outfit a free library in Pittsburgh on the condition that the government covered the cost of ongoing maintenance. The city initially turned him down because of a municipal law, but soon changed the law when Carnegie libraries started springing up in nearby towns.

By that time, Carnegie's dreams for ordinary Pittsburghers had mush-roomed beyond free libraries to an entire citadel of culture, including art galleries, a lecture hall, and a natural history museum. The philanthropist donated $1 million—$249 million in today's dollars—for the massive gray sandstone building that still spans nineteen acres, with Forbes Avenue on one side and Schenley Park on the other. He loved the place.

"The success of the Library, Art Gallery, Museum, and Music Hall—a noble quartet in an immense building—is one of the chief satisfactions of my life," Carnegie wrote in his autobiography. "This is my monument, be-cause here I lived my early life and made my start, and I am to-day in heart a devoted son of dear old smoky Pittsburgh."[9] The Carnegie Institute was dedicated in 1895. His friend, the famed paleontologist O. C. Marsh of Yale, was on the speakers' dais.

There is a story that may or may not be true about how Carnegie secured his first dinosaur. In late 1898, while sitting over breakfast in his Manhattan mansion, he read an article in the *New York Journal and Advertiser* with the headline, "Most Colossal Animal Ever on Earth Just Found Out West!" Accompanying the article was a funny cartoon of a massive sauropod-shaped dinosaur with its distinctive elephant-like legs sitting back on its tail and peering into the eleventh-story window of the New York Life Building. The story included a photograph of a massive bone propped next to the man who discovered it in Wyoming.[10]

Carnegie had seen dinosaur skeletons in other museums and dearly wanted one for his own. That day he jumped into action and wrote a letter to his friend Dr. William Holland, the Carnegie Museum's director. "My Lord—can't you *buy* this for Pittsburgh—try," he scrawled along the margin of the *New York Journal* story before slipping it into an envelope along with a ten thousand dollar check: the equivalent of $295,000 today. Now that Carnegie had a big new natural history museum, he wanted an impressive specimen to put in it. There's nothing quite as impressive as an exceptionally large dinosaur.

Holland immediately booked a fare to Laramie, Wyoming to meet William H. Reed, the bone hunter who had found the fossil. Holland's next stop was the American Museum of Natural History in New York where he poached paleontologist Jacob L. Wortman and fossil preparator Arthur S. Coggeshall, for the Carnegie's new paleontology department. The following year, Wortman and Coggeshall traveled to Medicine Bow, Wyoming to join Reed in his excavations and soon learned that the newspaper story that had caught Carnegie's attention was much less than met the eye. In fact, the entire report had been built from the discovery of a single bone, albeit an especially huge one, from the upper leg of a dinosaur. Lesser men might have been disheartened, but not the Carnegie team. As Coggeshall later wrote, "Discouraging? Yes it was, but bone hunters, like prospectors for gold and silver, have to take discouragement in stride."[11]

Within a few weeks, their perseverance was rewarded by the discovery of a remarkably intact skeleton of a huge *Diplodocus*. The following year other Carnegie paleontologists returned to what was by then called Camp Carnegie, enlarged the quarry, and found another *Diplodocus* skeleton. In 1901, Wortman's successor, John Bell Hatcher, designated the two skeletons as the type specimens of a new sauropod species that he dubbed *Diplodocus carnegii* in honor of Andrew Carnegie. These two skeletons and the tailbones of a third were later combined to form a complete, mounted skeleton of *D. carnegii*. In 1907, it was installed in the Carnegie Museum, which had been expanded to accommodate it.

Apatosaurus louisae was discovered two years later.[12] In September of 1908, while touring the West, Holland and another of his paleontologists,

Earl Douglass, heard about a rich Jurassic site in northeastern Utah. The two men set out to look for dinosaurs. After two days of touring the desolate landscape, Douglass discovered a weathered dinosaur thighbone that appeared to have been eroded out of a rock layer in a narrow ravine. Douglass and an assistant returned to Utah the following spring to look for rock strata that contained additional bones. After months of searching, Douglass discovered eight dinosaur tail vertebrae still joined together in the exact positions they had occupied in the living animal encased in a rocky ledge of a jagged saw-toothed ridge: "I have discovered a huge Dinosaur," he wrote Holland, "and if the skeleton is as perfect as the portions we have exposed, the task of excavating will be enormous and will cost a lot of money, but the rock is the kind to get perfect bones. . . . If it should continue as it has begun it would be the best Jurassic Dinosaur in existence."

This isolated ridge in Utah turned out to be the richest site of Jurassic dinosaur remains in North America. Here, sandstone strata are tilted upward at an angle of sixty-seven degrees, revealing massive accumulations of exceptionally well-preserved specimens.[13] Taphonomists, scientists who study the preservation of animals and plants in the fossil record, have advanced a hypothesis about why this is the case. During the Jurassic Period, they argue, the area was part of a gigantic river system where sauropods and other animals came to drink. During particularly arid years, the river dried out completely, or nearly so, and the sauropods and other dinosaurs died of thirst, overheating, malnutrition, or disease, falling where they stood on the banks or beds of the rivers. Not long afterward, torrents of rain began to fall and swept through the riverbeds, carrying tons of sediment with them, enough to bury the giant dinosaur carcasses. Over time, as the great piles of sediment hardened into sandstone, the skeletons remained intact, encased deep below the surface, untouched by weather or animals, for roughly 150 million years.

As the first *Apatosaurus louisae* emerged from its rocky bed, it became obvious that the skeleton was exceptionally large and complete. About twelve feet from the end of the skeleton's neck was a long, low, horse-like skull similar to that of *Diplodocus*.[14] This was surprising. According to the great Marsh, *Brontosaurus/Apatosaurus* skulls were supposed to be short and boxy. This one wasn't.

Apatosaurus louisae was the first of what eventually became 700,000 pounds of fossils from this exceptionally fossiliferous quarry.[15] Getting the goods home wasn't easy. The sandstone was so hard that chisels soon became dull, forcing the team to make new ones on-site. Piles of rubble had to be hauled away, first by a team of horses, later by specially constructed mine cars. The giant bones, many embedded in rock, were as heavy as

three tons each. They were wrapped in paste and plaster, packed in crates, and loaded into freight wagons for a sixty-mile journey on rutted roads to the nearest railhead. The crates were then loaded into boxcars, shipped to Denver, and reloaded for the final leg of their trip to Pittsburgh. Despite the long journey, the bones of *Apatosaurus louisae* arrived remarkably intact. The skeleton received Carnegie Museum Vertebrate Paleontology specimen number CM 3018. Because the skull had not been found attached to the neck, it was assigned its own number, CM 11162. In 1915, Holland identified the skeleton as the type specimen of a new species and named it *Apatosaurus louisae* after Andrew Carnegie's beloved wife, Louise. It was installed next to Dippy.

By 1922, 446 crates of fossils had taken the train ride to Pittsburgh, enough to build 20 mountable dinosaur skeletons with lots of bones left over. The Carnegie became the best place in North America to see animals from the upper Jurassic Period, and to this day, researchers mine its remarkable collection of 670 catalogued dinosaur specimens ranging from nearly complete animals to single bones.[16]

Although Peter Dodson's specialty is animals that have been extinct for a very, very long time, his primary appointment is in the school that teaches students about live ones: the School of Veterinary Medicine at the University of Pennsylvania. Visiting Dodson would be like spending time with your favorite uncle, if your uncle happened to be a world-renowned expert on horned dinosaurs. Dodson's suite of two offices and the corridor between them is packed and stacked with technical books and articles, professional journals, scientific treatises, and popular books through which he frequently and delightedly digs to illustrate his points.

Dodson calls himself a "geologist, paleontologist, veterinary anatomist, evolutionary biologist, and lifelong Christian."[17] In addition to coediting *The Dinosauria*, he has excavated dinosaurs in exotic countries and taught generations of students. He served as scientific advisor to the Academy of Natural Sciences when, in 1986, it became the first museum in the world to remount its *T. rex* horizontally. "We called that skeleton 'the roadrunner from Hell,'" he said proudly.[18]

I asked him why anyone would need a comprehensive tomb of dinosaur paleontology.

"It's important because the knowledge of paleontology has accrued over two centuries, and there was a lot of debris. For example, sometimes the naming was hasty and extremely basic and not even illustrated, so you don't know what on Earth the scientists were talking about. In *The Dinosauria* we codified the state of knowledge. Sort of tidied things up."

"When I visited the Carnegie Museum as a child, *Tyrannosaurus rex* loomed over the Dinosaur Hall, big and scary. Today *T. rex* is somehow friendlier."

"It's true that *Tyrannosaurus* was first displayed rearing up," Dodson replied, "but we now know the anatomy of the hips and the energetics of walking made it more sensible to show it horizontal. One of the advantages of being a reptile was that the long tail counterbalanced the front end of the body, but if you display the mount rearing up, it causes a problem with the tail. A lot of the old dinosaur mounts actually broke the tail in order to achieve the unnatural reared-up pose."

"What's your opinion of animatronic dinosaurs?" I asked, remembering the ones at the Academy of Natural Sciences and the Creation Museum. "After all, they're not based on science. For instance, we don't know what colors dinosaurs were, right?"

"Oh, you mean the 'prophylactic-osaurus,'" he said grinning. "You know, rubber dinosaurs. I'm not a purist. I don't object if they're responsibly done with scientific advisors and placed in an interpretative context so there's educational value. Kids today have different expectations."

The Creation Museum displays twenty-nine dinosaurs. One of them is an actual fossil specimen, five are "prophylactic-osauri,"[19] and the rest are either replicas of dinosaur fossils or models of what living dinosaurs might have looked like. At Peter Dodson's suggestion, I went to see them for myself. The day in early May when I visited, it was unseasonably cold and had been raining for days. The weather seemed appropriate, since the Creation Museum's parent ministry, Answers in Genesis, recently opened Ark Encounter, a life-size replica of Noah's Ark.

The museum is the brainchild of Ken Ham, a former public school science teacher from Australia who writes that he was called by the Lord to create a "ministry that would combat the lie of evolution and call the church and culture back to the authority of the Word of God." Answers in Genesis, his ministry, is what its website refers to as an apologetics ministry, "dedicated to helping Christians defend their faith and proclaim the gospel of Jesus Christ." Answers in Genesis hosts an especially robust website with many educational documents available for downloading, including *Answers Magazine*, and *Answers Research Journal*, a "professional, peer-reviewed technical journal for the publication of interdisciplinary scientific and other relevant research from the perspective of the recent Creation and the global Flood within a biblical framework."[20] From the site you can also purchase many of books, including one by Ham that explains the "7 Fs of dinosaur history: Formed, Fearless, Fallen, Flood, Faded, Found, and Fiction."

Ham's museum is spacious, welcoming. Within its 75,000 square feet, visitors encounter evocative exhibits, startling photography, compelling videos, and arresting interactive displays, along with well-stocked shops and cafés. There is a planetarium called the "Stargazer's Room," and a special effects theater where, to heighten the experience, visitors are rocked by vibrating seats, stunned with strobe lights, and splashed with sprays of water. The Creation Museum resembled a state-of-the-art natural history museum, but it's something very different. The place is actually an exceptionally well designed, three-dimensional creationism sermon that is carefully crafted to arm visitors with the arguments and "fire" they need to refute what the museum refers to as secular science.

Dinosaurs were everywhere. A long sinuous Chinese dragon glided over a corridor, surrounded by the kinds of red balloons typically found at a Chinese New Year celebration. In addition to the diorama of biblical-era children cavorting with dinosaurs, there are a couple of dinosaurs over the entrance and an animatronic *Pteranodon* wiggling its head and slowly opening and closing its jaw above "Dragon Hall," a bookstore with a medieval castle vibe.

I had never visited a place like the Creation Museum, and as I walked through, the experience became less about science and more about faith. The entrance to the galleries led past a sign describing the "7 Cs of History" as recorded in the Bible: "Creation, Corruption, Catastrophe, Confusion, Christ, Cross, and Consummation." A display nearby compared the falsehoods of human reason about the *Utahraptor* specimen (e.g., that it was slowly buried and fossilized) with the truth of God's Word (e.g., that the animal was suddenly buried by the Great Flood). Past the "Biblical Authority Room," "Graffiti Alley," "Culture in Crisis Room," and the "Time Tunnel" was "Corruption Valley" where a model of a life-size dinosaur was depicted eating fresh kill, signifying its loss of vegetarian status—its corruption—and, thus, the origins of death and disease. Noah's Ark was next, along with an explanation of how dinosaurs were among the creatures saved during the Great Flood. This was followed by an account of the difference between natural selection and evolution, and beyond that an exhibit about the Scopes Monkey Trial told from a religious fundamentalist perspective: "This battle of creation vs. evolution in schools began in a small town in Tennessee. Many families who believe in the biblical account of Genesis seek Christian schools or choose home school as education options." How interesting, I thought, to see the theory of evolution turned on its head.

The museum's most impressive specimen, a real fossil skeleton of the theropod dinosaur *Allosaurus fragilis*, nicknamed Ebenezer, had its own gallery. A video showed which parts of the skeleton are and aren't real and

reconstructs the animal's appearance when it was alive. It was an unusually complete specimen: more than half of Ebenezer's bones had been recovered, including the skull—which, when excavated, still had its original fifty-three teeth. In the gallery, Ebenezer was surrounded by interpretive text from both mainstream and creationist science. "These rock layers were laid down during the Flood of Noah's day about 4,300 years ago," read one panel, describing the find site in Colorado, about forty miles southeast of Dinosaur National Monument, in the vicinity of Carnegie's dinosaurs.

Down a flight of stairs, a video titled "Dragons and Dinosaurs" pointed out what people once called dragons were actually dinosaurs. Nearby was "Buddy Davis's Dinosaur Den," a two-story display of a dozen or so life-size dinosaur models, including *T. rex*, posed on its hind legs, in front of a wall with an ancient Babylonian motif, *Archaeopteryx*, and several flying reptiles. All were "sculpted by our own Buddy Davis" (see Figure 8.3).

Later, at lunch in Noah's Café, a couple that looked to be in their mid-fifties and I sat across from each other at a long trestle table. They were lawyers who had made the long trip from their small Midwestern town to visit the museum. They just loved the place, and looked forward to visiting Noah's Ark the next day. "I'm really interested in how Noah fed all those animals," said the woman.

As for me, I was even more interested in how the dinosaurs could fit on Noah's Ark. The Answers in Genesis website explained all. The Ark was huge—"large enough to hold the contents of more than 450 semitrailers," and the dinosaurs might have been very small. Perhaps juveniles, perhaps football-sized eggs. According to Answers in Genesis, there may have been "as few as about fifty kinds or as many as about ninety kinds of dinosaurs."[21] Paleontologists, by the way, have discovered about seven hundred valid dinosaur species.

What was going on here? Did my obviously well-educated lunch companions and the approximately one million others who have visited the Creation Museum since it opened eleven years ago actually believe that dinosaurs and humans occupied the earth at the same time? More to the point, what were all these dinosaurs doing in this very odd museum? What did they mean?

The Carnegie Museum of Natural History lacks the Creation Museum's biblical certainty. Instead, dinosaurs are explained scientifically, and because science continues to evolve as paleontologists unearth new information, so do the dinosaurs on display. *Apatosaurus louisae* is a case in point. Since its arrival, the Carnegie has mounted it four different ways, which if not a record for dinosaur revision, is certainly a whole lot of changes. It's very expensive to redo a dinosaur.

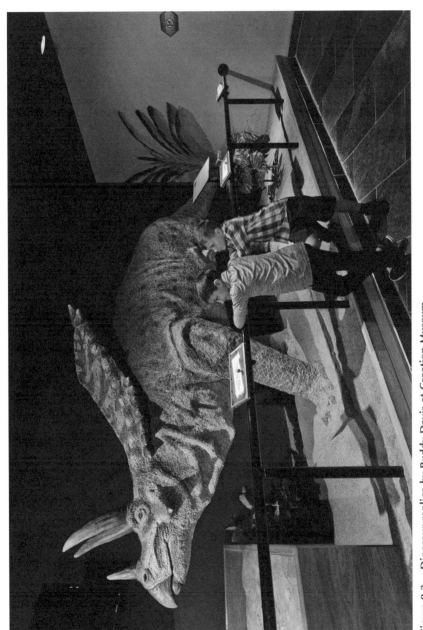

Figure 8.3. Dinosaur replica by Buddy Davis at Creation Museum.
Courtesy: Answers in Genesis

A. louisae's inaugural display was without a head (see Figure 8.4). This was a legacy of the Marsh-Cope Bone Wars. Marsh was convinced that *Apatosaurus* and *Camarasaurus* had similarly short, boxy skulls, and, because of his importance, his hypothesis persisted even after his death. The Carnegie Museum's William Holland wasn't so sure, since his paleontologist, Earl Douglass, had actually found a *Diplodocus*-like skull near *Apatosaurus louisae* in Utah in 1910. Holland had two choices: follow the entire paleontological community and mount what the evidence suggested was the wrong skull on his *Apatosaurus*, or mount what he suspected was the right one. Both options carried risks, so Holland found a third way. He took the politically prudent route and mounted no skull at all. *A. louisae* remained headless for seventeen years: a victim of a vituperative dispute waged eons after the creature's death.

Holland died in December of 1932. That same month, his colleagues at the Carnegie sought to put things to rights. Following the then-accepted wisdom, they mounted a *Camarasaurus* skull atop *Apatosaurus louisae*'s neck vertebra. Thus began the fossil's second incarnation as an *A. louisae/ Camarasaurus* mix. While a minor controversy continued over the proper

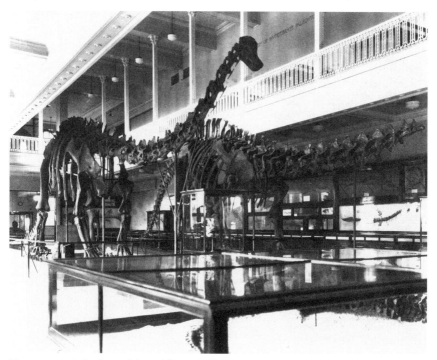

Figure 8.4. *A. louisae* (right) with no skull.
Image © Carnegie Institute, Carnegie Museum of Natural History

skull of *Apatosaurus*, the attention of science moved on to other things (see Figure 8.5).

The fourth and final recapitation of *A. louisae* happened almost fifty years later. It all started when an especially knowledgeable volunteer, Jack McIntosh, and an especially diligent paleontologist, David Berman, asked themselves whether *A. louisae* with a *Camarasaurus* skull was good science or only the accepted wisdom passed down from Othneil Charles Marsh. During the excavations in 1908, Earl Douglass wrote a letter to the William Holland, the Carnegie Museum's director announcing that *A. louisae* and the *Diplodocus*-like skull had been found very near each other and in the same sandstone stratum. When McIntosh and Berman read the letter decades later, they thought: this is very interesting. *A. louisae* had not been topped with this skull from nearby, but rather with another found some five miles further away. The Carnegie colleagues then moved to the specimens. They examined the *Diplodocus*-like skull from *A. louisae*'s dig site and realized it fit seamlessly onto *A. louisae*'s first neck vertebra. Taken together, the written and paleontological evidence made an overwhelming case that *A. louisae* had been topped with the wrong head since 1932.

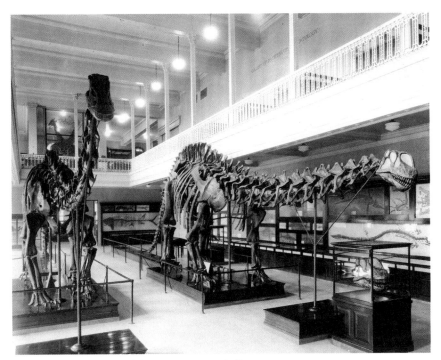

Figure 8.5. *A. louisae* with *Camarasaurus* skull.
Image © Carnegie Institute, Carnegie Museum of Natural History

In October 1979, the Carnegie Museum of Natural History celebrated the seventieth anniversary of *A. louisae*'s discovery by reuniting its skull and body. With the new head, *A. louisae* taxonomically moved from the sauropod group Camarasauridae—animals with square heads and spoon-shaped teeth—to the sauropod group Diplodocidae—animals with horse-like heads and pencil-like teeth. Over time, *Apatosaurus* at the University of Wyoming, the Field Museum of Natural History in Chicago, the American Museum of Natural History, and even Marsh's Yale Peabody Museum in New Haven came to sport horse-like skulls.

A. louisae's current appearance as a waltzing sauropod came about in the mid-2000s, as part of the thirty-six million dollar transformation of Dinosaur Hall into "Dinosaurs in Their Time." By this time, I was fascinated with dinosaur mounts, and wanted to follow the chain to its final link, so I called Phil Fraley, whose company handled the installation.[22]

Fraley, for many years, was the go-to guy on dinosaur display. He remembered remounting was quite a challenge. Although *A. louisae* was an exceptionally complete specimen, after ninety years on display it showed significant signs of wear. "It's lucky the Carnegie decided on the renovations when it did," he said. "Left alone, *Apatosaurus louisae* was at risk of eventually crashing to the floor."

Fraley's team took *A. louisae* apart bone by bone, removed the shellac layered over the bones, disassembled them, then removed and replaced the glue holding some of them together. They built new armatures that were better able to carry the skeleton's mighty weight. They then set it in the more expressive pose we see today. The process took the equivalent of ten people working full-time for fifteen months. The price tag was more than one million dollars.

"Every aspect of this *A. louisae*—the position of its long, sinuous tail, the placement of the bone material—was done as correctly as we could, from a paleontological, morphological, and scientific perspective," Fraley said proudly.

This was the last of *A. louisae*'s four incarnations, evolving from a headless, to a wrong-headed, to a right-headed, and finally to a waltzing sauropod. Each mount was correct at the time, then changed when new facts came to light, *showing* how the evolution of science transform what visitors experience (see Figure 8.6).

Brian Osborn, who holds a master's degree in education from Lee University, is proud to be a speaker, writer, and curriculum specialist for Answers in Genesis. A week after I visited the Creation Museum, we had a long chat. Osborn believes that people lived when dinosaurs walked the Earth. "The evidence exists now," he told me. "We see dinosaur fossils now. But they

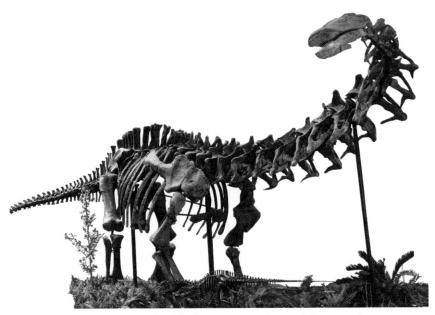

Figure 8.6. *A. louisae*, the scientifically accurate and graceful sauropod.
Image © Carnegie Institute, Carnegie Museum of Natural History

must be interpreted with a set of assumptions about the unseen past that are based on your worldview. If you interpret the evidence with the wrong set of assumptions, you'll most likely reach the wrong conclusions. And that is why we suggest that secular scientists are so far off on certain things. We interpret from a Bible point of view to get to different conclusions most of the time."

When I asked why there are so many dinosaurs at the Creation Museum, he gave a laugh, and then explained. "I joke about this when I talk about dinosaurs," he said. "They are just awesome critters, kids love dinosaurs, we all love dinosaurs. They really engage people, and we can use that as a way to answer a lot of questions. In our minds as a ministry, that's the role they play: to understand them biblically, historically, and then to use them as a springboard to get to the Gospel."

"Often in my talks," he went on, "I call dinosaurs 'missionary lizards,' for two reasons in my mind. One, when you understand them biblically they show a very important truth: that you can trust the Bible, you can trust everything that it says. So that's a part of telling the story of Creation and also the Gospel. We also call them missionary lizards because they remind us of death. One of the wages of sin is death, and it all comes from falling short of the glory of God. So dinosaurs remind us that we're all sinners like Adam."

I wondered what the ministry said about dinosaurs and extinction.

"From a biblical perspective we can make some good biblical educated guesses. You can't be dogmatic, but they seem to make sense for the context," he explained. "In Genesis 6:13, God told Noah that the purpose of the Flood was to destroy mankind and the Earth. After the Flood, the climate changed, which made it tougher for all animals, including man and dinosaurs, to thrive. Maybe there wasn't enough food. Maybe dinosaurs were threats, and man killed them off to protect livestock and crops. Maybe people hunted them for trophies, the exact same reason people hunt animals to extinction today," said Osborn. "So a good educated biblical guess is there was extinction after the Flood. That's how we put it."

He drew on a recent trip to the Grand Canyon to explain in more detail. "The rock layers in the Grand Canyon scream rapid deposition. You have one rock layer right on top of another; there's no sign of slow erosion, no time for bio-invasion. We find bent rock layers, supposed to represent millions of years. They're bent over ninety degrees without cracking, which is impossible since you can't bend a hard rock. They must have been soft, right after the Great Flood. You get the idea."

Where did the science in the Creation Museum come from? Osborn explained there are many Christian scientists, some trained in Christian colleges, others with graduate degrees from secular universities. All believe there are different ways to "guess" about the unseen past, and these scholars believe in the biblical worldview. They publish in *Answers Research Journal* and speak to Creation Museum visitors and outside groups about the connections between science and the Gospel. They extend the ministry.

A couple of months after visiting the Creation Museum, I went back to Pittsburgh to visit *A. louisae*. I climbed the sleek staircase to the balcony, which afforded a treetop view of the tableau. Three pterosaurs with skeletal wings were suspended in air close to the balcony, by almost invisible wire. Down below, in the Jurassic hall itself, a mural depicted a Peaceable Jurassic Kingdom. From this perspective, the Dippy and *A. louisae*'s skulls were close together, as if awaiting their waltz to begin. Armatures and metal fittings buttressed their body parts and cradled each bone, holding them in place. One of the *A. louisae* armatures arched the tail, curving it down and up again, supporting the ever-smaller bones leading to the end. The two back legs of *A. louisae* appeared almost identical, though only one is mostly real. That one is striated; the replica leg was smooth. The specimens were so compelling, the supports so subtle, that you quickly forgot the replica bones that filled in where the real ones were missing. You believed the creatures were real.

So, when it comes to dinosaurs, what's real and what's fake? Does evolutionary biology trump creationism or intelligent design? Does faith have a legiti-

mate voice in the debate? The progenitor of paleontology, Niels Steensen, theorized that Creation or a flood supplied the soil with the water that submerged the ancient sharks whose teeth eventually fossilized. Even Charles Darwin, educated for the clergy, struggled to reconcile his wife's devotion to Scripture with the physical evidence that led him to his theory of evolution. These questions are nothing new, but now they cleave our nation into ever more strident camps.

Some might find it surprising that creation science is spreading worldwide; that there are forty-five creation museums, including institutions in such far-flung locations as Portugal, Canada, South Africa, Hong Kong, and Australia, as well as the United States.[23] Kentucky's Creation Museum, perhaps the biggest of them all, is becoming even bigger as new attractions come on line.

But not everything called "science" actually is. Science is replicable; it draws from experimentation and observation; it uses empirical evidence to tests theories, and creative thinking to solve problems. Not creation science. As philosopher James Ladyman wrote, "No matter how much self-styled creation scientist cites their alleged empirical evidence for the Garden of Eden, Noah's Ark, the flood, and other events of the Bible, most geologists are convinced that all the scientific evidence points to the Earth and the life it supports having been in existence for millions rather than thousands of years."[24]

Likewise, not everything that looks like a science museum actually is one. While the Creation Museum employs the same iconography, images, display technology, and even the same dinosaurs as a science museum, its goal is not science education but rather religious indoctrination. Here is some supporting evidence: public schools regularly send classes to learn science in science museums. As I learned from Brian Osborn, public schools do not send classes to the Creation Museum. That's because it's about religion, not science.

Peter Dodson is interested in the intersection of faith and science and wrote about it in a paper titled, "On Fossils and Faith."[25] As a geologist, paleontologist, veterinary anatomist, and evolutionary biologist he has seen scientific evidence that life has a deep history reaching back 3.8 billion years. As a lifelong Christian, his faith tells him that there is more than a strictly scientific account of human affairs.

Dodson finds insight in Genesis 1:31, "God's own assessment of the work of Creation on the Sixth day: 'God saw everything that He had made, and indeed, it was very good.' Very good is not perfection," Dodson argues. "Creation is not finished—it is ongoing." It's evolving. Dodson occupies a world that cherishes science for scientific truth and the Bible for religious truth, undertaking the most rigorous science without sacrificing his belief. The great paleontologist carries both fossils and faith in his heart.

Peter Dodson and Matt Lamanna are amazed by the unprecedented pace of advances in their field, driven by the largest and most international cohort of paleontologists of all time. Some are conducting research that will undoubtedly affect the next generation of dinosaur exhibits. The new science of paleocolor is using such cutting techniques as time of flight secondary ion mass spectronomy to search for evidence of pigments.[26] Scientists at North Carolina State University, the Chinese Academy of Sciences, and Linyi University in Shandong Province, China, have found evidence of original keratin, which is protein, and melanosomes, which are pigment-containing structures, preserved in a 130-million-year-old specimen.[27] Though no one has completely solved the color conundrum, they are well on their way.

My personal favorite is the return of *Brontosaurus*. Recently, Emanuel Tschopp, a vertebrate paleontologist at the New University of Lisbon, Portugal, led a team that analyzed 477 different physical features of 81 sauropod specimens in museum collections in Europe and the United States. He and his collaborators wrote a paper arguing that *Brontosaurus*[28] is, in fact, distinct from *Apatosaurus* after all, and thus entitled to a genus all its own. Not surprisingly, many other paleontologists are skeptical.

One can imagine future natural science museums and creation museums displaying animatronic *Brontosaurus* sporting a scientifically accurate color palate. In the science museums, *Brontosaurus* would be a next step in the search for knowledge. In the Creation Museum, it would be another dinosaur that made it onto Noah's Ark.

Chapter Nine

Incorruptible

She lay on her right side on a marble slab in the glass-fronted gold casket, a marble virgin with a deep gash carved into her neck. Her body was draped in a marble gown, her head, fully covered with a marble scarf, was turned to the back, away from the viewer. Her arms were stretched in front of her, with fingers making the sign of the Trinity (see Figure 9.1).

The sleeping beauty glowed with celestial light in her black marble niche. An inscription in Italian was set in a medallion on the floor. Translated, it read:

> Gaze upon the likeness of the most holy virgin Cecilia,
> Which I saw myself lying in an entire state in the sepulcher.
> I have had this same likeness
> Precisely in the same position her body lay
> Expressed for you in marble.

Above the statue, a priest in a sea green and gold vestment raised his hands and chanted the ancient prayers of the Sunday afternoon mass. The faithful chanted in response, and the sweet voices of the parish choir filled the basilica. I stood respectfully in the rear, inhaling the incense and heavenly aura of this Roman-medieval-baroque-Victorian-modern church, the Basilica of St. Cecilia, an ecclesiastical time capsule.

Santa Cecilia—Saint Cecilia in English—is everywhere in this, her patronal church. In the ninth-century mosaic over the apse, she stands between Saint Paul and Pope Paschal I, her hand protectively on the pope's shoulder. She rises from her coffin in a thirteenth-century fresco. In another lavish baroque fresco, which fills the ceiling over the nave, she kneels before Jesus awaiting her crown of lilies, surrounded by angels, *putti*, prophets, the True Cross, the Virgin Mary, and a pipe organ. In one chapel of the basilica she

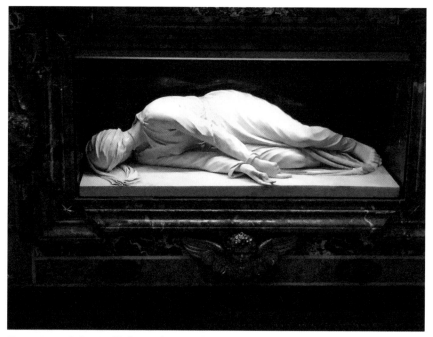

Figure 9.1. *Saint Cecilia* by Stefano Maderno, 1599, depicted at the moment of death, her hands showing undying love for the Trinity.
Getty Images

is rendered in majolica tiles; in another, she is the beatific virgin welcoming the executioner's sword—the source of that deep gash in her neck—in *The Beheading of St. Cecilia.*

Popes and cardinals who founded and financed St. Cecilia's basilica also claimed a permanent place in the church: Pope Urban I, who inherited her home and used it as a clandestine place of worship; Pope Paschal I, who, five centuries later, transformed the deteriorating *titular*, or neighborhood church, into a grand basilica; Cardinal Paolo Emilion Sfondrati, who rejuvenated it into a religious tourist attraction for the Jubilee of 1600; Cardinal Francesco Aquaviva, who raised the structure to high baroque style. Every tomb, fresco, painting, sculpture, and mosaic is embellished with gilt and Christian symbols.

The Basilica of St. Cecilia is located in the heart of Trastevere, an ancient riverfront neighborhood across the Tiber from central Rome. In Cecilia's time, less than two hundred years after the birth of Christ, it featured villas and gardens for the wealthy and routes for goods traveling into and out of Rome. The twisted ribbons of streets that travelers, merchants, sailors, and prostitutes once walked are now filled with tourists licking gelato, perusing

souvenirs, fending off beggars, and sitting at café tables watching other tourists. Adjacent to St. Cecilia is one of Rome's finest restaurants, a favorite of the archaeology professor and his wife who suggested that I choose this church, out of the more than nine hundred in Rome, to study.

It turned out to be an excellent choice, since the martyr and her church have everything you want if you are interested in saints, martyrs, and relics: an inspiring and gory story; a courageous girl who gladly sacrificed her life for God; a musical celebrity who attracts international acclaim. The building itself is an artifact of the devotion of the entire sweep of Christianity from its Roman roots to today. The basilica is also a vibrant, living church cherished by its parishioners. It even has its own order of Benedictine nuns. Moreover, because there are other Roman virgins who gave their lives to God, as well as other Roman churches dating to the early eras of Christianity, Cecilia and her basilica are not just unique but representative (see Figure 9.2).

Focusing on a single saint in a single church opened a larger, more intriguing world, a world about which I'd been curious ever since reading Chaucer's *Canterbury Tales*. As you will recall, *Canterbury Tales*, published in 1400, is a series of twenty-four stories told by a group of thirty pilgrims to pass the time as they traveled to and from Canterbury, England. "The Second Nun's Tale" recounts the legend of St. Cecilia in considerable detail. It started me

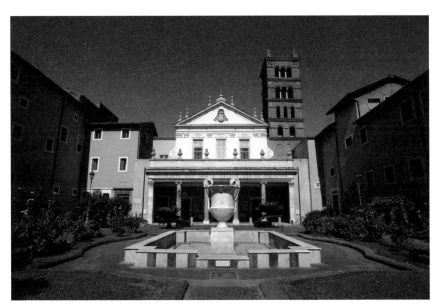

Figure 9.2. Basilica Saint Cecilia in Trastevere, Rome.
Almay Stock Photo/Vito Arcomando

wondering about this particular saint and, more generally, the authenticity of martyrs, saints, and their relics.

Were saints and martyrs real people who actually lived? How did they get to be saints? Who decides such things? What exactly is a religious relic? Why do the devout believe that relics are real, that they possess spiritual power? Those raised as traditional Catholics know the answers to these questions. To someone outside the faith, it's mysterious and confusing, especially the question of why these relics, these bits and pieces of cloth, wood, and the formerly living carry spiritual power. It was a mystery worth exploring, but only with the open heart and respectful curiosity that such matters deserve.

But where to start when you know so little? A trip to Rome was essential; but before that, I needed to make a pilgrimage to a saint closer by and find someone willing to guide me. I found both about a mile from home at the National Shrine of Saint John Neumann. Father Neumann, born in Bohemia in 1811, was a champion for immigrants and the poor at a time of anti-Catholic sentiment in America. While serving as Bishop of Philadelphia between 1852 and 1860, he established the first Catholic diocesan school system in the United States. Many miraculous cures have been attributed to him, and Pope Paul VI canonized him in 1977. Now busloads of devout Christians visit the Neumann Shrine, write prayers for his intercession on small slips of paper, and place them in a special box. In advance of my visit, I contacted Dr. Patrick Hayes, who manages the shrine and serves as archivist for the Redemptorists, the order to which Saint John Neumann belonged. Hayes met me at the shrine and led me to his cluttered office in a building nearby. He is rumpled, cheerful, knowledgeable, and exceptionally patient.

We chatted a bit about saints, martyrs, and relics. I learned that all martyrs are saints but saints include more than martyrs. According to the Roman Catholic Catechism, martyrdom is "the supreme witness given to the truth of the faith: it means bearing witness even unto death."[1] The category of "saint" is more inclusive. Saints are people who perform two verified miracles— either when they were alive or after they have died—and have lived such exemplary lives that they are thought to enjoy direct contact with God. Every saint has a cult, a group of the faithful that venerate him or her.

The cult of the saint was one of Christianity's gifts to the world. Before it, people prayed to spiritual beings like guardian angels. These spirits, in the words of Peter Brown, "linked the layers of the self to the divine through a close-knit chain of nonhuman intermediaries."[2] In contrast, saints were human. They had bodies. They were not different from people but, rather, individuals blessed with the power to intercede with God on behalf of others. In other words, saints are intimates to whom people turn for friendship, inspiration, and protection in this life and beyond.

A relic is a material object related to Jesus or a saint—for example, a finger, a bone, a hair, or a piece of clothing—preserved for posterity in a reliquary. There is actually a hierarchy of relics. A first-class relic is the body of the saint himself or herself. A second-class relic is an object that was used by the saint. A third-class relic is an object that touched a first- or second-class relic. The most reliable relics are those accompanied by provenance records that verify their authenticity, officially certified by a bishop or a postulator, an official tasked with gathering and vetting evidence related to sainthood.[3]

After reviewing the basics, Hayes told me that St. Cecilia, who is simultaneously a saint and a martyr, was an excellent choice, though there were many other early Christian women martyrs. He suggested I try to secure an interview with an official of the Congregation for the Causes of Saints, the Vatican department that oversees all the saints; but he cautioned me not to count on it.

Hayes had one more suggestion: "If you're interested in relics, you might want to visit the St. Anthony Chapel in the Troy Hill section of Pittsburgh. It has about five thousand relics, more than any place outside the Vatican."

A church in Pittsburgh with five thousand relics? I grew up in Pittsburgh, but this was news to me. It was swelteringly hot on the day I'd chosen to visit St. Anthony Chapel, at the top of the treacherously steep Troy Hill, and my rental car struggled up the hill before reaching it.

The chapel was cool and largely empty. There were about a dozen people there—some praying and others like me, and a group of Japanese tourists, visiting. A volunteer answered questions and ran the audiotaped history of the chapel. "People come here and cry," the volunteer said. "It's a very, very peaceful place." I took a seat in a pew near the front and looked around in awe. Every wall in the sanctuary was covered with shelves and cabinets, and every shelf and cabinet was filled with gold and jewel-incrusted reliquaries.[4] There were large and lavishly decorated reliquaries, including two that contained the skulls of the martyrs Saint Macharium and Saint Stephana and another housing the entire skeletal remains of the martyr Saint Demetrius. There were small reliquaries with tiny windows through which you could see minuscule slivers of saints, apostles, martyrs, virgins, and canonized popes. The most venerated reliquary contains both a piece of the True Cross and a relic of Mary Magdalene. Five hundred and twenty-five relics have certificates of authentication.

All of the reliquaries were collected in the mid-1800s by Father Suibert Godfrey Mollinger, pastor of the Most Holy Name parish, then an inconsequential congregation in the Pittsburgh suburbs.[5] Mollinger came from a noble and wealthy Belgian family. He used a substantial amount of his wealth

to travel back and forth to Europe in the mid-nineteenth century to harvest relics from the churches and monasteries that had been closed in the wake of republican revolutions in Germany and Italy. Many of the relics were being discarded or destroyed, and others could be bought for very little. He acquired so many reliquaries that the Most Holy Name church could no longer hold them, so he built a chapel nearby.

Although the reliquaries carried no identifying labels—St. Anthony is a chapel, not a museum—there was a typewritten catalogue that lists each saint alphabetically, his or her feast day on the liturgical calendar, and the location of each relic in the chapel. St. Cecelia of Rome had a number of listings. One was at location M-0006 E22, in the center of the case above the main altar, a prime location. Her relic could look out directly over the parishioners or admire the highly decorated walls, nave, and stained-glass windows. "Cecelia of Rome is one of the four Virgin Martyrs," explained the volunteer.

The presence of the relic was surprising. According to legend, when St. Cecilia's remains were disinterred in the ninth century, her body had totally disintegrated. If that was true, there was no body; and if there was no body, how did three pieces of St. Cecilia get to Pittsburgh? Was I in the presence of a saintly miracle, a spiritual mystery? Could the answer be found in the Basilica of St. Cecilia in Rome?

There are many accounts of Cecilia's martyrdom, which is not surprising, since the events happened so long ago and her legend was passed on so many times. Most versions are based on the *Passio Sanctae Ceciliae*, a set of documents written by those who witnessed the martyrdom and the creation of the cult that handed down her story through the ages.[6] After I read a number of the accounts, it seemed best to follow the version by Anna Lo Bianco, itself based on the *Passio Sanctae Ceciliae*[7] that the Benedictine order of St. Cecilia sells at the basilica.

Cecilia was a girl from a wealthy Christian family that lived in Rome in the second century CE. When she came of age, her parents decided to marry her to a pagan named Valerian. After the wedding was celebrated, Cecilia told Valerian she planned to remain a virgin; in fact, it is said, an angel watched over her chastity. She persuaded her new husband to consider becoming a Christian and to meet a venerable old man called Urban (he became Pope Urban I) who lived in the catacombs along the Via Appian. Valerian did as she asked. He found Urban, had a vision, and was converted and baptized.

When Valerian returned to Cecilia, he was greeted by an angel holding two crowns, one made of roses for the bride and one made of lilies for the groom. Cecilia then explained the basic tenets of Christianity: the mystery of the Trinity, the Incarnation, and the beauty of eternal life. Valerian asked for

the grace of conversion for his brother Tiburtius. He took Tiburtius to Urban, who converted and baptized him.

Soon, the two new Christians were recovering the bodies of Christian martyrs in order to give them an honorable burial and undertaking other works of charity. When Alamachio, the prefect of Rome, learned of this subversive activity, he arrested and jailed the young men, insisting they relinquish their faith. When they refused, Almachio had them beheaded. Marcellus, one of Valerian and Tiburtius's jailers, was so impressed by their piety and sacrifice that he also became a Christian. Soon afterward, he, too, was beheaded.

Almachio then arrested Cecilia and commanded that she sacrifice to idols. When she refused, he gave her respite—until he learned that she had invited Urban into her home to baptize more than four hundred people. Now furious, Almachio called Cecilia into court. She showed great courage at her trial, arguing with Almachio, who became so irritated by her audacity that he condemned her to death. Cecilia was locked in her own bathhouse, and the steam was turned on to suffocate her. A day and a half later, instead of being suffocated, she emerged intact. Alachua then sent for the executioner, who was required by Roman law to kill her in no more than three strikes. The executioner raised his sword and struck three times but failed to sever her head from her body. Cecilia survived for three days. During that time, she turned her great wealth over to the Church, converted hundreds of people to Christianity, and gave her home to Urban, asking that it become a church. When she died, Urban gave her a solemn burial and did consecrate her home as a church.

Should we believe that the legend is true? Did Cecilia, her husband, her brother-in-law, and their jailer actually live and actually die horribly at the hands of the prefect of Rome? Evidence suggests that parts of the story could be true. There was an ancient plebeian clan known as the *gens Ceciliae*, which may be the origin of the name Cecilia. The clan may have had Christian connections, since some wealthy Romans were turning to the faith by the second century CE—especially Roman women. According to recent scholarship, women found Christianity especially appealing, in part because the Virgin Mary and Mary Magdalene were so central to it. Women had agency in the early Church: they could proselytize, host clandestine services and baptisms, and even serve as deaconesses—that is, church officials.[8]

From an historical perspective, the story of Cecilia's wedding also seems to make sense: Roman families married off their daughters in their early teens, soon after menses. A Christian family might well have chosen a pagan as a husband. In the first centuries after the birth of Christ, there were relatively many Christian girls but few Christian men. Christian families married their daughters to pagans, hoping to convert their spouses.[9]

There was also an actual bishop of Rome named Urban—this was before the bishop of Rome was called pope—who lived during the reign of Emperor Alexander Severus, 222 to 235 CE;[10] but that may have been fifty or more years after Cecilia's martyrdom, which some date to 174 CE. The story of Urban's mass conversion of pagans taking place in Cecilia's home aligns with the fact that early Christian Mass was generally held in homes. The Apian Way and catacombs that figure prominently in the legend predate Christianity, but though many Christians were buried there, including martyrs and saints. Some believe that St. Cecilia may have been a Jewish Christian, since many Jews lived in Trastevere during the Roman Empire.[11]

Archaeology may hold additional clues to Cecilia's authenticity. Beginning in the nineteenth century, archaeological excavations revealed foundations from second and third century villas in Trastevere, some with bathhouses: wealthy Romans valued cleanliness. Some of these villas were later replaced by multifamily apartment buildings to accommodate a population boom in the area. Underneath St. Cecilia's basilica are remains from a villa, a multifamily structure, an atrium, and a bathhouse, raising the possibility that Cecilia may have lived and died in this very spot, though most contemporary scholars doubt it.

Finally, there are religious documents. The *Passio Sanctae Ceciliae* is more detailed than the *Passio* of any other saint, suggesting that some accounts in it may have been from eyewitnesses. St. Cecilia is included in the earliest liturgies; it is highly improbable, some argue, that a mythical saint would have been included.

These bits of evidence add up for some but not for all. The *Oxford Dictionary of Saints* argues that the legend of St. Cecilia "is unsupportable by any near-contemporary evidence" and points out that a number of important early authors failed to mention her.[12] Thomas H. Connolly, in *Grove's Dictionary of Music*, goes even farther. He denies that Cecilia ever existed and argues that *Passio Sanctae Ceciliae* is largely fictional. Some scholars question whether Cecilia or Urban could have found hundreds of pagans who wanted to be baptized en masse.

Bertha Ellen Lovewell, in *The Life of St. Cecilia*, drawing on medieval sources from the collections of Oxford University, attempted to disentangle truth from fiction. She pointed out that Christians were being severely persecuted and put to death, but not during Emperor Alexander Severus's reign, when Christians were accepted and even allowed to build churches—perhaps because Severus's mother was a Christian. A Roman precept named Almachio could have persecuted Christians when the emperor was away fighting the Persian War; but that is not likely, since the name does not appear in any list of Roman prefects. Lovewell concluded that the basic story is "reasonably

authentic" but may have been modified and enlarged "through the natural inaccuracy of a scribe."[13]

"Logic can probably never smooth the present discrepancies of the legend," she wrote. "History may some day contribute an element, which will modify or enlighten."

So, there you have it: evidence that suggests St. Cecilia may or may not have actually lived, and if she did, may or may not have been unsuccessfully steamed before being successfully mortally chopped.

Despite the discrepancies, there was enough in the legend to make this maiden martyr especially beloved. As early as the fourth century CE, St. Cecilia was included in the liturgy of the church of Milan and in Eusebius's *Martyrology*, later translated by Jerome (330–420). In the sixth century, Venantius Fortunatus located St. Cecilia's martyrdom in Sicily, which few believed but which some attributed to the fact that sixth century Sicilians especially venerated her.[14] From the seventh century, Cecilia's name appeared with the names of the other early Roman women martyrs, Lucy, Agnes, and Anastasia, in the Roman Canon. By the end of the eighth century, liturgies in Gaul, southern France, Spain, England, and Ireland included St. Cecilia; a century later, she was listed in martyrologies by Rabinus Maurus, Archbishop of Mayence, and Odo, Archbishop of Vienna, as well as the great Menology of the Greeks. According to W. Wendell Howard, Chaucer, who read voraciously among the Latin and Italian authors, probably knew St. Cecilia's *Passo* and used it to write "The Second Nun's Tale."

Over the years, St. Cecilia became the patron saint of music. Some say the connection arose because of the song she "sang in her heart" while organs played at her wedding. Others say it was because of the prayer she sang when she was locked in the bathhouse to die.[15] She was celebrated in Latin hymns as early as 400 CE. She is frequently depicted playing a flute, harp, or other instrument, especially pipes or a pipe organ, because they symbolize spiritual music. As patroness of music, she gave her name to a musical academy that was briefly located with the Benedictine nuns of St. Cecilia and to a musical society established in Louvain in 1502. Since the sixteenth century, innumerable musical societies have given performances in her honor in England, Italy, Germany, and Scotland.[16] Her musical connection is one of her most endearing attributes and a main reason for the spread and resilience of her cult.

The Basilica of St. Cecilia in Trastevere was a twenty-minute walk down a steep hill from the American University of Rome, which is located in a former seminary on the Gianicolo, one of the city's Seven Hills. I grew to love Gianicolo's peaceful parks, tiny cafes, and *tavernas* serving up local specialties, a respite from central Rome's crowds and daredevil drivers.

The university is fifty years old and one of about thirty American colleges and universities with a footprint in the city. The school's president, Richard Hodges, is a British-born archaeologist and international authority on cultural tourism development, which has raised the profile and revenue of the university. With his endorsement, I was appointed a Visiting Scholar, a title that provided introductions to the faculty and access to the library and other facilities, including Hodges's own office, which he lent me while he was out of the country. The president's office commands a corner on the top floor of the main classroom-cum-administrative building, surrounded by an outdoor patio and featuring a panoramic view of Rome.

Hodges had asked a university trustee to help arrange for the interview I most wanted: a session with an official from the Vatican's Congregation for the Causes of Saints. Since my own efforts had failed multiple times, I was delighted when the trustee used his contacts to secure a meeting with the undersecretary of the Congregation, the chief manager.

A few days after Sunday Mass, I returned to the Church of St. Cecilia to tour the sanctuary and basement. Through the closed metal gates of the grand gold and cream portal, part of the basilica's transformation to a high baroque structure, I could see a Roman *cantharus* urn, more than twice the height of a man, set inside a fountain surrounded by a square of grass and some rose bushes. A monastery was connected to each side of the church portico, and on the right side was a four-story bell tower that looked like a medieval layer cake leaning slightly to the left.

The church portico was up three steps. Its walls were embedded with inscriptions and tombstones from the fourteenth and fifteenth centuries. I entered the basilica and paid a nun an entrance fee to tour the crypts. A flight of stairs led down to the foundations of a Roman *domus*, or residence, from the second century BC, and an *insula*, an apartment building, dating from the second century CE, built on top of part of the *domus*. Did Cecilia live in an apartment building?

Beyond this first room was a corridor. Parts of the floor were decorated with colored stones set in bands, zigzags, and more elaborate patterns (see Figure 9.3). The corridor led deeper into the crypt. Rooms opened off one side of the corridor, a couple of them containing abandoned archaeological supplies. In another room, there were eight circular basins with bricked interiors that scholars hypothesize may have held grain. Farther down the corridor was a room with five ancient sarcophagi.

Walking deeper under the building, it became cooler, danker, close. Crypts are not my favorite.

The corridor led to a room that, tradition has it, was the ancient *balneum* where Cecilia was unsuccessfully steamed, then mortally wounded. It was

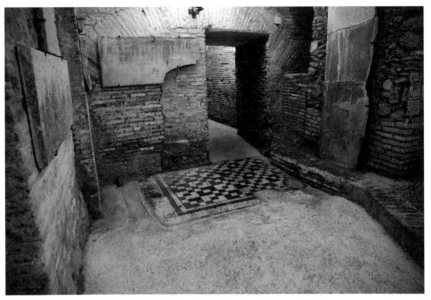

Figure 9.3. Ruins of a Roman home, underneath Saint Cecilia in Trastevere; second century CE.
Almay Stock Photo/Boris Karpinski

directly below the basilica's Chapel of Caldarium, which could be spied through a small grate on the ceiling.

The final room was a surprise: a brightly lit, dazzling array of gilt and elaborate stonework, plasterwork, and marble that dated from the early twentieth century. The floor was covered with a syncopation of marble tiles in black, white, and beige. Twenty thin marble columns supported twenty ceiling coffers elaborately decorated with paintings, mosaics, and sculpture that portrayed St. Cecilia and the other martyrs as sweet-faced youth.

At the center of the room was an altar. Under it were urns holding martyrs' remains that had apparently been moved out of their sarcophagi. St. Cecilia's urn was elevated above the others. One of the most delightful things about the basilica is that it has been a work in progress since at least the eighth century—or even six centuries earlier, if you believe the legend.

On a still night around the year 817, Pope Paschal I was visited by a young girl "who had the appearance of a virgin" and was "adorned with the clothing of an angel." She introduced herself as St. Cecilia. Her appearance was timely. The Pope had recently rescued St. Cecilia, then just a neighborhood church, from "extreme old age."[17]

Although its origins remain a mystery, by the fifth century, a church of St. Cecilia was located on the site of her house, as she had requested during her final days on earth. Now, under Pope Paschal I, the structure would be expanded into a basilica with "magnificent workmanship."[18]

Paschal I had recently been appointed pope and wanted to make his mark. There was no better way than to create a beautiful church and bring the martyred Roman virgin and her fellow martyrs home. In the ninth century, she was one of Rome's most popular early saints.[19] Moreover, church reconstruction was all the rage. The Church wished to better serve the devout—and boost the economy through religious tourism. Since the fifth century, pilgrims had traveled to Rome to visit the Church of Peter and Paul, what later became the Vatican. Religious tourism really picked up in the seventh century, when Rome became Christianity's number one tourist destination.[20] Martyrs were believed to have a living presence in churches that held their remains.

In his autobiography, Paschal I described his quest for the virgin with the gash in her neck, now dead for more than six hundred years.[21] He found her body in the cemetery of Praetextaus outside the Appian Gate "clothed in gold vestments," together with the body of her husband Valerian. She was wrapped in a swath of cloth "soaked in sacred blood from the executioner's three strokes." He knew it was the right spot because St. Cecilia had told him where she was. He may have found the graves of Valerian, Tiburtius, and Marcellus by examining the fish and other symbols that sometimes marked the graves of Christian martyrs.

With the saint's divine sanction, Paschal I carried her body with his own hands to her church in Trastevere. Soon, she, Urban, her husband, her brother-in-law, and Marcellus, the martyred Roman guard, were snug in their sarcophagi. The Church calls the moving of saintly remains "translations." "They're translated by ritual," explained Patrick Hayes. "They just don't throw someone in a box and ship him or her across town. There's a lot of fanfare that goes along with it."[22]

Underneath the church were some foundations from Roman times. Here, Paschal I built a long corridor to provide access to a baptismal font that had been in the church from the fifth century. He laid St. Cecilia's remains in a sarcophagus in the crypt under the altar, along with the bloody shroud from her grave. The remains of Valerian, Tiburtius, and Marcellus were placed head to toe on top of each other in another sarcophagus, and Urban's remains in a third one. Paschal then added the votive inscriptions from the spot in the catacombs where the martyrs had been found, a move that may have been motivated by the need to reassure Romans and pilgrims that the relics were authentic.[23]

In the church, Pascal I used marble and granite columns harvested from ancient buildings, long a common practice in Rome.[24] Like St. Peter's Ba-

silica, but on a much smaller scale, the Basilica of St. Cecilia featured a long nave, two side aisles with chapels, open roof trusses, and a single apse.[25] The presbytery at the end of the nave was the focal point, raised and opulently adorned. For the semicircular apse over the altar, Paschal I commissioned a mosaic depicting Christ standing among Saint Peter, Saint Paul, and the martyrs. Paschal I stood on the extreme left next to St. Cecilia, his head encircled with a square nimbus—signifying he was alive at the time of the mosaic—and holding a miniature version of her church. Below was an inscription that, translated into English reads in part:

> Wealthy Bishop Paschal has built this house of the Lord for the better, forming it with a bright foundation. . . . Here, joyous with the love of God, he has united the holy bodies of Cecilia and her companions. Here the youth in their prime shine brightly, those blessed limbs which long ago rested in death in the catacombs Rome, forever embellished, always exulting, resounds.[26]

The Basilica of St. Cecilia was a remarkable achievement. It reunited the martyrs in their ancestral home. It allowed Paschal I to insert himself into their story. Finally, it became an all-in-one attraction where locals and pilgrims could admire the saintly girl, visit the scene of her grisly martyrdom, and send up a prayer for their personal redemption.

And we know they did. When the pilgrims returned home, St. Cecilia's legends traveled with them. Their devotion, first developed in Rome, spread to other places, with devotees building churches to honor her. "People came to the faith through the stories," said Patrick Hayes. "It's word of mouth, but you can't just say, 'oh yes, we need to build a church.' You need a story behind it. Otherwise, it doesn't make sense: it's only four walls and a roof."[27]

The basilica played an important role in medieval Rome's economy, but more important still was its role in the medieval Church. During this period, the pope and his entourage traveled throughout Rome and held large public masses at "stational" churches. St. Cecilia was one of these, honored by a papal visit each year on the Wednesday after the second Sunday of Lent. Papal insignia and imagery marked the stational churches, so this basilica continually basked in the presence and potency of the pontiff, even in his absence.[28]

Throughout the centuries that followed, St. Cecilia continued to change. In the twelfth century, frescos, mosaics, a portico, and a classic Roman bell tower were added. In the thirteenth, a ciborium, or liturgical vessel, was installed, likely replacing an older one. The new ciborium was a medieval confection of four black columns topped with carvings of St. Cecilia, Urban, Valerian, and Tiburtius rendered on horseback. At the end of the fifteenth century, Cardinal Sfondrati launched the next major renovation to coincide with the Holy Jubilee Year of 1600, another religious tourist opportunity.

Cardinal Sfondrati was a member of the Oratory, a group of clergy dedicated to reinvigorating Rome's churches after the Protestant reformation. He served as the titular cardinal for St. Cecilia, a role he inherited from this uncle when the latter became Pope Gregory in 1591. Soon after becoming a cardinal, Sfondrati found a letter from an archaeologist and member of the Oratory that described Cecilia's martyrdom and Pope Paschal I's translation of her body and those of her companions from the catacombs to the church. With that discovery in mind, and with an eye to the coming Jubilee, in 1597 Sfondrato launched a series of major renovations of the church. These included adding the Chapel of Caldarium, dedicated to the saint, and a painting depicting her decapitation.

Then a miracle occurred. On Wednesday, October 20, 1599, three marble sarcophagi containing six incorrupt bodies were discovered below the altar. When word of Sfondrati's miraculous discovery reached Pope Clement VIII, he quickly dispatched two scholars to the site. One of them, a Cardinal Baroni, recorded what he saw:

> we found the venerable body of Cecilia in the same place that we have read that she was found and placed in the tomb by Pope Paschal. . . . One saw with admiration that the body was not extended like the dead in their tombs; but the very chaste virgin was lying on her right side, as on a bed, knees tucked in with modesty, offering the aspect of a sleeping person, and inspiring in all a respect that, despite the attraction of a pious curiosity, no one dared lift the vestments in order to discover the virginal body.[29]

Miraculously, St. Cecilia's body showed no signs of deterioration or decomposition: instead, it emitted the sweet fragrance of the perpetually blessed. How did it happen? Some speculate that the coffin of cypress, an especially dense wood, preserved the body intact. The faithful believe that Cecilia's incorruptibility verifies her sainthood.

Cardinal Sfondrati quickly commissioned a young sculptor named Stefano Maderno to render the startlingly well-preserved corpse in white marble. His creation is exceptionally lovely and quite unusual. Instead of portraying St. Cecilia lying in her coffin, she is rendered at the very moment of her martyrdom, with her head twisted and her neck slashed.

On November 10, 1599, Pope Clement VIII himself came to the church, and soon all of Rome was invited to wonder at St. Cecilia's uncorrupted corpse. The crowds were so large and excited that the Swiss Guard was dispatched to control them. Cardinal Sfondrati quickly isolated her from public view; and on her feast day, November 22, 1599, Pope Clement VIII, accompanied by forty-two cardinals and the entire papal court, reinterred her corpse in St. Cecilia.

Then, the body disintegrated.

St. Cecilia came to the rescue at the very moment when the Church sought to reconnect with the devout. She became a star attraction of the Holy Jubilee of 1600, a source of pride, and a reason for pilgrims to travel to Rome and renew their spirituality. Guidebooks printed in German, Italian, French, Spanish, and Flemish encouraged a stop at her basilica. Some also recounted the miraculous story of her recovery, translation, and reinternment.[30]

Boguslaw Turek, CSMA, undersecretary for the Congregation for the Causes of Saints, evidences the intellectual and supervisor authority typically found in a provost of a distinguished university, which is fitting for the official who manages the Vatican department responsible for saints. Appointed by the Pope, the secretary has served the congregation for many years.

The Congregation for the Causes of Saints, one of the Vatican's nine congregations, or decasteries, is located in a nondescript office building on St. Peter's Square. Laura Estrada, a member of the staff of the American University of Rome, had agreed to serve as translator. To reach the building, we squeezed through long lines of tourists, cardinals, priests, nuns, and people hawking Vatican tours, then signed in with a guard and took an elevator to the Congregation's suite, where we were greeted by a staff member and led to a small room with sofas and chairs. Father Turek soon joined us. Originally from Poland, the Secretary spoke Polish and Italian, so Estrada translated the questions I had carefully prepared. Before beginning, the secretary cautioned that his answers would be a simplified explanation of more complicated matters.[31]

The Congregation for the Causes of Saints was originally established in 1588 as the Congregation of Sacred Rites, with responsibility over both the liturgy and the causes of saints. During the first millennium, bishops proclaimed canonization and saints. The establishment of a central congregation in Rome was intended to formalize and make the criteria uniform throughout the Church. It was also meant to avoid politics and guarantee "objectivity" in canonization. In the twentieth century, the Congregation of Rites was restructured into two new decasteries, one of which was the Congregation for the Causes of Saints. Its staff of thirty is augmented by a network of approximately three hundred *postulatori* responsible for gathering and vetting the extensive historical and spiritual information that the Vatican requires for applications for canonization. Currently there are three thousand active cases, some for a single individual, others for a group.

By time the congregation was established in 1588, Cecilia was already considered a saint, so she was essentially "grandmothered." According to the secretary, her significance comes from her role as the patron of music, her martyrdom at an unusually young age, and her devotion to Holy Trinity.

"That is why she is always represented with three fingers raised," he pointed out. "If the Christian community has handed down this image, it means that it was something that remained in the memory and narrations of the people."

"The Pardoner," another of Chaucer's pilgrims, describes the brisk trade in unsubstantiated relics, a huge problem for the Church during the medieval period. I wondered whether the market for fake relics was still active, and how the Church knows which relics are authentic.

"There has always been a questioning of the authenticity of relics," Father Turek said. "And there has always been great abuse. At one point there were five heads of Saint John the Baptist. In the past it was rogue merchants; now you can find them on eBay." He then explained that relics must be related to the actual body of a saint. To determine whether or not a relic is real, the Church starts from the body. If the relic can be historically traced from hand to hand, it is deemed authentic.

"For the devout," he continued, "the relationship and substance of having a saint to pray to or to intercede for them before God remains the same. Modalities change, the procedures change, but the human soul still has the same desires and needs that it had centuries ago."

What about the connection between secular and religious history? What happened if, after canonization, something was discovered that raised questions about whether the individual was actually a saint?

"When there are new historical truths, these might lead to the questioning of certain assumed saints," agreed the secretary. In this instance, the Church excludes them from the Liturgical Calendar, mainly to avoid confusion among the devout, but will not decanonize them. They will not disturb the cult of the saint.

In St. Cecilia's legend, her church was built on the foundations of her home. Now, archaeology suggested otherwise. Would this affect her saintly status? Not according to the secretary: "With saints like Santa Cecilia, what is pivotal to the story and her sainthood is the body, not whether the church is actually built on her house. But, it's important to remember, sainthood is not an end in itself; relics do not have any value in themselves. The value of the relic transcends the object itself; it is a symbol of something bigger and more transcendent."

After an hour together, the secretary extended a very special invitation to accompany him on a tour of the archives that hold all of the records pertaining to the canonization of saints, as well as reference books on the subject. Estrada and I followed him down a long hallway, through an office, past a secured door, and into a large, spotlessly clean room lined with metal shelves that reached almost to the ceiling. The Congregation for the Causes of Saints receives all the historical and spiritual information on the candidate for canonization, and then prepares a dossier for ultimate approval by the pope. As

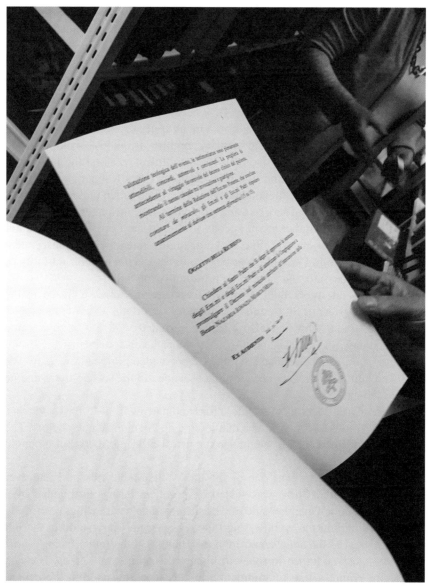

Figure 9.4. Father Boguslaw Turek, CSMA, with Pope Frances's signature and papal seal on a recent canonization dossier.
Courtesy: Nancy Moses

we walked among the shelves, the secretary pointed out some of the treasures. There was a series of very old books with dates on their leather binding: 1592–1654, 1655–1673, 1692–1702, and so on. There was a handwritten piece of vellum that argued for the canonization of a Polish king. Father Turek called a staff member over; she brought him a new folder. Inside was the official dossier for the most recent canonization, with Pope Francis's actual signature and the official papal seal (see Figure 9.4).

I returned to St. Cecilia in Travestera many times to view Cecilia's statue, study the paintings, tombs, and statuary, or just sit quietly, soaking in the heavenly aura. I was often one of just a handful of visitors: the basilica is a bit off the beaten path and not as majestic as other Roman churches. By this time, my natural skepticism had subsided; I had fallen under the spell of this martyred maiden. The glass and golden casket no longer held a silent, sleeping beauty but rather a courageous soldier of the Lord, cut down at her moment of greatest majesty. She spoke of the terrible cost and transcendent glory of martyrdom. I would never believe in St. Cecilia's incorruptibility or power of intercession, but I could be profoundly moved.

There was one more thing to see before leaving Rome: a fresco in the Benedictine Sisters of St. Cecilia's Monastery next door.

Laura Estrada, who had also become intrigued with St. Cecilia, came along that day. She knocked on the heavy door, the custodian answered, and, although it was after the posted hours, she persuaded him to allow us in. We followed him into a rickety elevator that ascended to the second floor, and he opened the gate.

The room in front of us was wide across and narrow front-to-back. Benches faced a perforated wooden screen that looked down on the church below. The occupants of this choir loft could see the priest offering Mass, but he could not see them.

Behind the benches was one of the most remarkable frescos I had ever seen. In the center, Christ was seated on a golden throne surrounded by a mandorla, or aura. On either side of Christ were angels with wings of brightly colored feathers in red, yellow, and blue. The Virgin Mary stood to the left of Christ, next to the angels, and John the Baptist on the right. Facing Christ were six apostles draped in robes of blue, gold, purple, and green. Beneath the entire group, a line of trumpeting angels faced away from the center. The fresco showed some damage, but the colors remained vivid. The overall composition seemed to be a blend of stylized Byzantine and realist; the figures were flat, but their hair and clothing was individualized and their faces expressive. Most surprising, the figures were life size—and close enough to touch. Most church frescos are removed from the viewer. This one was up close and personal (see Figure 9.5).

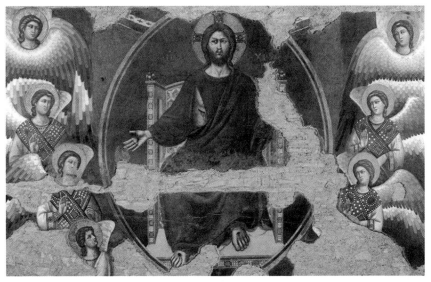

Figure 9.5. *The Last Judgment* by Pietro Cavallini, thirteenth century, Monastery of Saint Cecilia in Trastevere, Rome.
Courtesy: Italian Ways Travel

Christ at the Last Judgment Attended by the Heavenly Court was painted by Pietro Cavallini and his school at the end of the thirteenth century. It is one of the few works that illustrate the transition from medieval to renaissance art. It is Cavallini's only surviving painting and the only fresco remaining from the ones that originally covered the whole of the chorus walls. This hidden treasure ranks as among one of the most important art-historical works in the world.

How did it get here? Why is it blocked from view? The reason has to do with the Benedictine nuns. In the thirteenth century, St. Cecilia's statue had a direct sight line to the fresco and it would have been the last thing parishioners saw as they exited the church, reminding them of eternal life. Three centuries later, in 1530, the Benedictine sisters moved into what had formerly been a monastery. Being cloistered, they had a wooden screen installed that hid them and the artwork from view.

Although they were isolated, the Benedictine Sisters of St. Cecilia were afforded advantages not available to their secular sisters. They were spared the constant threat of death during childbirth. They had some leisure time to read, study, and sing. Those from wealthy families enjoyed many of the comforts of home, including servants and quality food. Choir sisters were the most important nuns in the convent. From the choir loft, their sweet voices would soar through the basilica of the Patron Saint of Music. The room that today

is bare and plain was once lavishly adorned with ethereal artwork, a special, secret space reserved for just them.

Christ at the Last Judgment Attended by the Heavenly Court was covered with wooden paneling in the eighteenth-century renovation, perhaps because thirteenth-century artwork didn't appeal to eighteenth-century sensibilities. Perhaps the paneling protected this fresco while the other ones flecked and faded away. In 1900, during yet another restoration, the hidden fresco was rediscovered. The nuns initially resisted allowing visitors in but eventually realized the importance of the work. Now, Cavallini's masterpiece remains a comfort to the sisters—and a surprise and delight for others who are fortunate enough to know it is there.

"Now that you've been to Rome and visited St. Cecilia, can you tell me, what is a relic?" asked Patrick Hayes soon after my return to Philadelphia.[32]

I carefully considered the question. At St. Anthony in Pittsburgh, I had learned that a relic is a part of a saint's body, a piece of clothing, or something that had touched it. There was nothing left of Santa Cecilia. Did that mean there are no authentic St. Cecilia relics? Did it mean that the one I saw in Pittsburgh is a fake? No one can ever know. Some things will always remain a mystery.

But even without any relics, St. Cecilia's cult grew and spread. Her second-century martyrdom, her ninth-century translation by Pope Paschal I, her seventeenth-century rediscovery and reinterment by Cardinal Sfondrati, and her role as patron saint of music are proof of the salience of her story. Is there an alternative way to view relics beyond the direct corporal connection? In this light, could the sculpture of the martyred maiden in the glass and gold coffin be a relic? Could her urn be in the basement crypt? Could the entire church be a relic?

Hayes grinned and nodded.

The statue is a relic of St. Cecilia's incorruptible corpse. It portrays her life, her martyrdom, and her miraculous preservation. Here, her entire legend, her life, death, and continuing influence, is captured in luminous marble. The urn is a relic. Those in the twentieth century who moved what allegedly remained of her remains from Paschal I's sarcophagus into the extravagantly decorated basement chapel believed it. The entire basilica of St. Cecilia in Trastevere is a relic to generations of the faithful who came to experience her martyrdom and request her intercession on their behalf. According to Father Turek, it is the cult that makes the saint as much as it is the saint that makes the cult.

St. Cecilia's influence is indisputable. She inspired painters: the ancient painter who rendered her image in early murals in the Catacombs of Calisto; Van Eyck; and Raphael, who painted her twice: once holding a small reed

instrument the second time with wreaths of roses and lilies, an attendant angel, and a palm branch.[33] She inspired poetry by Addison, Dryden, Tennyson, and Pope and compositions by Handel, Henry Purcell, and Amboise Thomas. Choirs continue to sing hymns to her glory. Most recently, the Seattle-based rock band Foo Fighters composed and recorded "Saint Cecilia," which peaked at number three on the Billboard Mainstream Rock Songs chart in 2016. As Percy Bysshe Shelley said of Raphael's painting, *Ecstasy of St. Cecilia*, she inspires with a "unity and perfection of an incommunicable kind."[34]

One might argue that Cecilia, dead, was more influential than Cecilia, alive; but that's true of all saints. Which again raises the question: Did she actually live? Was she real?

As for whether she lived, there is sufficient evidence to satisfy the faithful. For some, many details in the *Passio Sanctae Ceciliae* have the ring of truth. But whether you believe St. Cecilia lived, married a pagan, died an excruciating death in a bathhouse, occupied a villa or apartment building where her church now stands, or converted hundreds while on her deathbed—none of these is really the point. That's not what makes her real or not real. What makes St. Cecilia authentic is what she inspired.

Is there something about this Christian virgin martyr that remains relevant today? Does she continue to inspire? Patrick Hayes believes she does. "One of the characteristics of early female Christian martyrs," he told me, "was that they exemplified tremendous courage. What they bumped up against wasn't just castigation by their peers, it was death. When they opened their homes to provide space for Eucharist for this nascent and very fearful Christian community, they were taking their lives in their hands."[35]

While a martyr's courage is seldom required in the modern world, a martyr's inspiration may be. St. Cecilia stood up to authority, knowing the cost. She was never a victim. She welcomed her horrible death, her martyrdom.

St. Cecilia continues to lend her voice to the voiceless, her power to those confronting evil. She's real because we need her to be.

Notes

CHAPTER 1

1. As one of the greatest scholarly scandals of the late nineteenth century, the Shapira Affair is the subject of many books, articles, and even television documentaries. This account is based on two: Fred N. Reiner's article, "C. D. Ginsburg and the Shapira Affair: A Nineteenth-Century Dead Sea Scroll Controversy" (London: *British Library Journal*, British Library Board), 109–127, and Leo Deuel, *Testaments of Time: The Search for Lost Manuscripts and Records* (New York: Alfred A. Knopf, 1965).

2. Thierry Lenain, *Art Forgery: The History of a Modern Obsession* (London: Reaktion Books, 2011), 39.

3. http://www.interlude.hk/front/kreisler-scandal/.

4. James Koobatin, *Faking It: An International Bibliography of Art and Literature Forgeries, 1949–1986* (Washington, DC: Special Library Association, 1987), cited in Lemain, *Art Forgery*, endnote 4, p. 325.

5. *The Nara Document On Authenticity*, UNESCO World Heritage Centre, https:wch.unesco.org/document/116018.

6. Deuel, *Testaments*, 406.

CHAPTER 2

1. http://www.worldcat.org/search?qt=worldcat_org_all&q=Shakespeare.

2. Derick Dreher interview with author, October 2015.

3. Ian Wilson, *Shakespeare: The Evidence* (New York: St. Martin's Press), 37.

4. James Shapiro, *1599: A Year in the Life of William Shakespeare* (London: HarperCollins, 2005), 10.

5. Rosenbach Company stock card #439/26.

6. Jack Lynch interview with author, January 2016.

7. Jack Lynch, *Becoming Shakespeare: The Unlikely Afterlife That Turned a Provincial Playwright into the Bard* (New York: Walker & Company, 2007).

8. Ibid., 279.

9. William-Henry Ireland, *The Confessions of William-Henry Ireland* (Middletown, DE: Adament Media Corporation, replica of Edition published in 1805 by Thomas Goodhall, London, 1805), 6.

10. Ibid.,7.

11. Beulah Trey interview with author, November 2016.

CHAPTER 3

NOTE: Unless otherwise noted, the biographical information in this chapter comes from Valentine O'Connor and Eugene Victor Thaw, *Jackson Pollock: A Catalogue Raisonné, of Paintings, Drawings, and Other Works* (New York and London: Yale University Press, 1978).

1. Catalogue, Vol. 1, x.

2. Samuel Sachs II, interview with author, January 2016.

3. Catalogue, Vol. 4, 217.

4. Ibid., 219

5. Carter Ratcliff, *The Fate of a Gesture: Jackson Pollock and Post World War II American Art* (New York: Farrar Straus Giroux, 1996), 9.

6. Catalogue, I, iv, p. 241.

7. Ibid.

8. Clement Greenberg, "Review of One-Man Show at Art of This Century," *Nation*, April 13, 1946.

9. Ratcliffe, 123.

10. Catalogue, I, vi.

11. Lisa Duffy-Zeballos interview with author March 2016.

12. Lisa Duffy Zeballos, "Did Fidel Castro Really Own a Pollock? *IFAR Journal*, Vol. 19, No. 3, 2018, pp. 18–21.

13. John Re appealed the conviction and the US Court of Appeals, Second Circuit, affirmed the judgment of the district court. United States Court of Appeals, Second Circuit, United States, *Appelle v. John Re*, Defendant-Appellant, No. 15-1629.

14. Helen Harrison interview with author, May 2016.

15. Randy Kennedy, "Is This a Real Jackson Pollock?" The *New York Times*, May 29, 2005.

16. Tom Zeller, Jr., "Purported Pollock Paintings: Still a Pickle," The *New York Times,* January 31, 2007.

17. Steven Litt, "Florida Gallery Withdraws Suggestion of Authenticity for Paintings Once Attributed to Jackson Pollock by CWR Professor," *Plain Dealer*, September 9, 2014, at 12:33 p.m.

18. David R. Williams, "Resiliency and Creativity in the Face of Great Odds," *Psychiatric Times*, May 17, 2016.

CHAPTER 4

1. M. de Boer, J. Leistra en B. Bross, Bredius, *Rembrandt en het Mauruitschius* (The Hague: Mauritshuis, 1992), 17. Cited in van de Wetering, *A Corpus of Rembrandt Paintings, vol. 6* (New York: Springer Publishing, 2011), chapter 1.

2. *The Polish Rider* provenance files, the Frick Collection Art Reference Archives.

3. Kenneth Clark in Wetering, *Corpus*, 104.

4. Gary Schwartz interview with author, The Hague, July 2017.

5. Josua Bruyn, letter, *New York Review of Books*, 30, October 1986.

6. Schwartz interview.

7. Anthony Bailey, *Responses to Rembrandt: Who Painted* The Polish Rider? *A Controversy Considered* (New York: Timken Publishers, 1994).

8. *The Polish Rider* provenance files, the Frick Collection Art Reference Archives.

9. Baily, *Responses*, 4.

10. Ben Bross, "Het mysterie va De Poolseruit," *Vrij Nederland, Lii*, No. 49, December 7, 1991.

11. Letter from Edgar Munhall, Curator, to Professor D. E. van de Wetering, Sept. 10, 1997 (Amsterdam: Strichting Foundation, Rembrandt Research Project).

12. Ibid.

13. *The Polish Rider* provenance files, the Frick Collection Art Reference Archives.

14. Ian Wardropper interview with author, November 2017.

15. Anna Tummers, *The Eye of the Connoisseur: Authenticating Paintings by Rembrandt and His Contemporaries* (Amsterdam: Amsterdam University Press, 2001), 70–76.

16. Wetering, *Corpus*, 8.

17. Ibid.

18. Tummers, *Eye*, 42.

19. M. de Boer, *Rembrandt en het Mauruitschius* (The Hague: Mariuritschius, 1992), 17. Cited in Wetering, 3.

20. Milko den Leeuw interview with author, June 2017.

21. Teresa Lignelli interview with author, November 2017.

CHAPTER 5

1. Oscar P. Fitzgerald, *American Furniture, 1650 to the Present* (Lanham, MD: Rowman & Littlefield, 2018), 560.

2. Stephanie Grumman Wolf, "Centennial Exhibition (1876)," accessed July 25, 2017, philadelphiaencyclopedia.org.

3. Philip Zimmerman, interview with author, May 2017.

4. Deborah Buckson, interview with author, March 2018.

5. Bob Flexner, "The Great Brewster Chair and How It Was Re-Created," *Woodshop News*, July 16, 2017, accessed May 25, 2017, www.woodshopnews.com.

6. Luke Beckerdite and Ala Miller, "Furniture Fakes from the Chipstone Collection," *American Furniture*, 2002. http://www.chipstone.org/article.php/140/American-Furniture-2002/Furniture-Fakes-from-the-Chipstone-Collection.

7. Philip D. Zimmerman, "Truth or Consequences: Restoration of Winterthur's Van Pelt High Chest," *Winterthur Portfolio*, Vol. 33, No. 1 (Spring 1998): 59–74.

8. Joshua Lane and Philip Zimmerman interview with author, May 2017.

9. Joan Johnson with interview with author, March 2018.

10. Clayton Pennington, "Fake Civil War Masterpiece: A Tale of Two Photographs," *Maine Antiques Digest Online*, February 26, 2018, https://www.maineantiquedigest.com.

11. Ibid.

12. Alyce Perry Englund, "The Civil War Has Left Its Mark on Two Important Pieces of Vernacular Furniture Acquired by the Wadsworth Atheneum," *The Magazine Antiques,* January–February 12018, www.themagazineantiuews.com/magazine-January-February-2018.

13. John Banks, "I Cheated, Says Woodworker Who Fooled the Antiques Experts," *The New York Times*, March 11, 2018.

14. Lynda Cain, email to author, April 23, 2018, re: American Furniture, Folk & Decorative Arts Lot No. 64.

15. Philip D. Zimmerman, "From the Collection: Truth or Consequences: Restoration of Winterthur's Van Pelt High Chest," *Winterthur Portfolio*, Vol. 33, No. 1 (Spring, 1998), 59–74.

CHAPTER 6

1. Stephen Brockmann, *Nuremberg: The Imaginary Capital* (Rochester, NY: Camden House, 2006).

2. Robert Wilburn, former director, Colonial Williamsburg Foundation, interview with author, September 2017.

3. Brockmann, *Imaginary*, 34, footnote 5, Ludwig Tieck and Heinrich Wackenroder, Herzengergiebunger eines kunstliebender Klosterbruders, 1795.

4. Tieck and Wackenroder, Herzengergiebunger.

5. Martin Schieber, translated by John Jenkins, *Nuremberg: The Medieval City: A Short Guide* (Nuremberg, Germany: Geschichte Fur Alle e.V-Institut fur Regionalism, 2009), 8.

6. http://www.jewishencyclopedia.com/articles/11632-nuremberg.

7. Schieber, *Nuremberg*, 44.

8. Dr. Thomas Schauerte, Script for Nuremberg exhibit at Fembo House, unpublished.

9. Schauerte interviews with author, July 2017.

10. Schauerte, Script.

11. Joshua Hagan and Robert Ostergren, "Spectacle, Architecture and Place at the Nuremberg Party Rallies: Projecting a Nazi Vision of the Past, Present, and Future"

(Thousand Oaks, CA: SAGE Publications, 2006, 13 [2]), 167–170. https//hal.archives
-ouvertes.fr/hal-00572185.

12. Armin Glass in email to author, 2017.

13. Hagan and Ostergren, "Spectacle," 164.

14. Scobie, *Hitler's State Architecture*, pp. 80–85, cited in "Spectacle," 179.

15. Historical Exhibit, Documentation Center, Rally Grounds, Nuremberg, Germany.

16. Imaginary, 205.

17. Glass interview.

18. Imaginary, 233.

19. Imperial castle website.

20. Imaginary, 233.

21. Ibid.

22. Karl-Heinz Enderlie interview with author, July 2017.

23. Armin Glass interview with author, July 2017.

CHAPTER 7

1. Nicolas Tabarrok, producer, *Art of the Steal* (Darius Films, 2013).

2. http://www.philly.com/philly/entertainment/arts/barned-foundation-philadel
phia-parkway-merion-20171024.html.

3. Japan for Sustainability, *JFS Newsletter*, No. 132 (August 2013).

4. Paul P. Cret, the Building of the Barnes Foundation at Merion, PA, *Architecture*, Vol. LIII, January 1926, p. 1.

5. Paul P. Cret, "The Building for the Barnes Foundation," *The Arts*, Vol. III, No. 1, January 1923.

6. Cret, "The Building of the Barnes," p. 102.

7. David Brownlee, *The Barnes Foundation: Two Buildings, One Mission* (Philadelphia: Skira Rizzouli in Association with the Barnes Foundation, 2012), 33.

8. Ed Sozanki, "Barnes at the Pennsylvania Academy: A Scandal in 1923" (Philadelphia: *Philadelphia Inquirer*, April 15, 2012).

9. The 1950 amendment also excluded members of the faculty, board of trustees, or directors of the University of Pennsylvania, Temple University, Bryn Mawr College, Haverford College, Swarthmore College, and the Pennsylvania Academy of the Fine Arts.

10. Court of Common Pleas of Montgomery County, Pennsylvania, Orphans' Court Division, No. 58,788, Memorandum Opinion and Order Sur Second Amended Petition to Amend Charter and Bylaws, January 29, 2004, Judge J. Ott.

11. Court of Common Pleas of Montgomery County, Pennsylvania, Orphans' Court Division, December 13, 2004, Judge J. Ott.

12. Derek Gilman, former executive director, Barnes Foundation interview with author, June 2018.

13. Laurie Olin, Olin Partnership, interview with author, July 2018.

14. Thom Collin, executive director, The Barnes, interview with author, September 2018.

CHAPTER 8

1. Matthew Lamanna interview with author, September 2016.
2. Helen J. McGinnis, *Carnegie's Dinosaurs: A Comprehensive Guide to Dinosaur Hall at Carnegie Museum of Natural History, Carnegie Institute* (Pittsburgh: Carnegie Institute, 1984), 15.
3. www.intelligentdesign.org.
4. Laurie Goodstein, "Judge Rejects Teaching of Intelligent Design" nytimes .com, December 21, 2005.
5. Martin J. S. Rudwick, *The Meaning of Fossils: Episodes in the History of Paleontology* (Chicago: Chicago University Press, second edition, 1978), 51.
6. David Weishampel, Peter Dodson, and Halszka Osmólska, *The Dinosauria* (Berkeley: University of California Press, 2007).
7. www.pewforum.org/religious-landscape study.
8. *Dinosauria*, Table 13E, 264.
9. Andrew Carnegie, *Autobiography of Andrew Carnegie* (New York: Houghton Mifflin, 1920), 348.
10. *Carnegie's Dinosaurs*, 13.
11. "How Dippy Came to Pittsburgh" (*Carnegie Magazine*, September 25, 1951), 238–240.
12. *Dinosaurs in Their Time*, DinoGuide.
13. Ibid.
14. David S. Berman and John S. McIntosh, "The Recapitation of Apatosaurus," *The Paleontological Society Special Publications*, Vol. 7, 1994, 83–98.
15. *Carnegie's Dinosaurs*, 21.
16. Ibid., 23.
17. Peter Dodson, "On Fossils and Faith," Paper S4-2, Penn Program for Research on Religion, www.PPRUS.upenn.edu.
18. Peter Dodson interview with author, December 2016.
19. https://answersingenesis.org/.
20. https://answersingenesis.org/answers/research-journal/.
21. David S. Berman and John S. McIntosh, "The Recaptiation of Apatosaurus," *The Paleontological Society Special Publications*, Vol. 7 (Dino Fest), 1994, pp. 83–98.
22. Philip Fraley interview with author, December 2016.
23. www.visitcreation.org.
24. James Ladyman, *Understanding Philosophy of Science* (London: Routledge, 2002)
25. Dodson, "On Fossils and Faith."
26. Helen Gordon, "Everything You Thought You Knew about Dinosaur Colors Is Wrong," www.wired.co.uk/article/paleocolor-dinosaur-facts.

27. http://phys.org/news/2016-11-keratin-melanosomes-million-year-old-bird -fossil.html#jCp.

28. http//www.scientificamerican.com/article/the-brontosaurus-is-back.

CHAPTER 9

1. *Catechism of the Catholic Church*, 2nd ed., 2473.

2. Peter Brown, *The Cult of the Saints: Its Rise in Latin Christianity* (Chicago: University of Chicago Press, 2015), 56.

3. Dr. Patrick Hayes interview with author, December 2018.

4. https://saintanthonyschapel.org/relics-2.

5. Ibid.

6. Boguslaw Turek, CSMA, undersecretary for the Congregation for the Causes of Saints, interview with author, October 2018. Translation by Laura Estrada.

7. Anna Lo Bianco, *Basilica of Santa Cecilia in Rome* (Rome: Provincia di Rome, 2007).

8. Dr. Maria Galli Stampino, Dean, American University of Rome, discussions, October 2018.

9. Patrick Hayes interview with author, December 2018.

10. Bertha Lovewell, *Life of St. Cecilia* (New York: Lamson, Wolffe and Company, 1898), 23.

11. H. Wendell Howard, "Who Is Cecilia, What Is She?" *Logos: A Journal of Catholic Thought & Culture*, Vol. 18, No. 3 (Summer 2015), 26.

12. Ibid., 17.

13. Ibid., 23–24.

14. Ibid., 14, 16–17.

15. Joe Nickell, "Incorruptible" Corpse of St. Cecilia," http://centerforinquiry.org/ (August 28, 2014).

16. Lovewell, *Life*, 29.

17. Caroline J. Goodson, "Material Memory: Rebuilding the Basilica of S. Cecilia in Trastevere, Rome," *Early Medieval Europe*, Vol. 15, No. 1 (February 2007), 13.

18. Raymond Davis, Translator, *The Lives of the Ninth-Century Popes, Vol. 20: The Ancient Biographies of Ten Popes from AD 817–819* (Liverpool, UK: Liverpool University Press, 1995), 16–17, section 15.

19. Goodson, "Material Memory," 13

20. Matthew Kneale, *Rome: A History of Seven Sackings* (New York: Simon & Schuster, May 2018), 50, 111.

21. *Ninth-Century Popes*, 16–17.

22. Hayes interview, December 2018.

23. Goodson, "Material Memory," 21.

24. Ibid., 7.

25. Ibid., 6.

26. Whitworth, p. 42, footnote 84: quoting from Calvin, B. Kendall, *The Allegory of the Church: Romanesque Portals and Their Verse Inscriptions* (Buffalo, NY: University of Toronto Press, 1998), 29.

27. Patrick Hayes interview, December 2018.

28. Goodson, "Material Memory," 9.

29. Kelly Anne Whitford, "Present at the Performance," Master's Thesis, pp. 19–20. See Cesare Baronio, *Annales Ecclesiastici, vol. 9* (Antwerp 1601), 692–693, trans. By Andrew Farrington and quoted in Smith O'Neil, "Stefano Maderno's Santa Cecilia," 16.

30. Whitford, "Present," 20.

31. Turek, interview October 2018. Translations by Laura Estrada.

32. Patrick Hayes interview with author, January 2019.

33. Lovewell, *Life of St. Cecilia*, 30.

34. Howard, "Who Is Cecilia," 31.

35. Hayes interview, January 2019.

Additional Reading

CHAPTER 1: ABOUT AUTHENTICITY

Charney, Noah, *The Art of Forgery: The Minds, Motives and Methods of Master Forgers*. London: Phaidon, 2015.

Deuel, Leo, *Testaments of Time: The Search for Lost Manuscripts and Records*. New York: Alfred A. Knopf, 1956.

Lenain, Thierry, *Art Forgery: The History of a Modern Obsession*. London: Reaktion Books, 2011.

Ragai, Jehanne, *The Scientist and the Forger: Probing a Turbulent Art World*. Singapore: World Scientific, 2018.

CHAPTER 2: FAKING SHAKESPEARE

Ireland, William-Henry, *The Confessions of William-Henry Ireland*. Middletown, DE: Elibron Classics, 2015.

Lynch, Jack, *Becoming Shakespeare: The Unlikely Afterlife That Turned a Provincial Playwright into the Bard*. New York: Walker & Company, 2007.

CHAPTER 3: ZOMBIE POLLOCKS

O'Connor, Valentine, and Eugene Victor Thaw, *Jackson Pollock: A Catalogue Raisonné of Paintings, Drawings, and Other Works*. New Haven, CT: Yale University Press, 1978.

Ratcliff, Carter, *The Fate of a Gesture: Jackson Pollock and Postwar American Art*. New York: Farrar Straus Giroux, 1966.

CHAPTER 4: TWO-THIRDS REMBRANDT

Bailey, Anthony, *Responses to Rembrandt: Who Painted* The Polish Rider? *A Controversy Considered.* New York: Timken Publishers, 1994.

Schama, Simon, *Rembrandt's Eyes.* New York: Alfred A. Knopf, 1999.

Tummers, Anna, *The Eye of the Connoisseur: Authenticating Paintings by Rembrandt and His Contemporaries.* Amsterdam: Amsterdam University Press, 2001.

Van De We Wetering, *A Corpus of Rembrandt Paintings. Vol. 5*, Stichting Foundation Rembrandt Research Project, Stichting Foundation, New York: Springer Publishing, 2011.

CHAPTER 5: "NOT RIGHT"

Fitzgerald, Oscar P., *American Furniture, 1650 to the Present.* Lanham, MD: Rowman & Littlefield, 2018.

Zimmerman, Philip D., *Delaware Clocks.* Dover, DE: A Publication of the Biggs Museum of American Art, 2006.

CHAPTER 6: AUTHENTICALLY BARNES

David Brownlee, *The Barnes Foundation: Two Buildings, One Mission.* Philadelphia: Skira Rizzouli in Association with the Barnes Foundation, 2012.

CHAPTER 7: DINOSAUR TALES

Answers in Genesis, *Journey Through the Creation Museum.* Green Forest, AR: Master Books, 2008.

Carnegie, Andrew, *Autobiography of Andrew Carnegie.* New York: Houghton Mifflin Co., 1920.

McGinnis, Helen J., *Carnegie's Dinosaurs: A Comprehensive Guide to Dinosaur Hall at Carnegie Museum of Natural History.* Pittsburgh, PA: The Board of Trustees, Carnegie Institute, 3rd printing, 1993.

Rudwick, Martin J. S., *The Meaning of Fossils: Episodes in the History of Paleontology*, 2nd ed. Chicago: University of Chicago Press, 1978.

CHAPTER 8: DREAMING NUREMBERG

Brockmann, Stephen, *Nuremberg: The Imaginary Capital.* Rochester, NY: Camden House, 2006.

Schieber, Martin, translated by John Jenkins. *Nuremberg: The Medieval City: A Short Guide*. Nuremberg, Germany: Geschichte Fur Alle e.V-Institut fur Regionalism, 2009.

CHAPTER 9: INCORRUPTIBLE

Bianco, Anna Lo, *The Basilica of Santa Cecilia in Rome*. Rome: Provincia di Rome: 2007.

Brown, Peter, *The Cult of the Saints: Its Rise in Latin Christianity*, Chicago: University of Chicago Press, 2015.

Hayes, Patrick J. Editor. *Miracles: An Encyclopedia of People, Places, and Supernatural Events from Antiquity to the Present*. Santa Barbara, CA: ABC-CLIO, LLC, 2016.

Index

About the Author

Nancy Moses is an award-winning author whose books take readers behind the "staff only" doors of museums and other collecting institutions to discover iconic cultural treasures and explore the provocative issues they raise. She is the author of *Lost in the Museum: Buried Treasures and the Stories They Tell*, and *Stolen, Smuggled, Sold: On the Hunt for Cultural Treasures*. Nancy has produced exhibits, film, and historic celebrations; served as executive director of the Atwater Kent, Philadelphia's history museum, and held management positions at the National Endowment for the Humanities, University of Pennsylvania, and WQED-Pittsburgh. In 2015 she was appointed Chair of the Pennsylvania Historical & Museum Commission. She holds an MA in American Studies from George Washington University, and lives in Philadelphia with her husband.